THE ART OF
KANEOYA SACHIKO

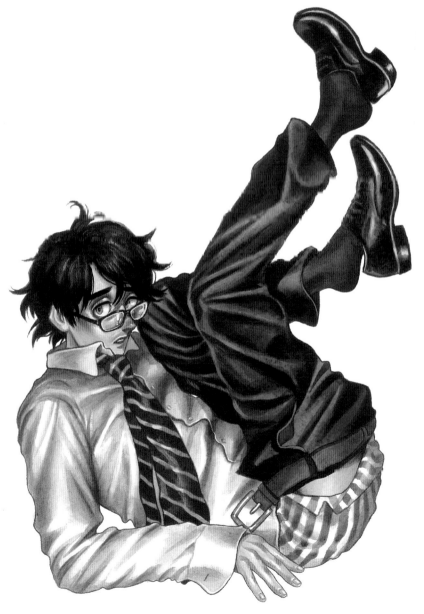

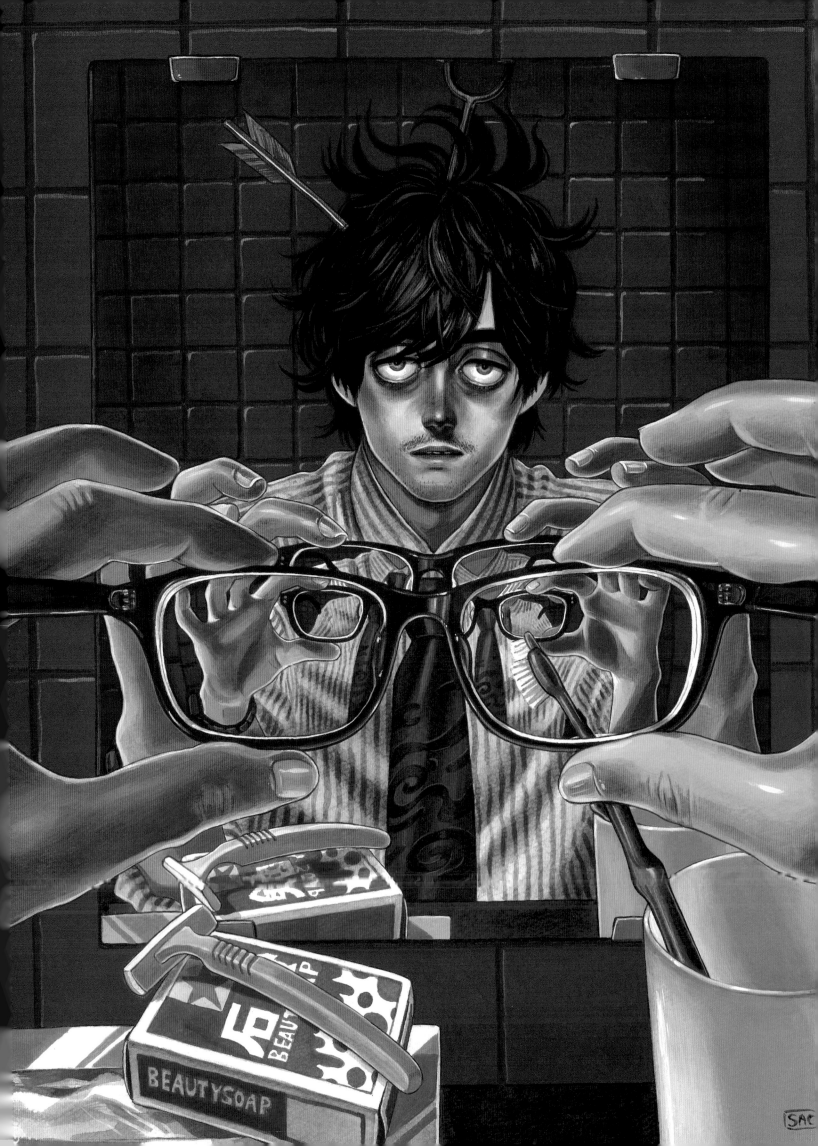

THE ART OF KANEOYA SACHIKO

ART BY
KANEOYA SACHIKO

FOREWORD BY
KANEOYA SACHIKO

Publisher
C. Spike Trotman

Editor
C. Spike Trotman

Designer
Rick DeLucco

Translator
Abby Lehrke

Production Technician
Rhiannon Rasmussen-Silverstein

THE ART OF KANEOYA SACHIKO

Published by
Iron Circus Comics
329 W. 18th Street Suite 604
Chicago, IL 60616

IronCircus.com | Yoiko-Yokochou.com

First edition: November 2018

Print Book ISBN: 978-1-945820-22-9
Ebook ISBN: 978 1 945820 21 2

10 9 8 7 6 5 4 3 2 1

Printed in China

CONTENTS

CHAPTER 1
GIRLFRIEND7

CHAPTER 2
AUTOMATA 23

CHAPTER 3
FLORAL 31

CHAPTER 4
SOLO43

CHAPTER 5
UNIFORM 61

CHAPTER 6
FANTASY ,......................... 73

CHAPTER 7
PORTRAIT89

CHAPTER 8
COLORING BOOK 119

CHAPTER 9
SKETCH............................ 176

CHAPTER 10
ABERRANT....................... 187

FOREWORD

What is the Absolute Territory of an "onii-san"?

-An endless vista of dreams and romance stretches out past the horizon of cloth to a young man's bare skin-

I must truly thank you for picking up this collection. Before you actually set your eyes upon the art, I'd like to explain to you the meaning of the word "onii-san." [Onii-san] n. Japanese. A man who has finished growing into adulthood. He's past the lustrousness of his teen years and has entered life as a full-fledged member of society. As he continues his tedious daily grind, he suddenly realizes that years have passed. Though his spirit may have stagnated, his body remains pure. A man who has come to believe that many things just don't make much of a difference anymore. He's not living a vivid life.

In other words, my theme lies between the boy and the businessman, and in large part I'm concerned with young men. I'd like to stress my use of the concept of "Absolute Territory."

The Absolute Territory I refer to isn't the AT field of Evangelion, or the conventional use referring to the bare skin between a young woman's socks and her skirt. This is the Absolute Territory of the "onii-san." So what is the Absolute Territory of a young man, then? For instance, it is the space between the rolled-up shirtsleeve of a salaryman and his wristwatch. Or the glimpse of wrist between the cuff of the workclothes and the work glove. Perhaps the flash of ankle that shows when a man seated on the train or something casually crosses his legs and the cuff of his slacks rides up above his socks. The wrist that peeks from between gloves or mittens and cuffs of jackets. Perhaps even the flash of neck beneath the chinstrap of a helmet or military cap. You may only see a little, but because of that tantalizing peek, you watch during those casual movements, seeking the territory of those few inches of skin that you cannot escape thinking of. That is, perhaps, the Absolute Territory of the "onii-san."

If you can grasp that feeling even fleetingly through this collection and enjoy it as well, that's all I need to be happy.

—Kaneoya Sachiko

おにいさんの絶対領域とは何なのか

ーおにいさんの布と皮膚の向こう側には無限の夢とロマンが広がっているー

画集をお手に取っていただき誠にありがとうございます。画集をご覧いただく前にまずおにいさんとは何なのか【おにいさん】成人済み男性。十代の瑞々しい少年期はとうに過ぎ、社会人として単調な日々を送り、気がつけば数年経過。精神は淀んでいるが肉体は清い。色んな事がどうでもいいと思い始めている男性の意。生き生きとはしていない。

さて私は半ズボンの少年からサラリーマンの男性まで、「男子」を主なテーマとしてきました。その中でも「絶対領域」というものに重点を置いてきました。

ここでいう「絶対領域」はATフィールドでも一般で言う女性のスカートと靴下の間の素肌の部分のことでもない。「おにいさん」の絶対領域である。ではおにいさんの絶対領域とは一体なんなのか…例えばそれはサラリーマンの腕まくりしたワイシャツの袖と腕時計の間であったり、作業着と軍手の間の手首、または電車等で脚を組んだ際にスラックスの裾から思いがけなく覗く靴下を履いた足首かもしれないし、その手袋と袖の間からチラリと見え隠れする手首か、ヘルメットや軍帽の顎に掛けたベルトから襟までの首の間かもしれない。わずかしか見えない、見えないからこそ何気ない動作の際に覗く、その数センチの領域に思いを馳せずにはいられないもの…それがおにいさんの絶対領域なのかもしれない。

これをこの画集で少しでも感じていただき、楽しんでいただけたのであれば幸いです。

—Kaneoya Sachiko

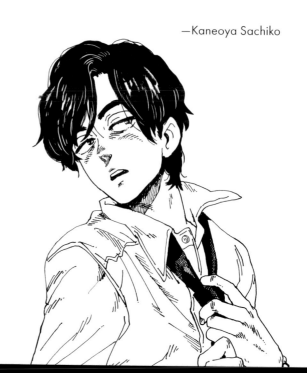

CHAPTER 1
GIRLFRIEND

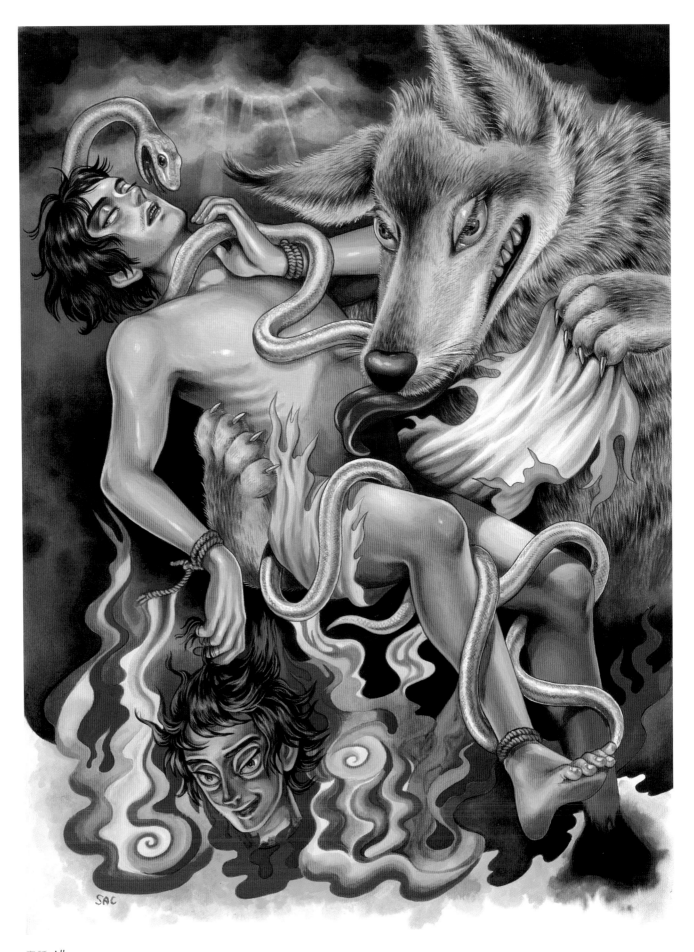

寓話 *Allegory*

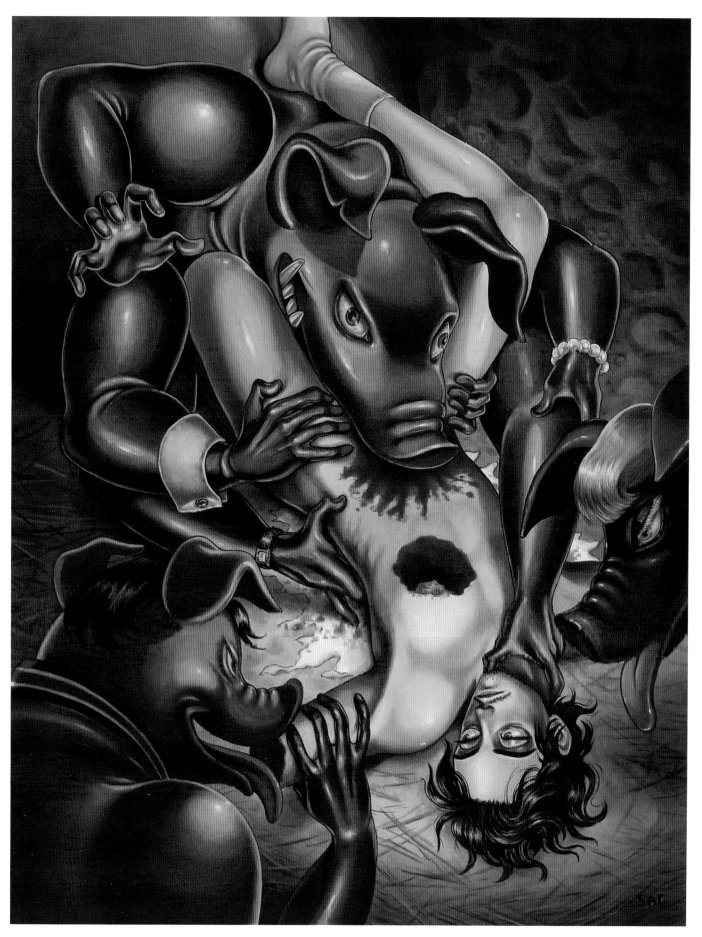

豚 *Domination of the Game*

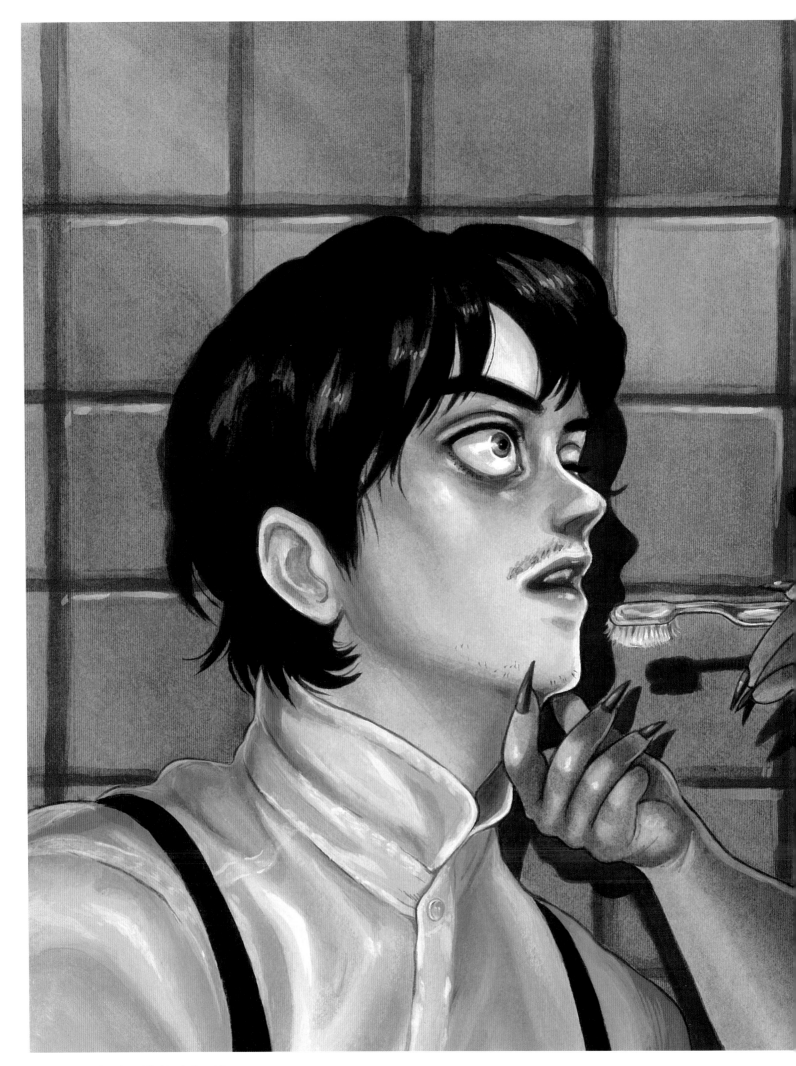

強制はみがき *Brushing His Teeth Forcibly*

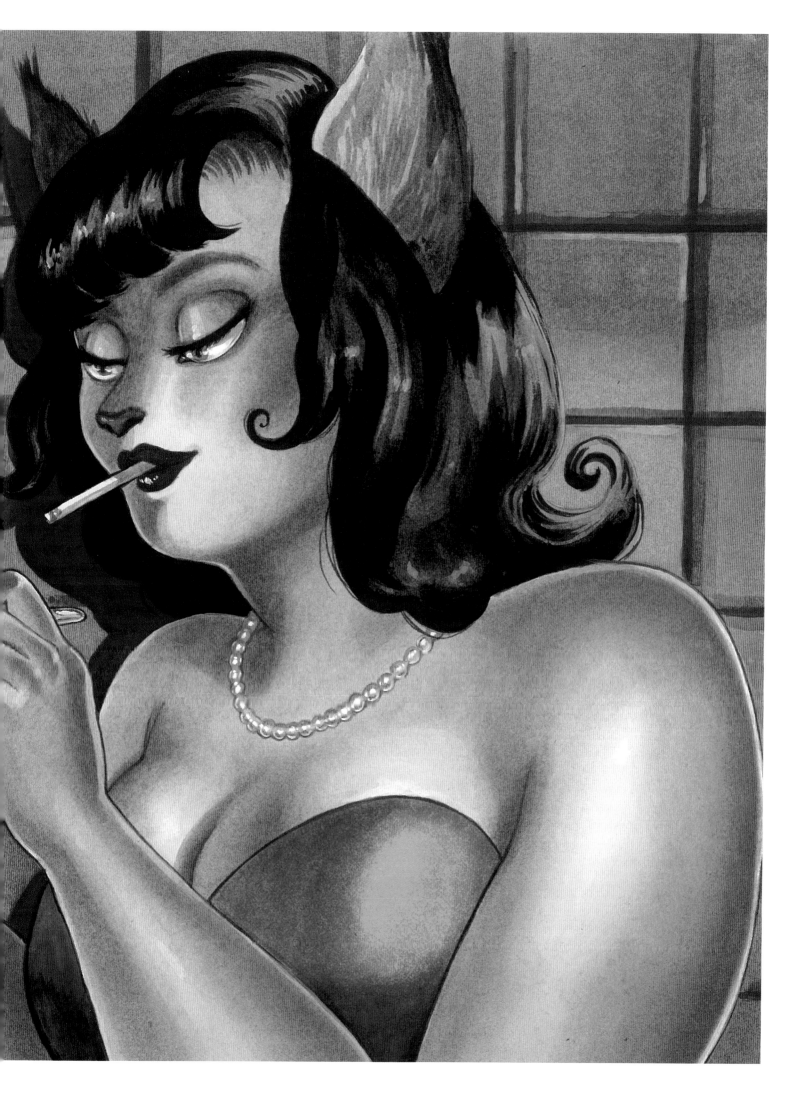

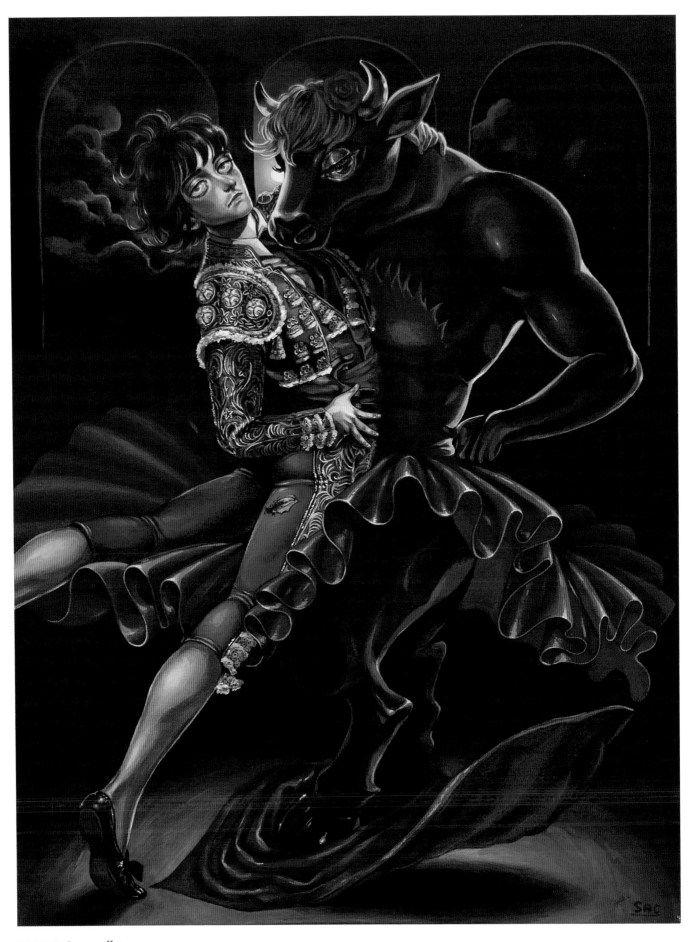

TORERO *Secret affair*

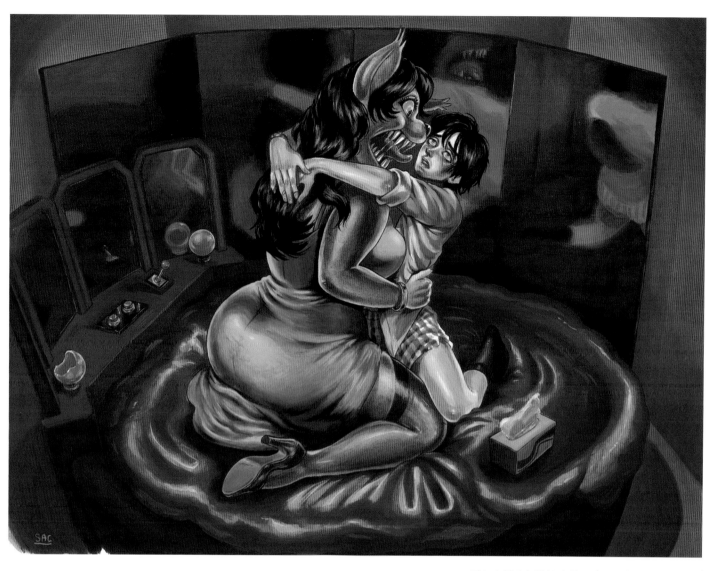

周りを回る白昼夢 *A Daydream Turning Around*

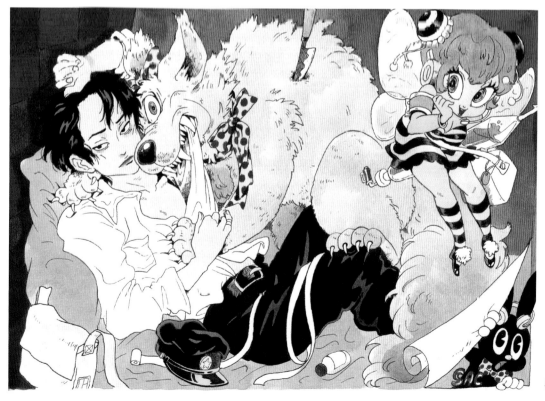

桃色クラブ *Pink Club*

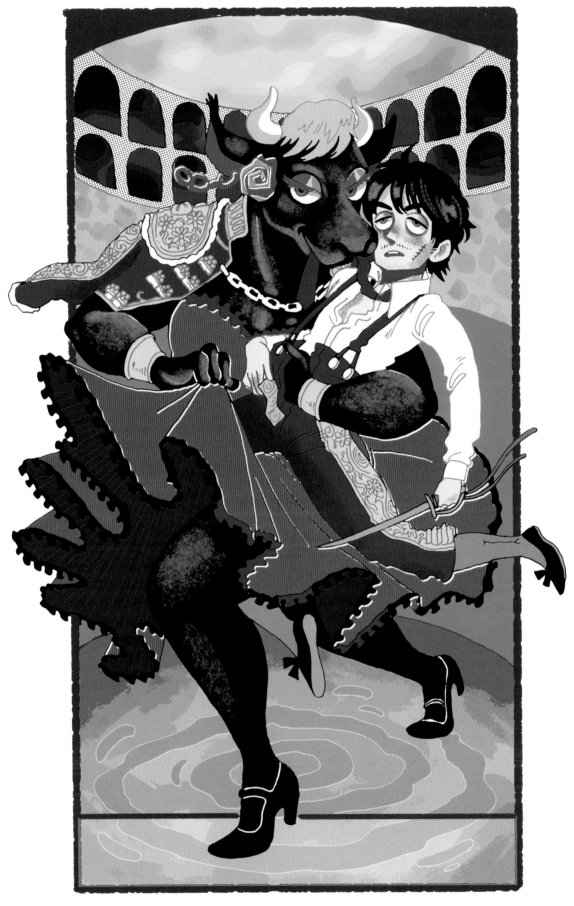

TORERO *Torero*

英語表記なし（共通）*Gimme Your Blood!*

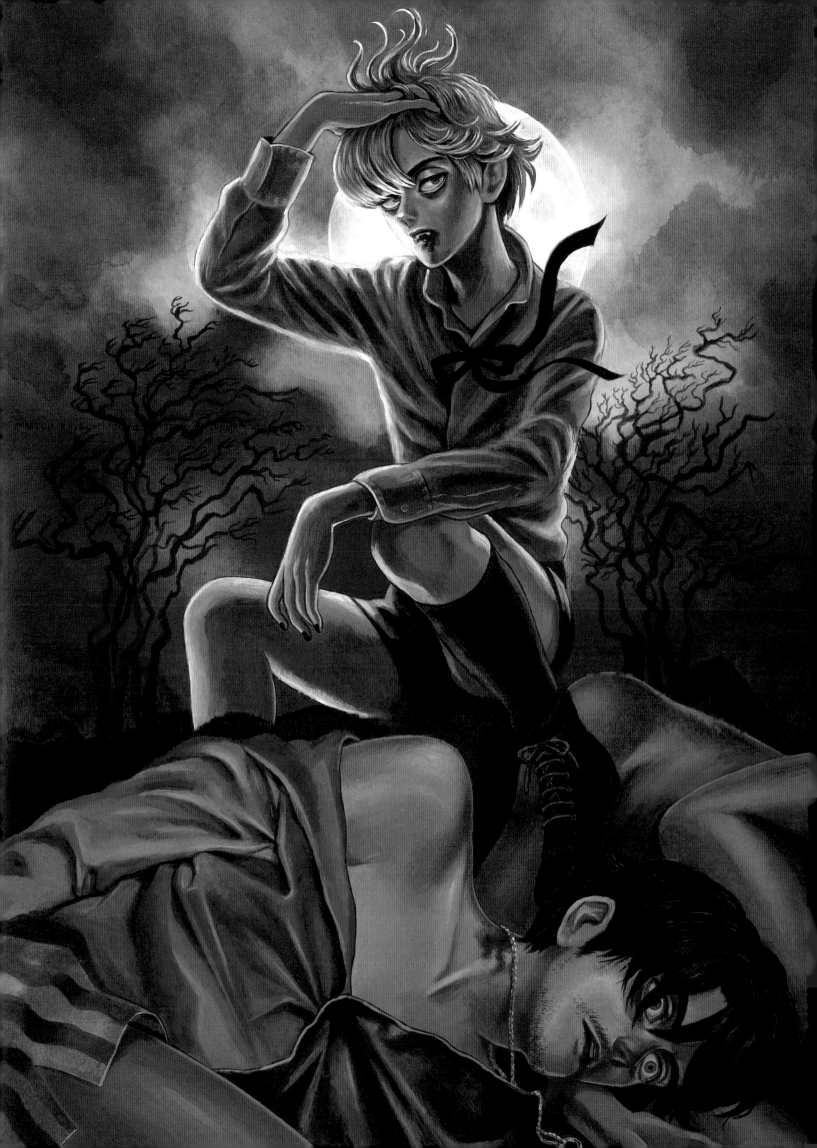

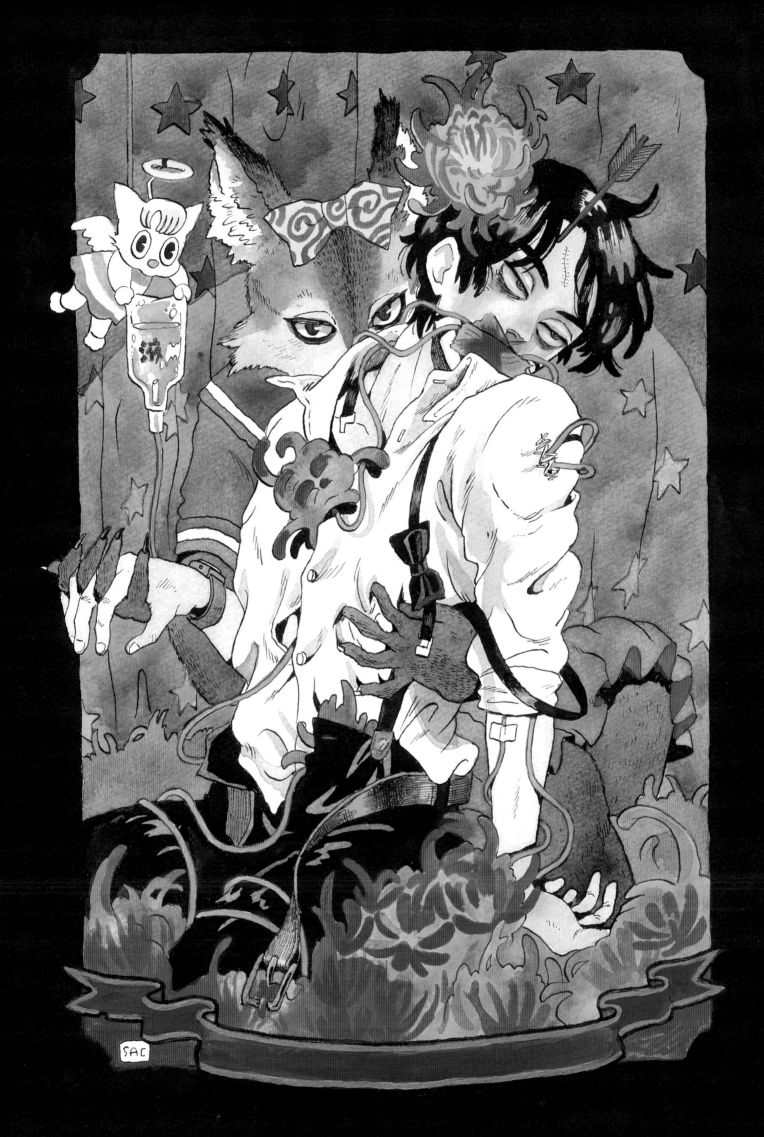

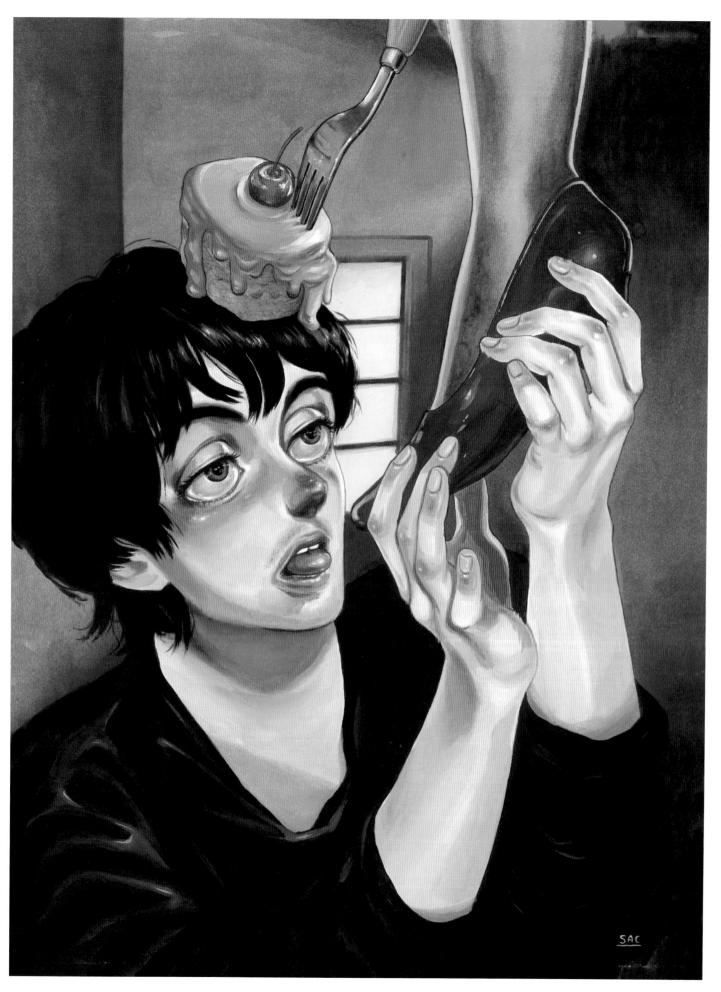

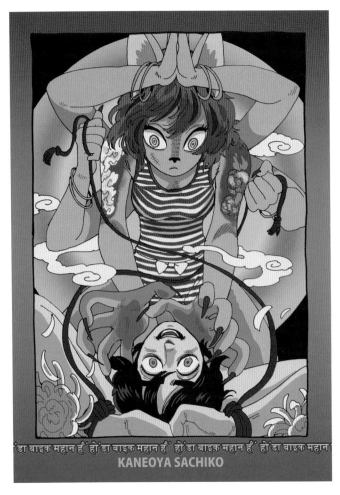

Shiva *Shiva*

素晴らしい関係 *Oral Fetish*

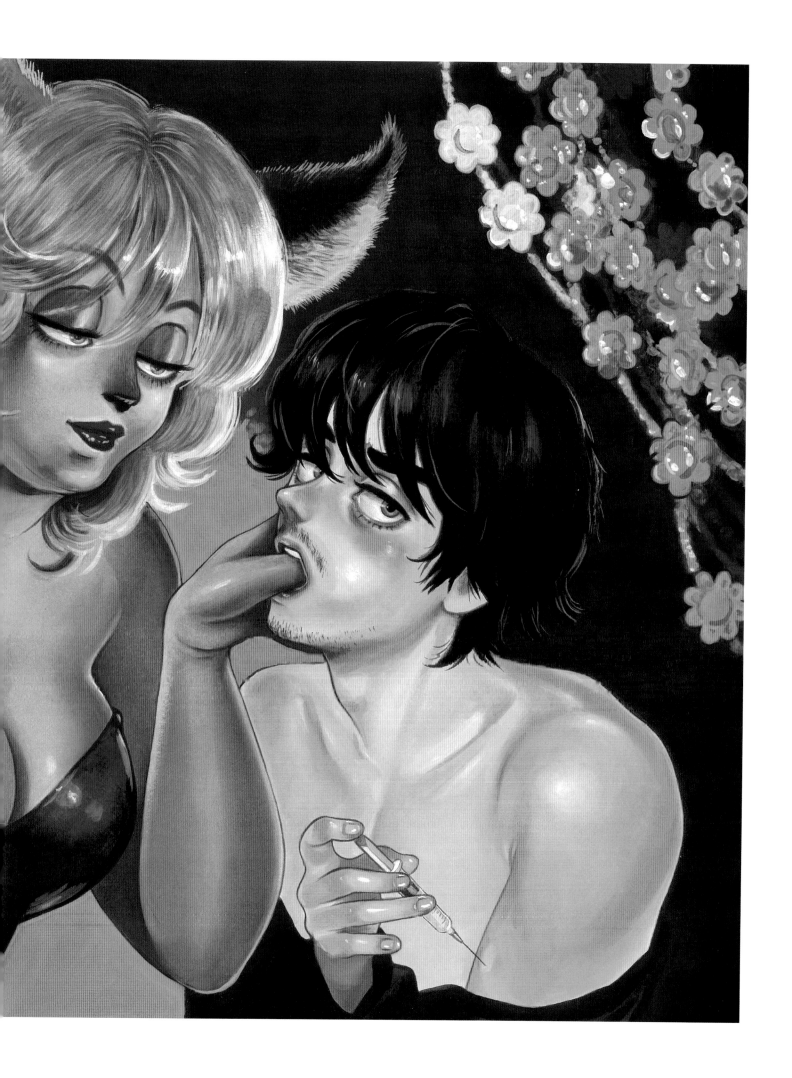

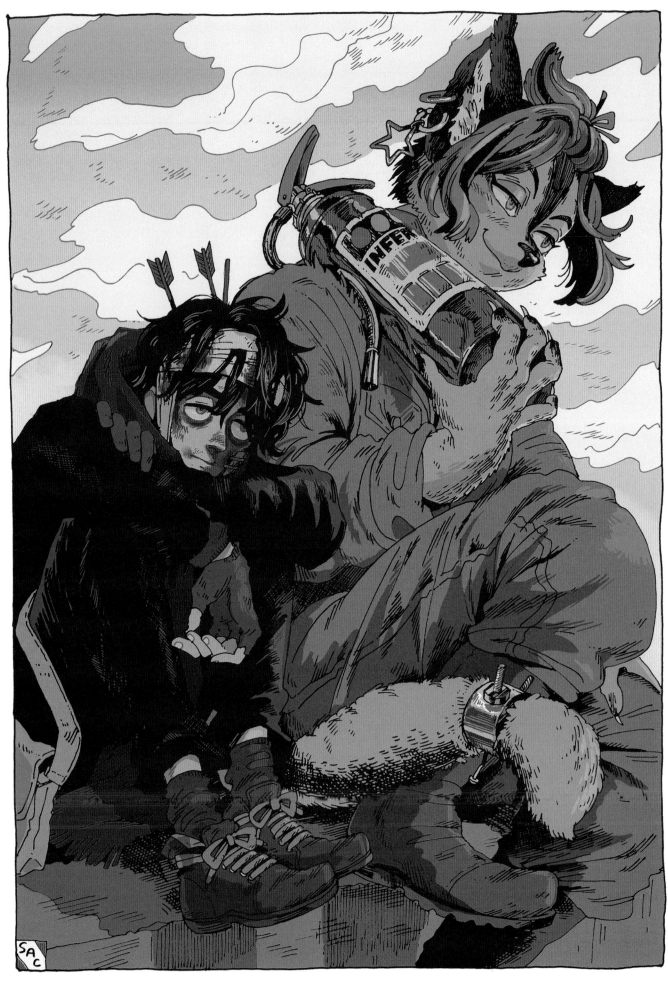

消化器と山猫 *Digestive Tract and Wildcat*

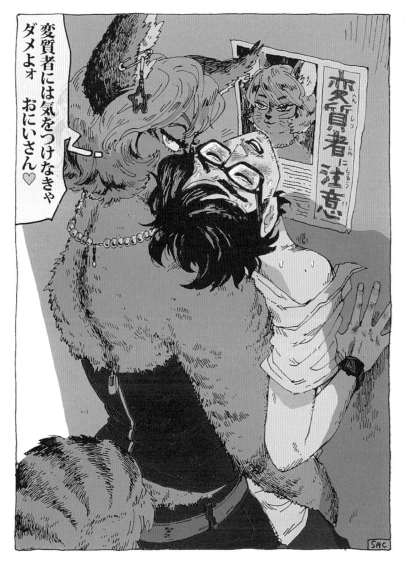

変質者にご注意 *Attention: Pervert*

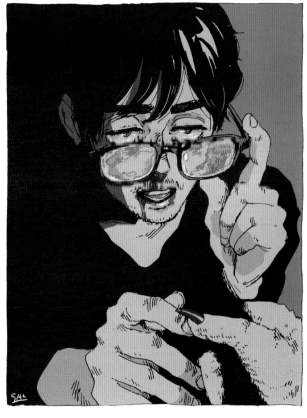

奉仕 *Service*

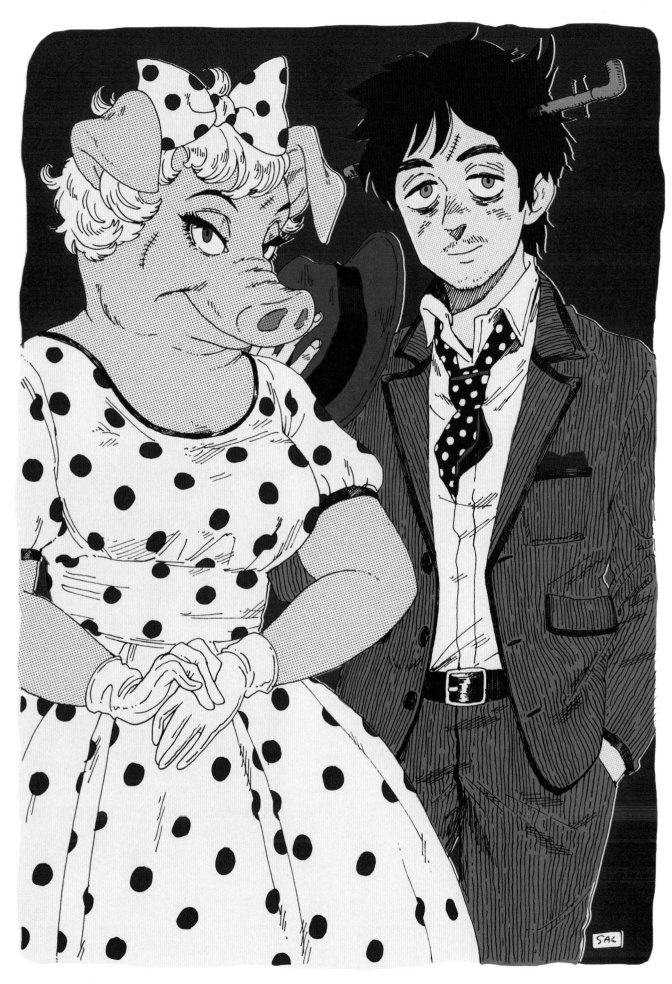

豚と男 Pig and a Man

AUTOMATA

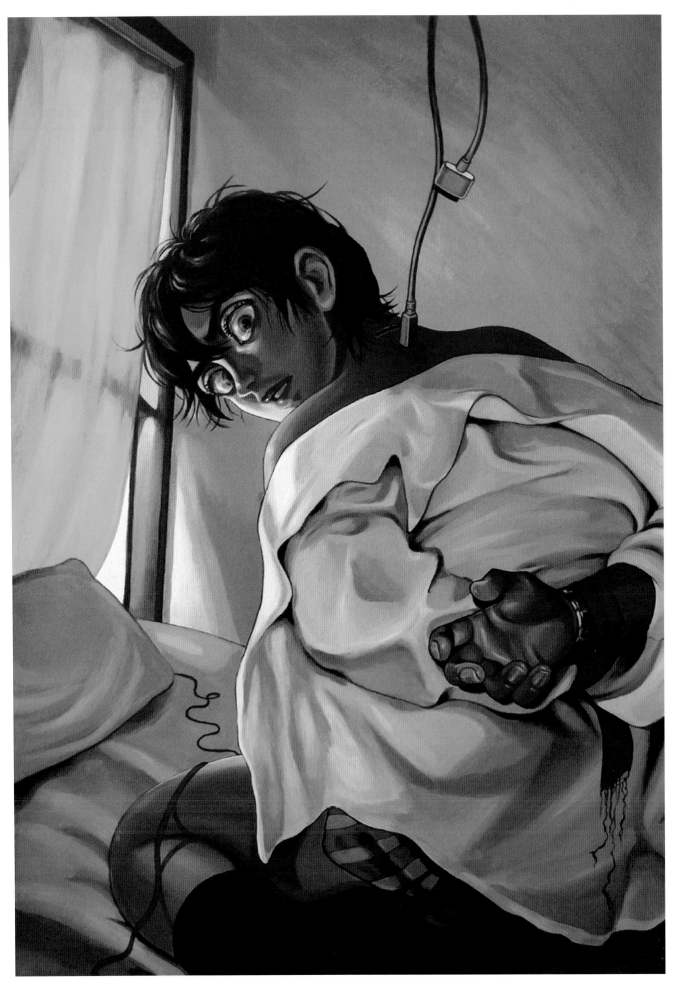

206 号室の秘密 *The Secret of #206*

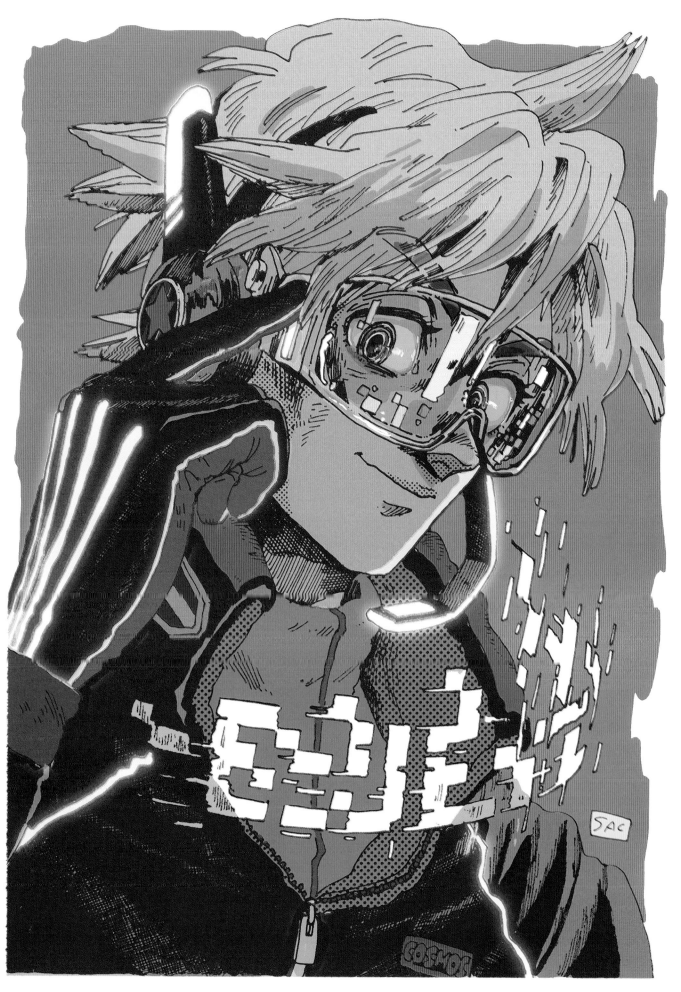

未来通信 *Message from the Future*

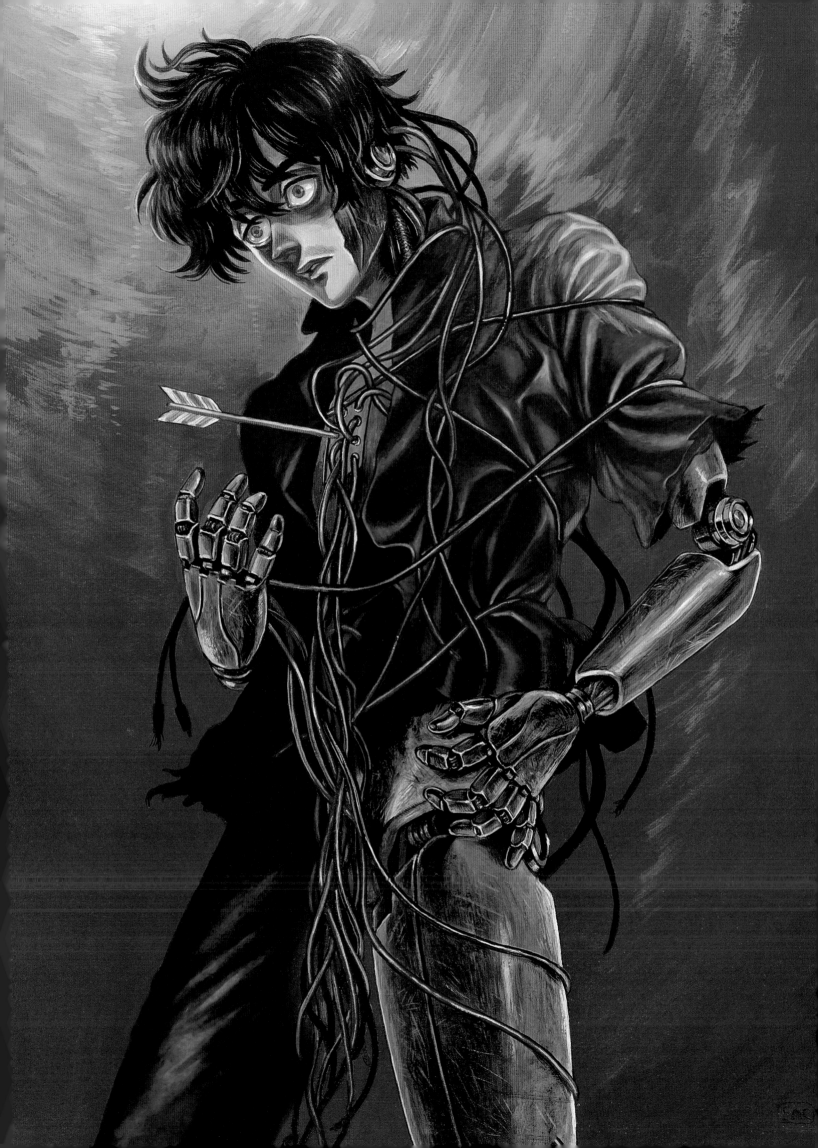

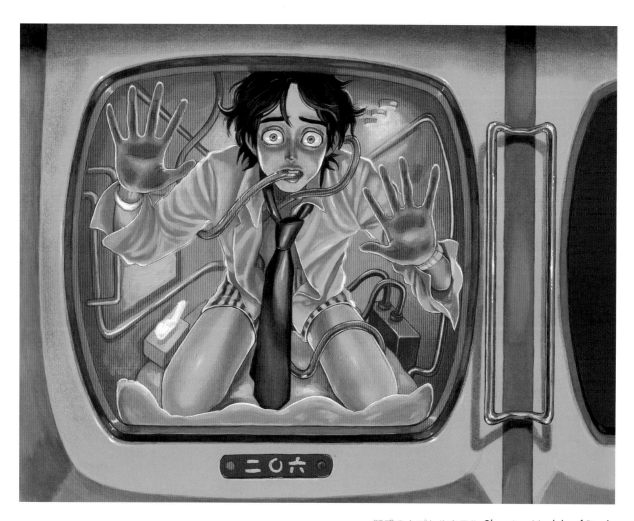

疑惑のカプセルホテル *Sleeping Module of Doubt*

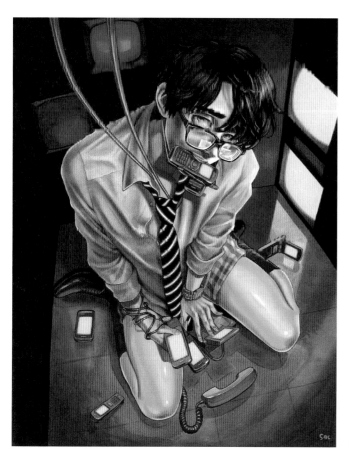

消極的社畜 *Chain of the Electric Wave*

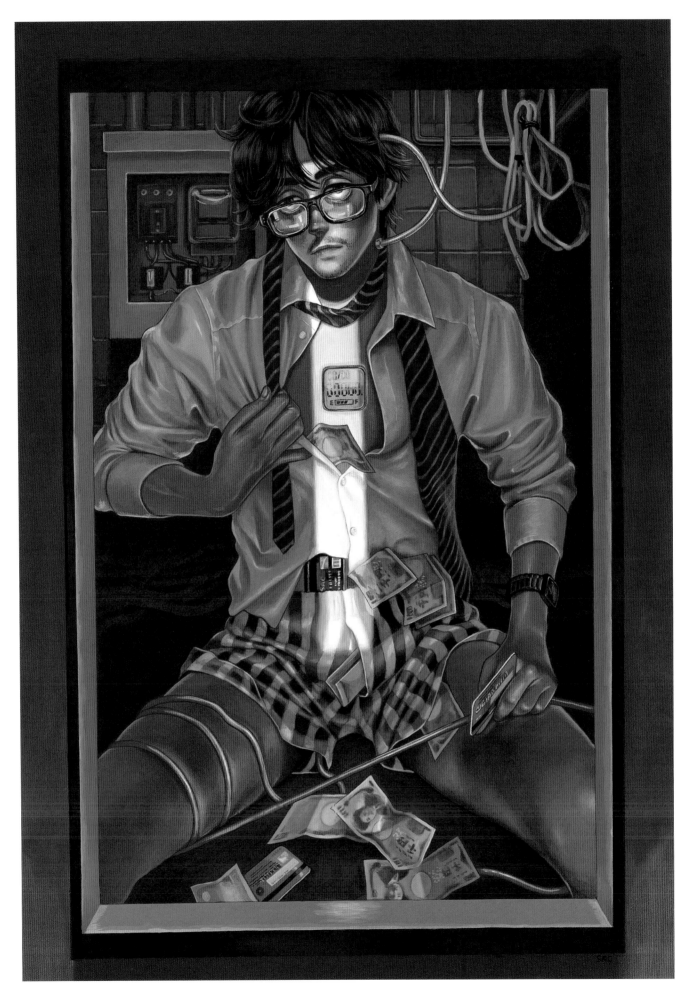

明るい家族計画 *2.5-Dimensional Convenient Man*

完全な自己防衛 *Complete Self Defense*

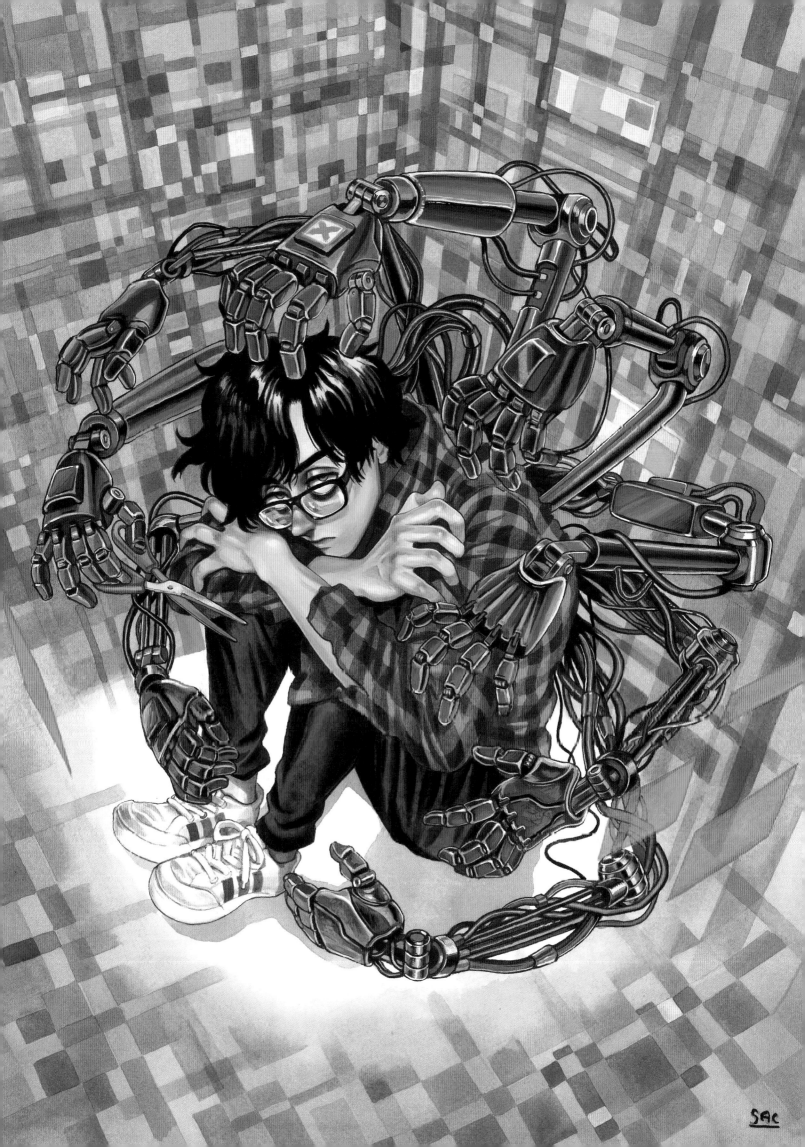

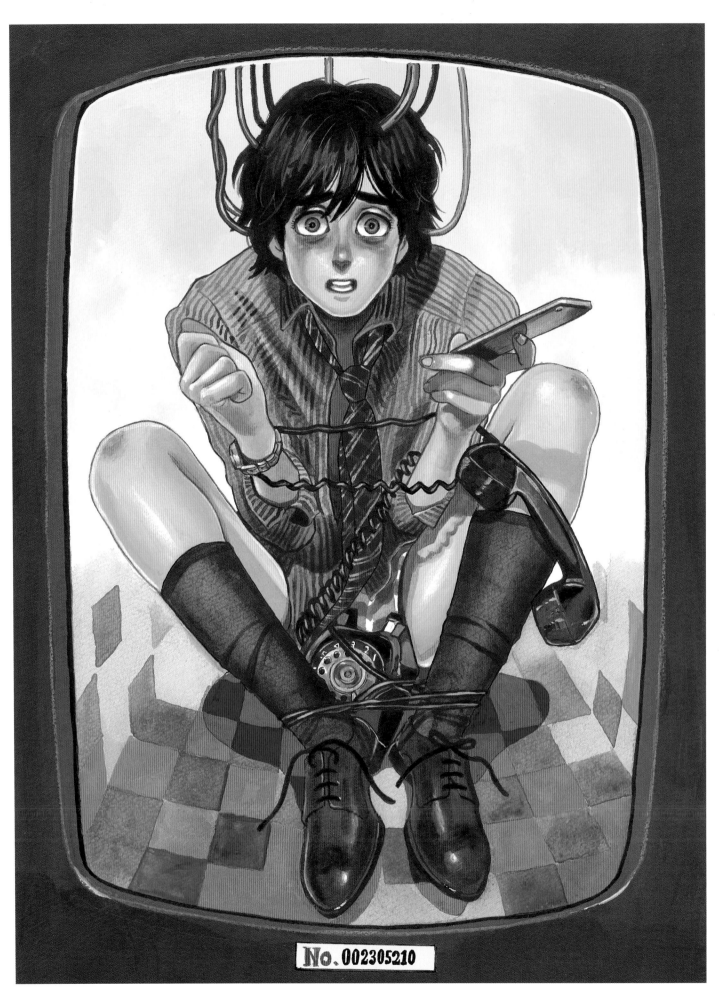

No. 002305210

新人研修 *Brainwashing*

CHAPTER 3
FLORAL

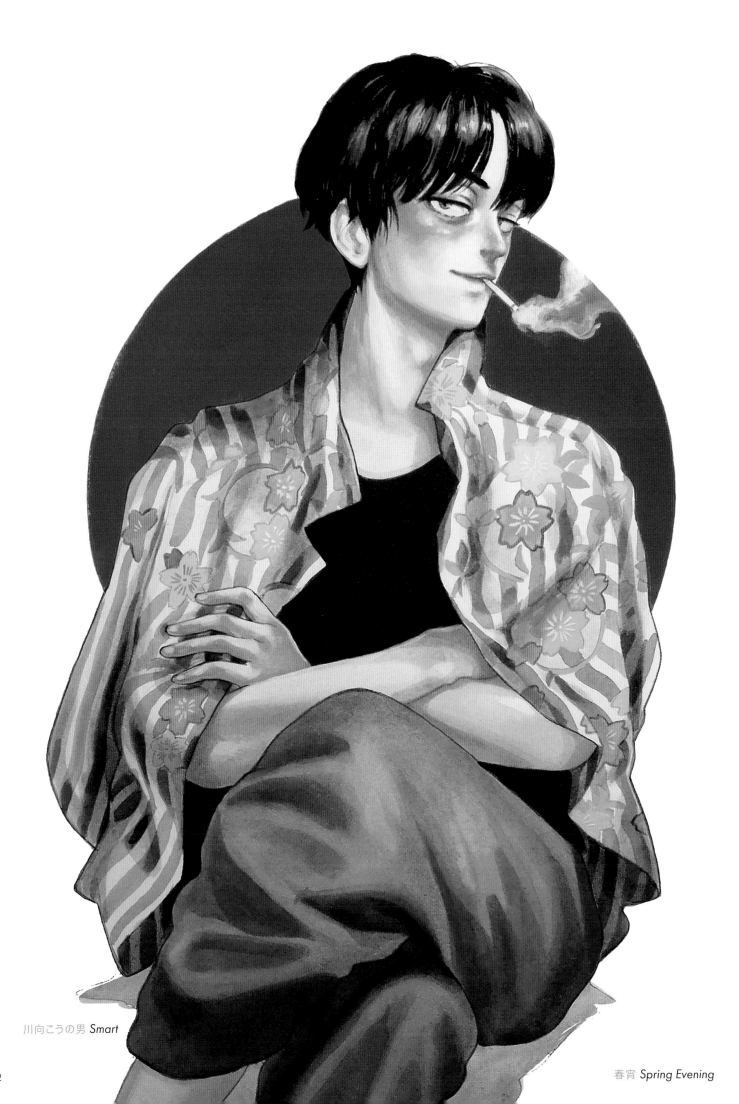

川向こうの男 *Smart*

春宵 *Spring Evening*

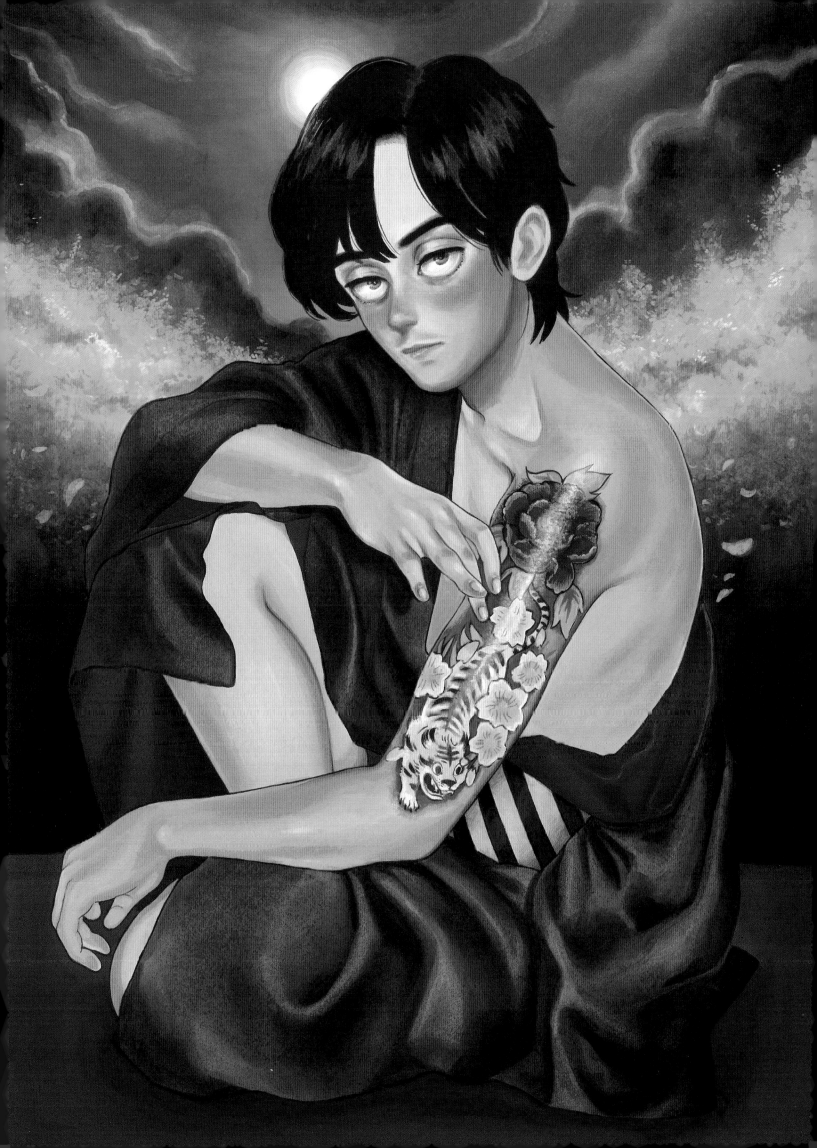

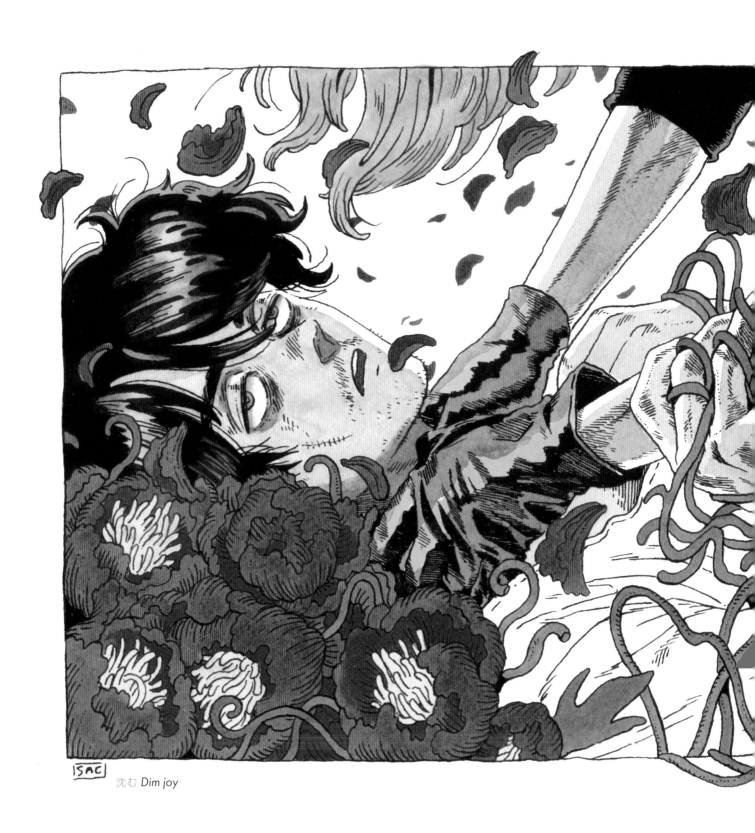

SAC 沈む *Dim joy*

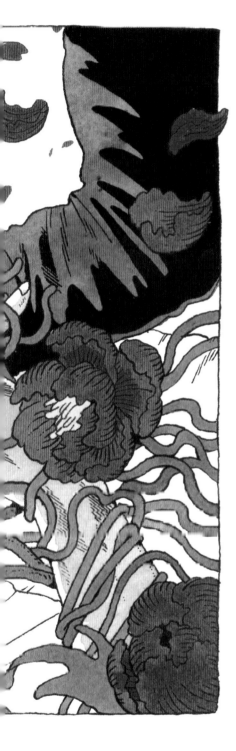

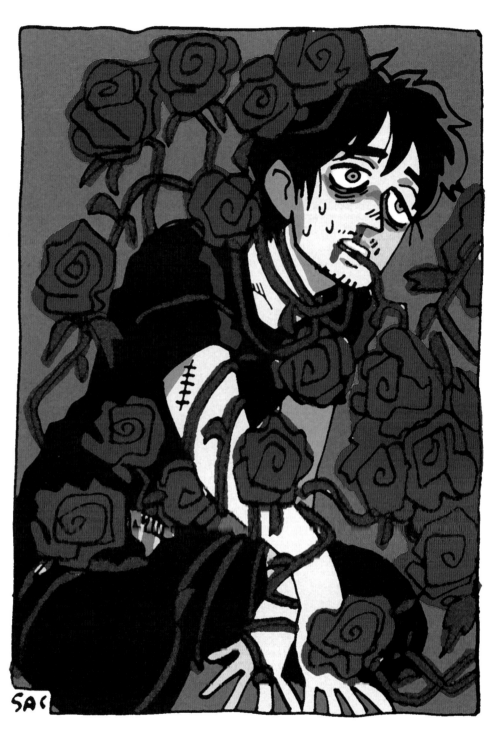

冬虫夏草 *Cordyceps Sinensis*

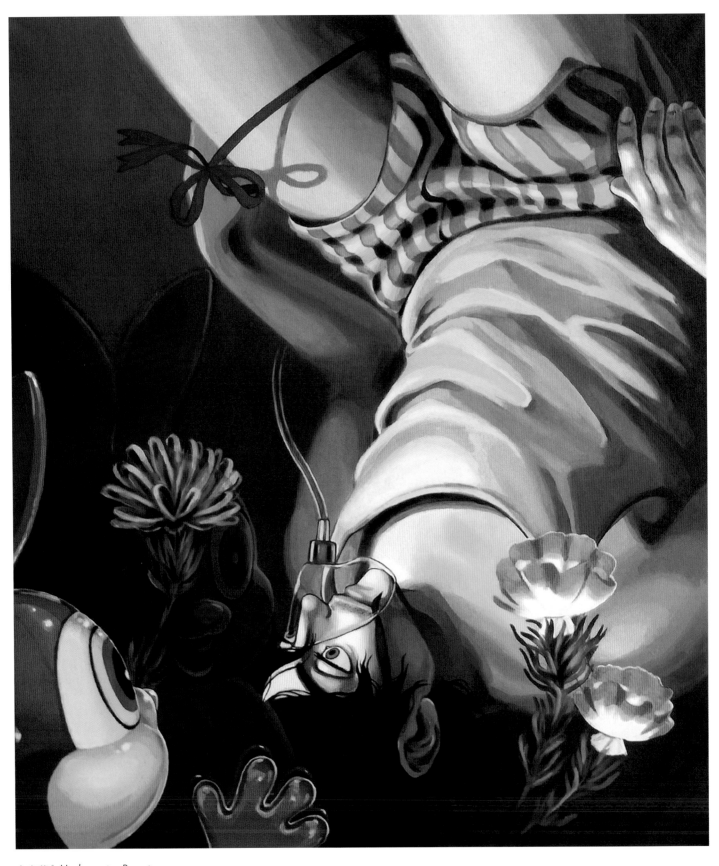

水中花 1 *Underwater Beauty*

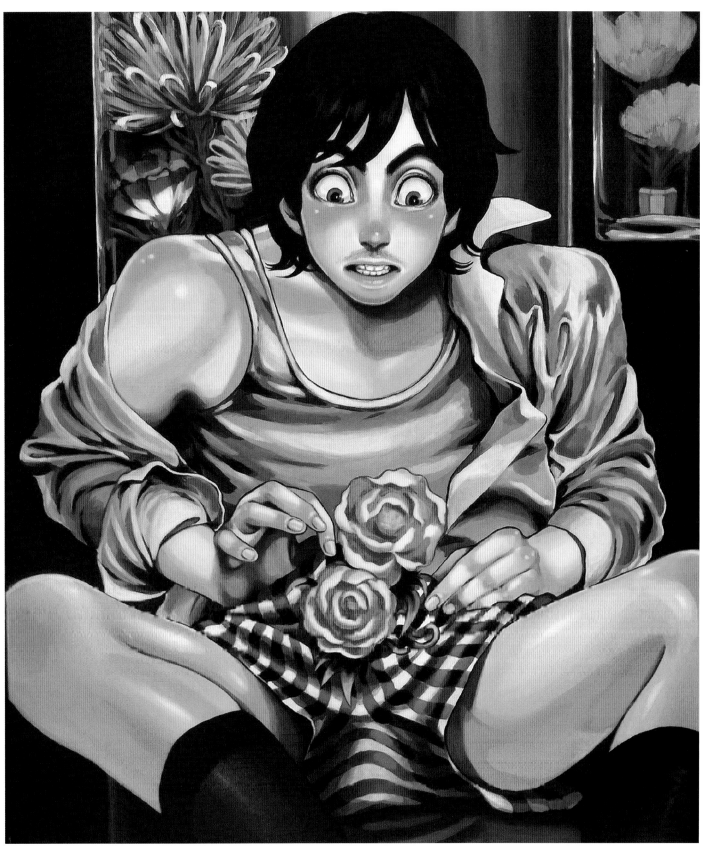

水中花2 Wonderful Flower

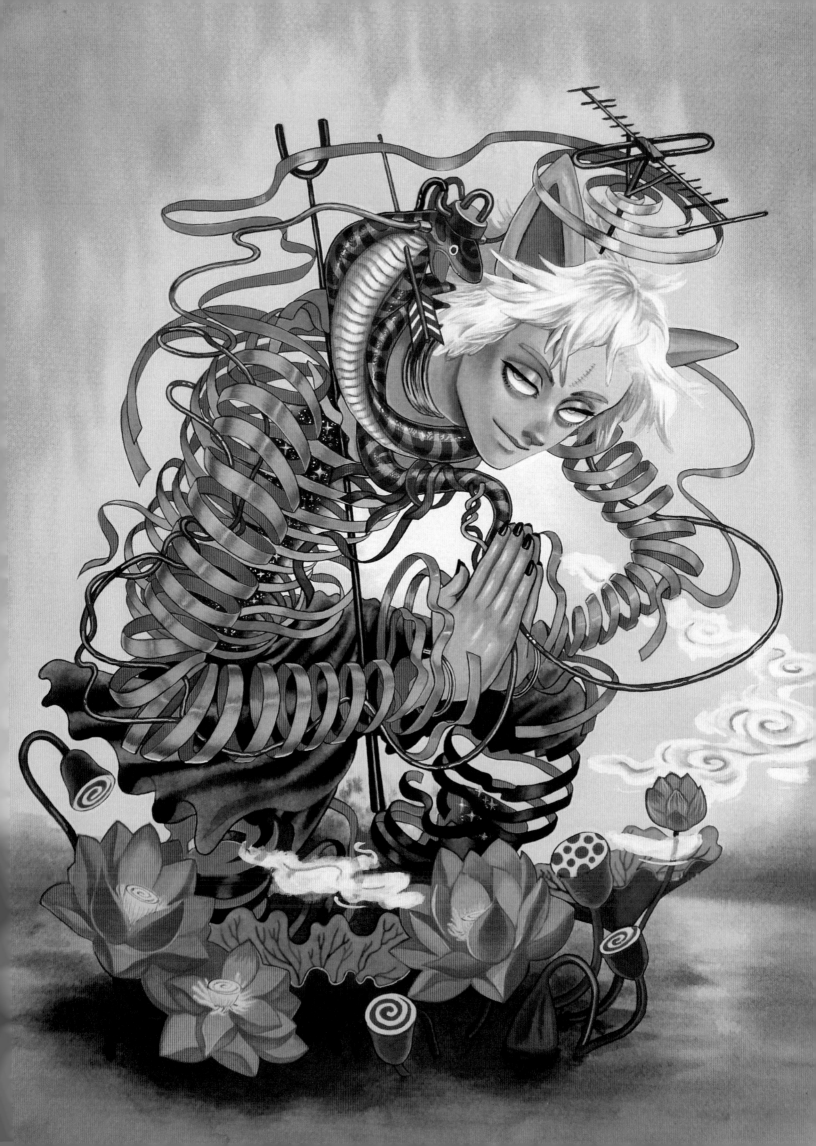

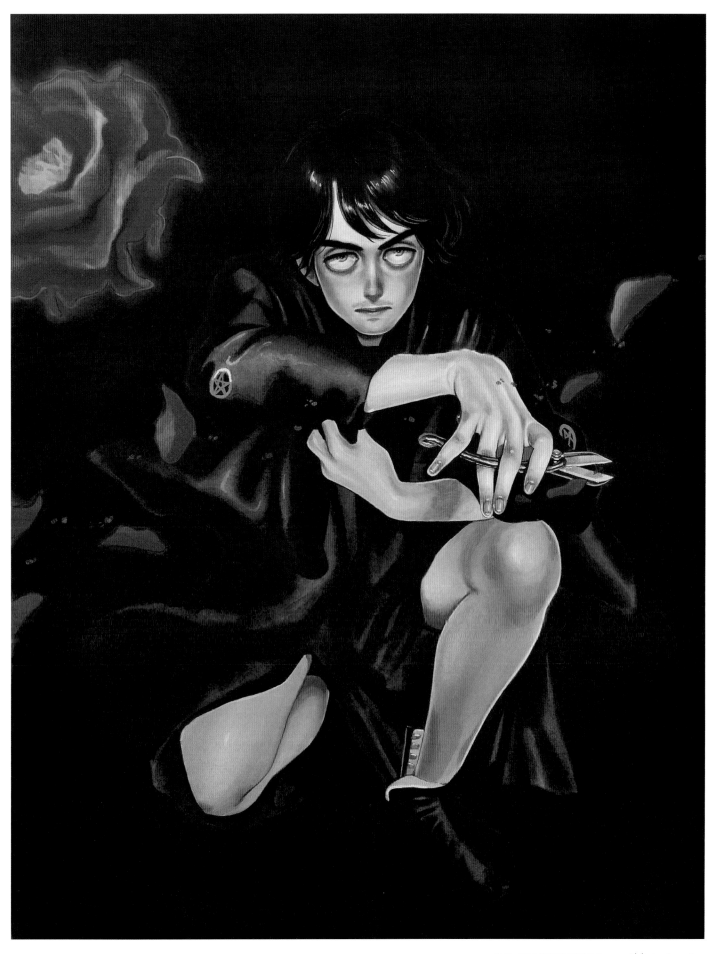

先生の不可思議領域 *Impossible to Peeping*

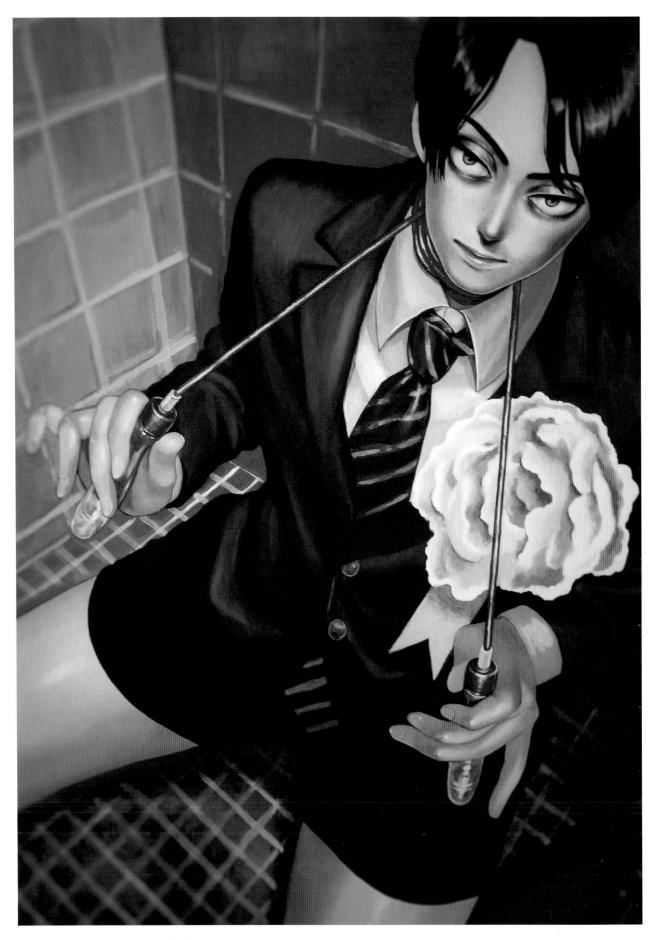

よいこのたしなみ *Manner of Good Boy*

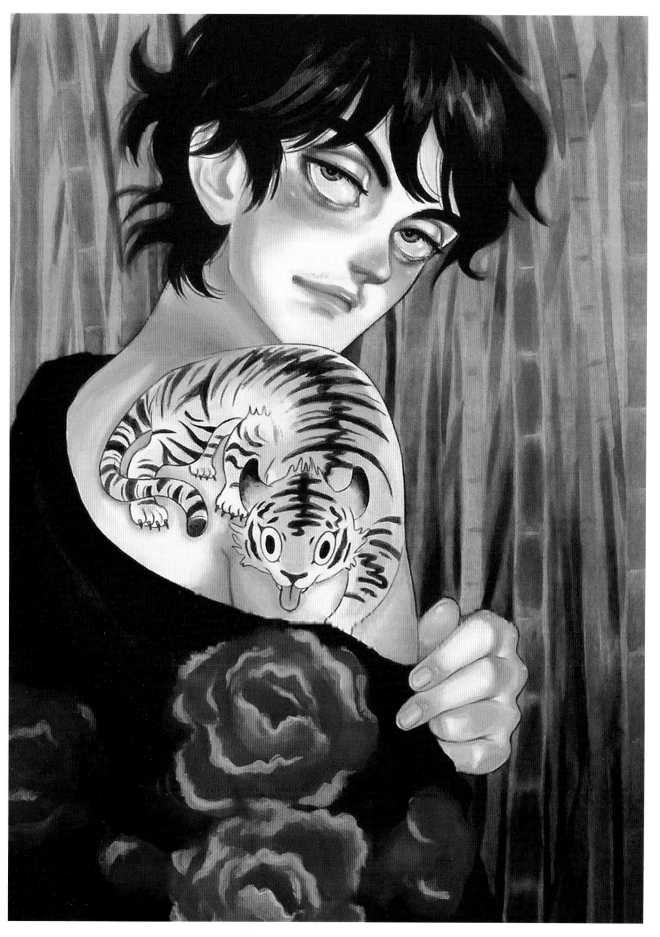

刺青の男 *Phantom of Mountain*

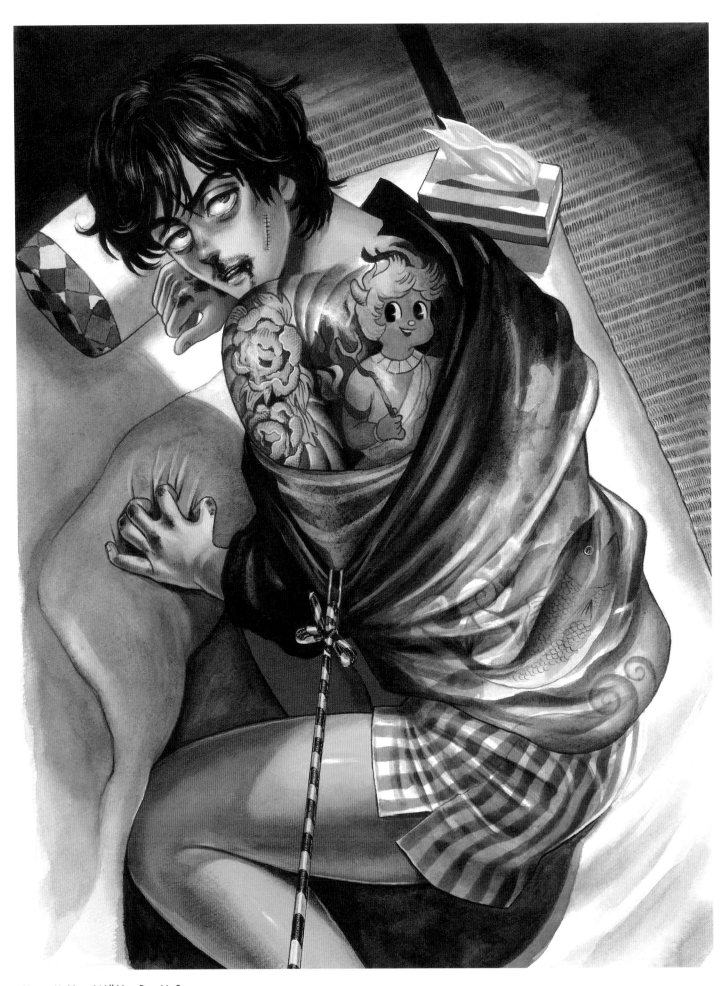

落とし前 *How Will You Pay Up?*

CHAPTER 4

SOLO

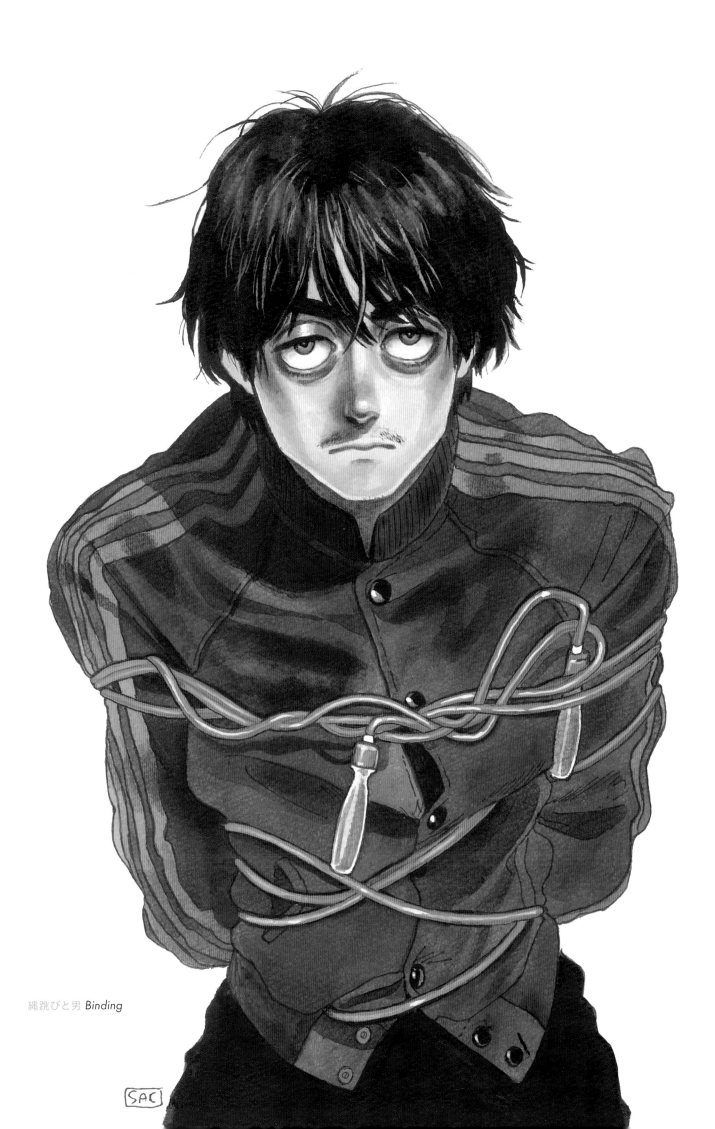

縄跳びと男 *Binding*

SAC

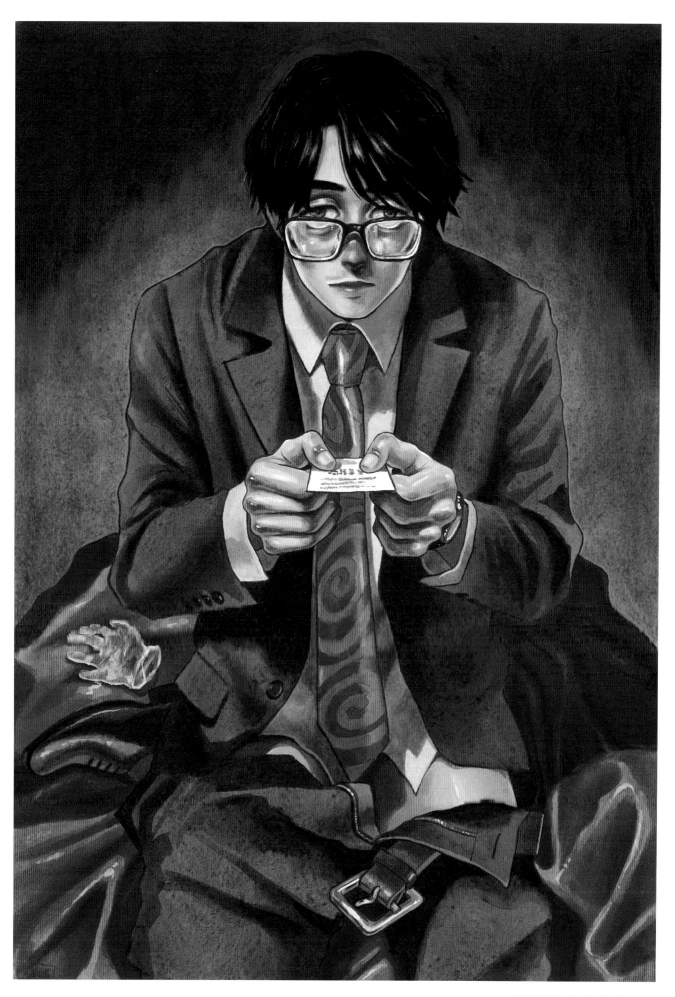

営業 *Sell a Body for Business*

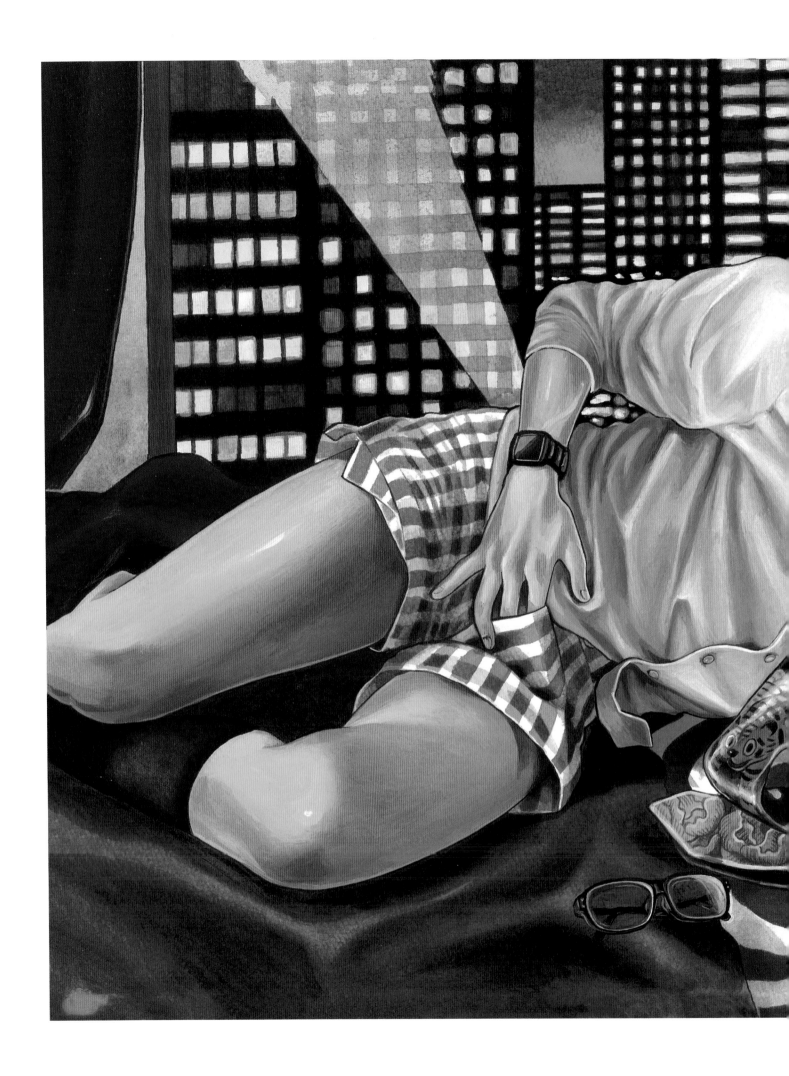

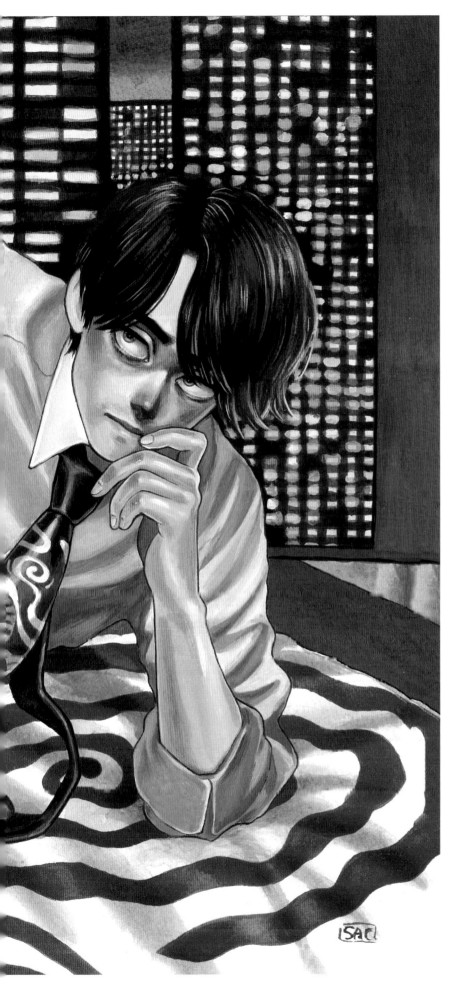

不本意な撮影会 Delusion Material

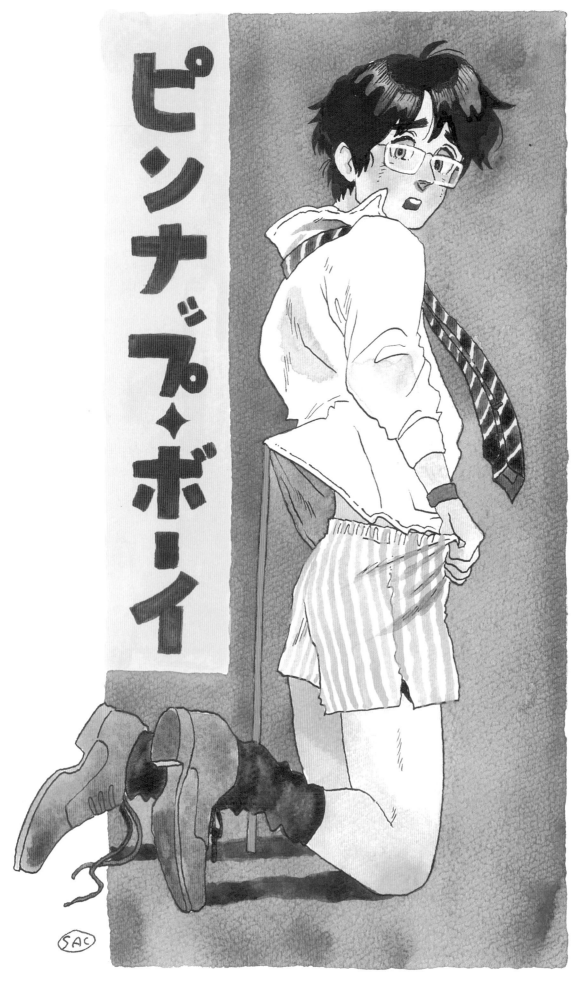

ピンナップ・ボーイ

PINNP-BOY2.0

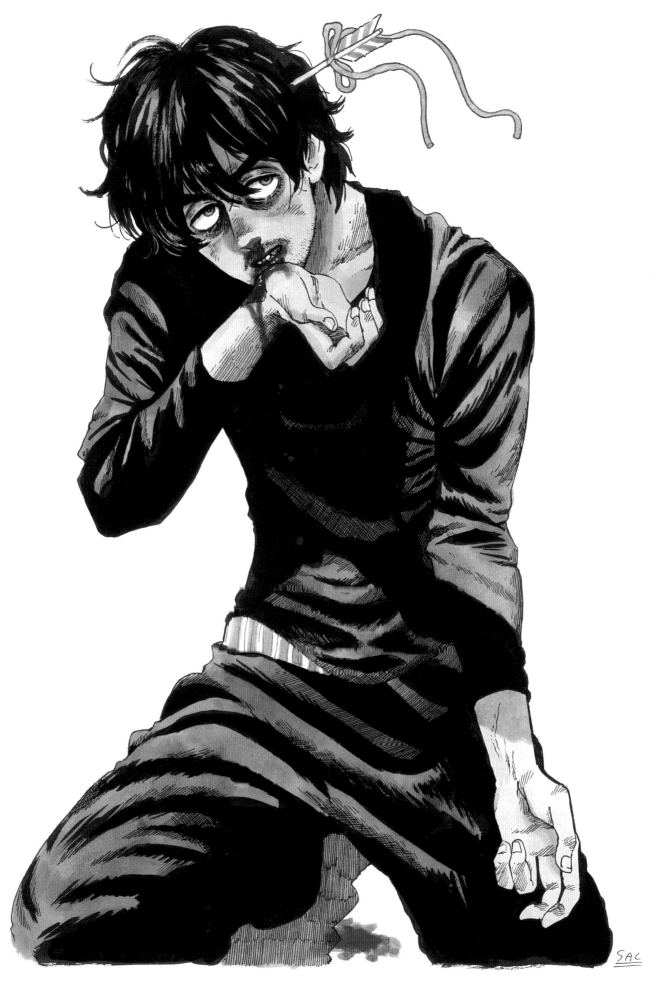

血液嗜好症の男 *Blood*

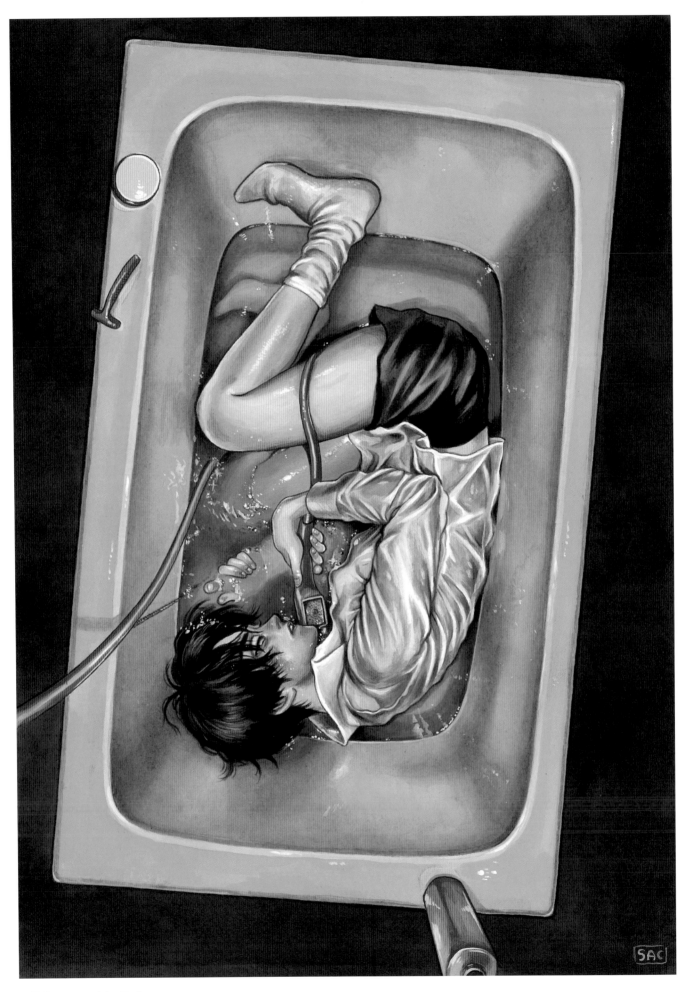

水槽 Preserve of the Collector

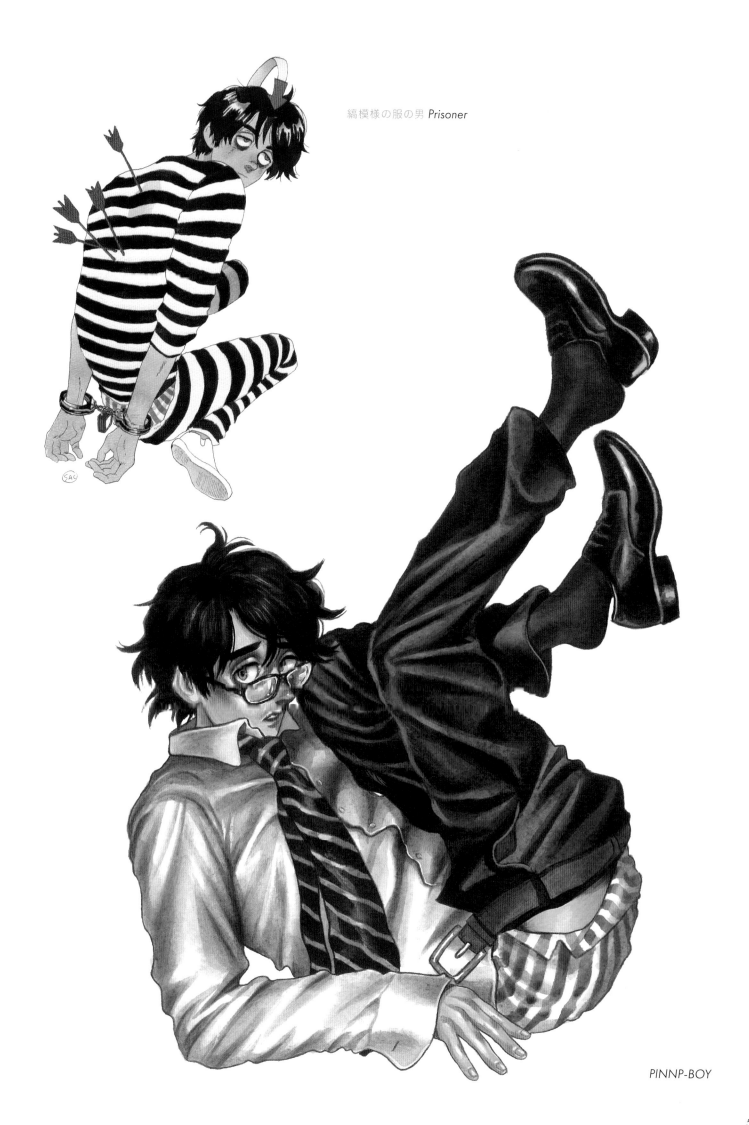

縞模様の服の男 Prisoner

PINNP-BOY

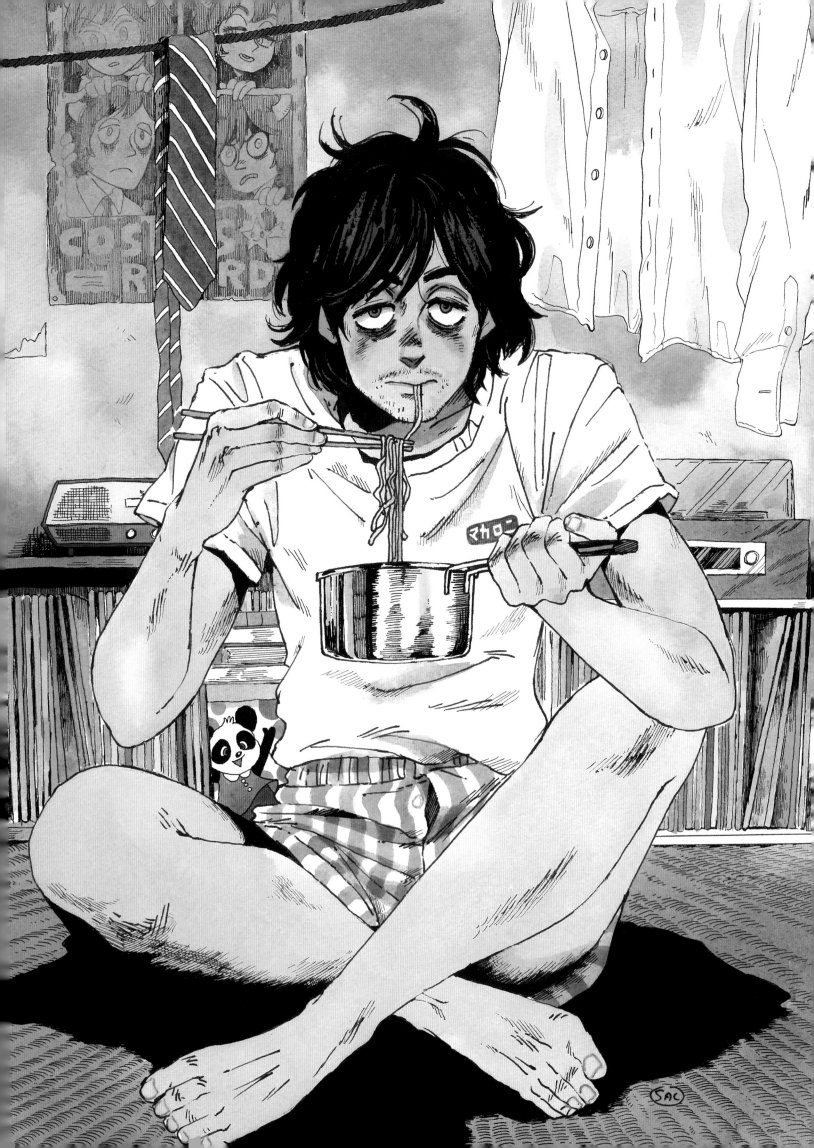

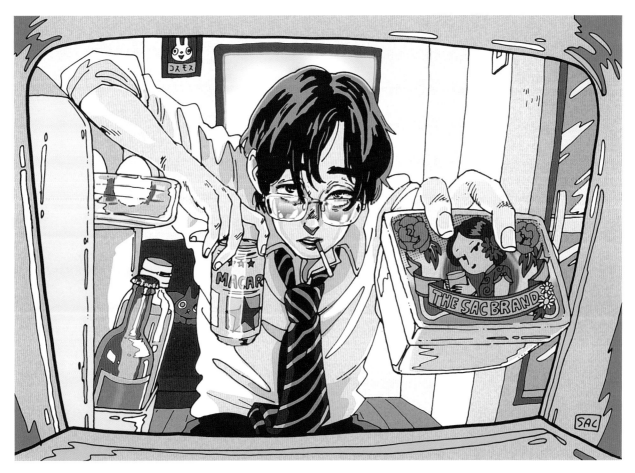

ブルーボックス *Bluebox*

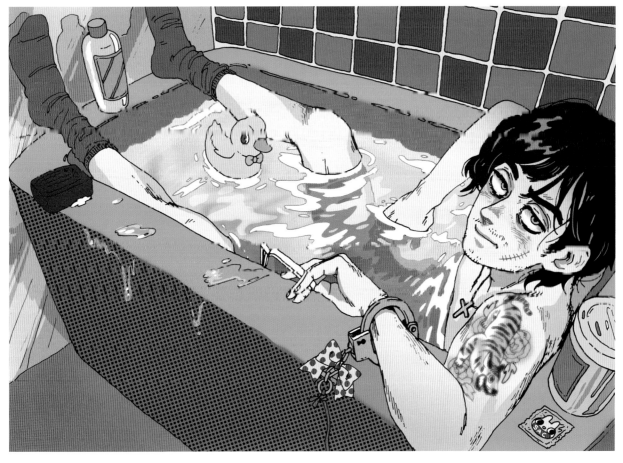

バスルーム *Bathroom*

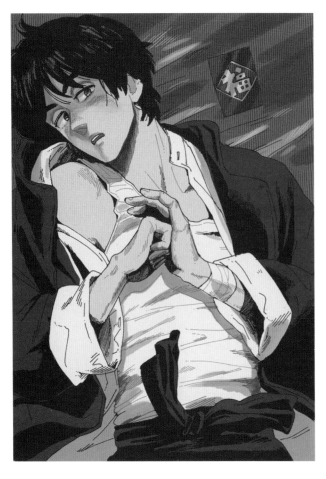
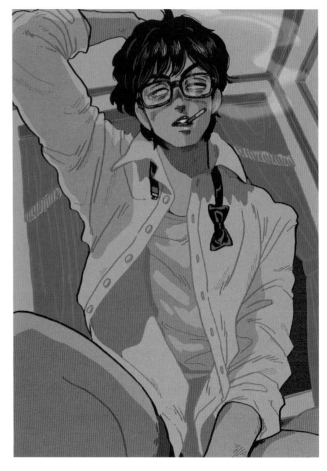
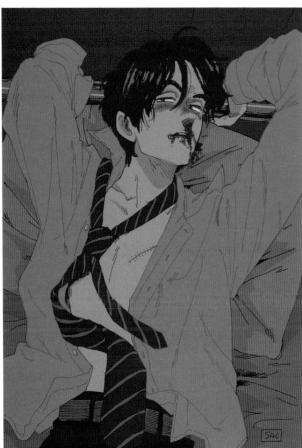
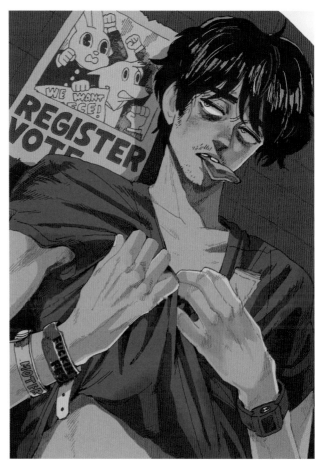

Clockwise from top: 旧正月 *Lunar New Year,* ミラーボール *Mirror Ball,* これ以上は . . . *Any More Than This . . . ,* それとも . . . *Or Maybe . . .*

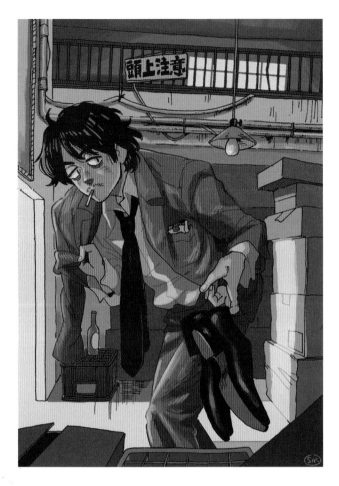

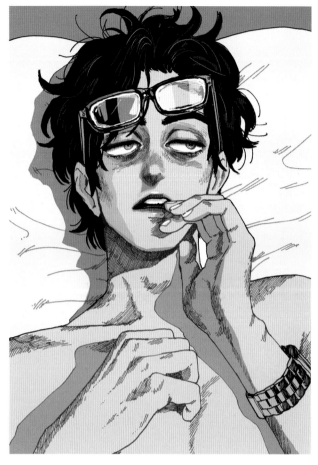

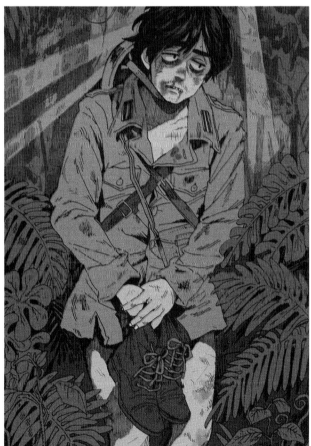

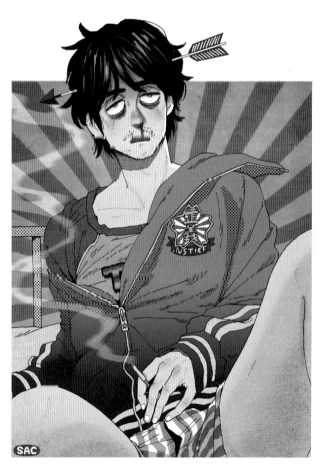

Clockwise from top: お先に失礼します *Pardon Me, I Have To Go Now,* まどろみ *Madromimi,*
明日から本気出す *Will Be Serious Starting Tomorrow,* 下穿きがない *No Underpants*

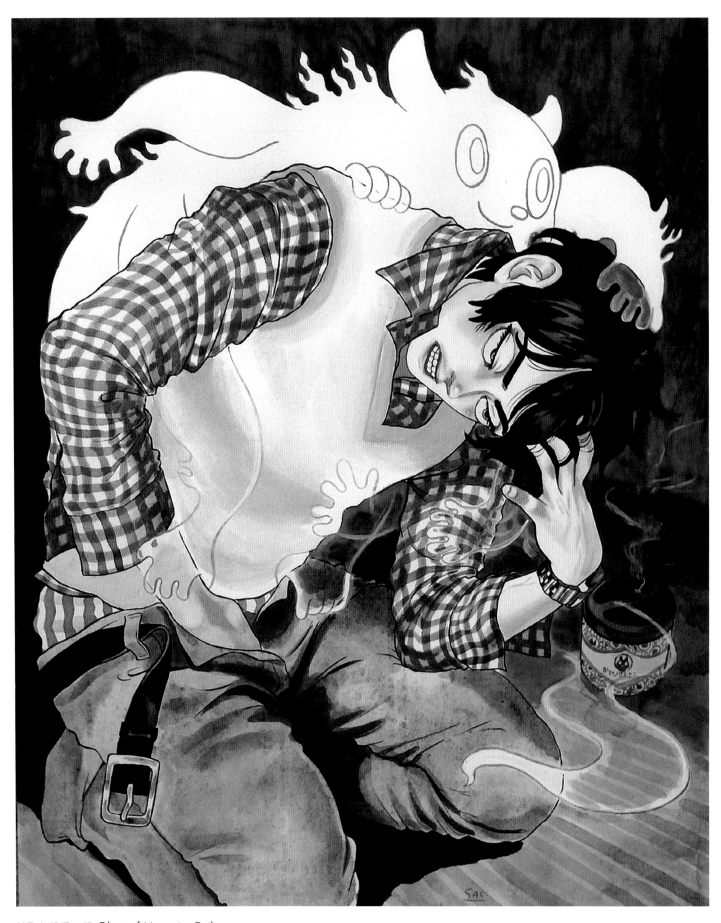

蚊取り線香の精 *Ghost of Mosquito Coil*

彼は合理的 *He Makes Sense*

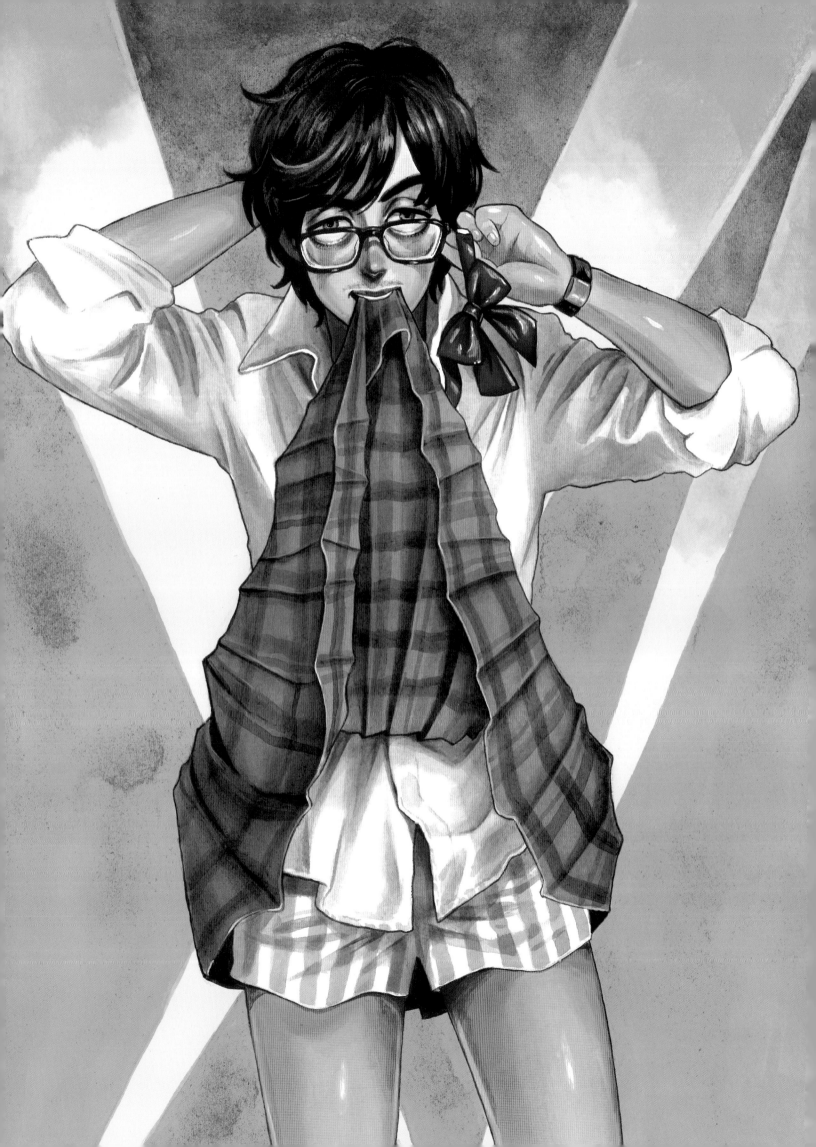

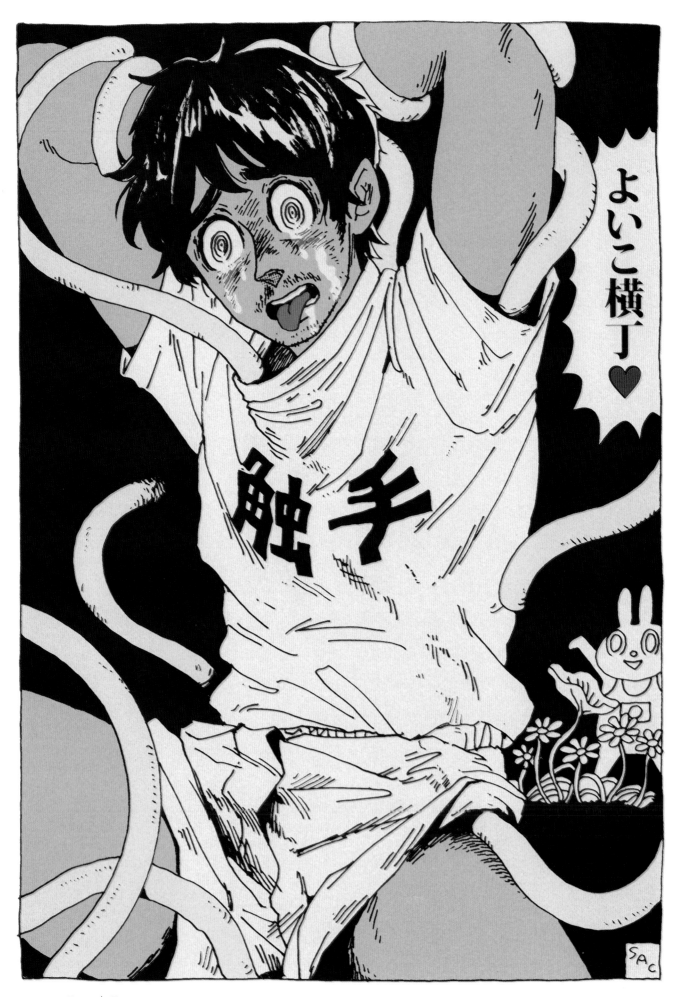

触手責め Tentacle Torture

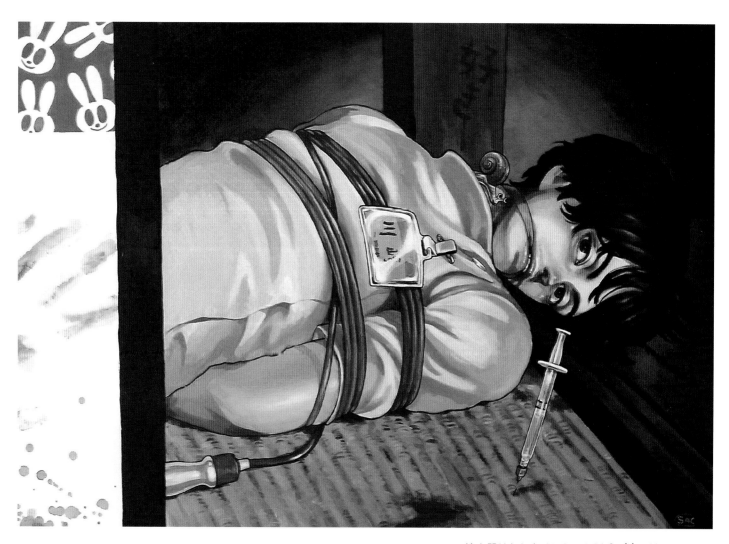

襖を開けたら幸せになった話 *Sudden Happy Event*

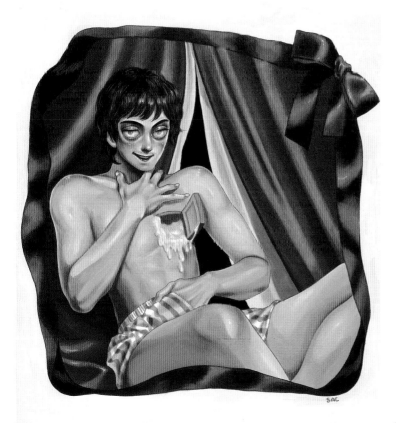

飾り窓の男 *Male Prostitute*

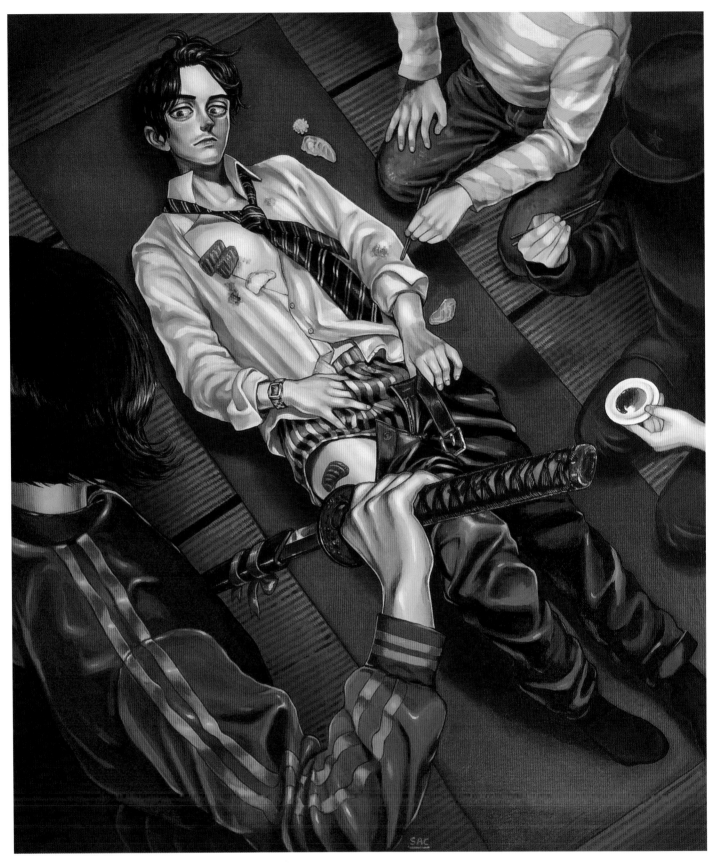

男体盛り Nantai-Mori

CHAPTER 5
UNIFORM

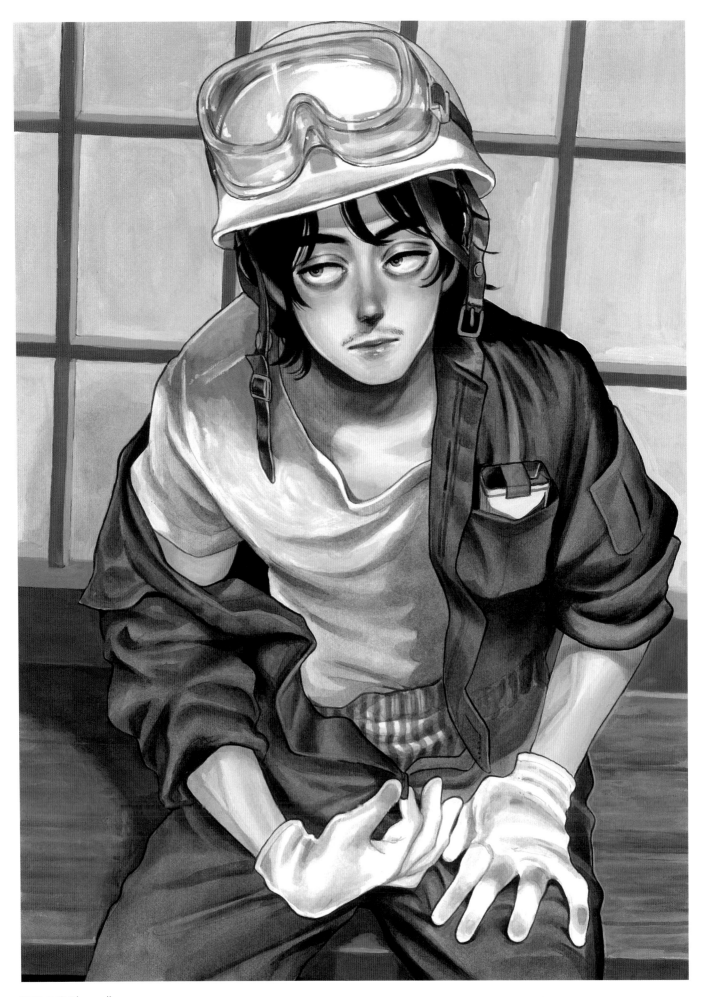

現場の男 Blue collar

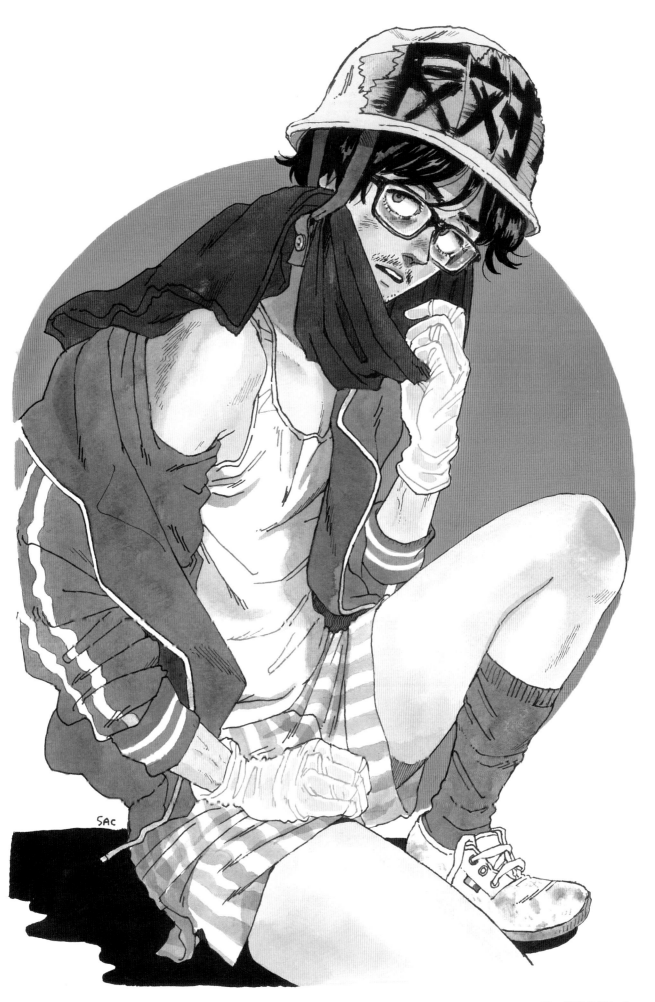

私の四畳半闘争 *Sanrizuka*

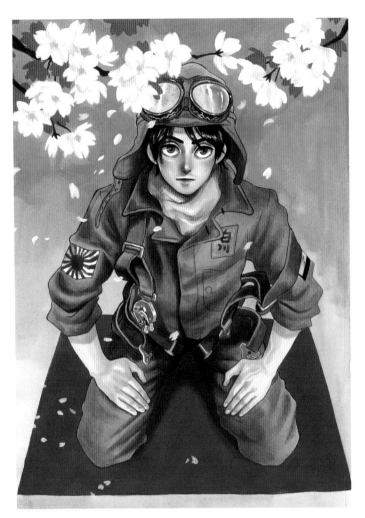

桜の下で君を待つ *Doki No Sakura*

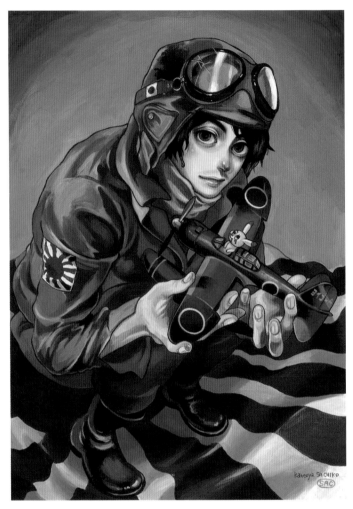

航空隊の男 *Pilot of Japanese Navy*

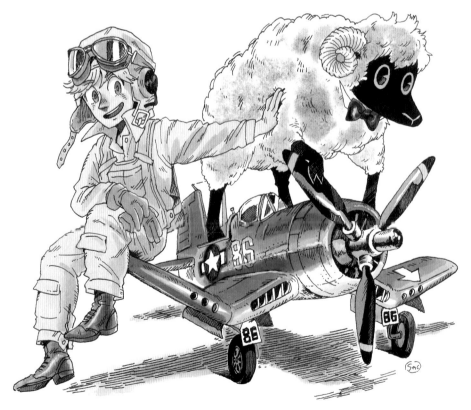

F4U *F4U Corsair*

清掃おにいさん *Scavenger*

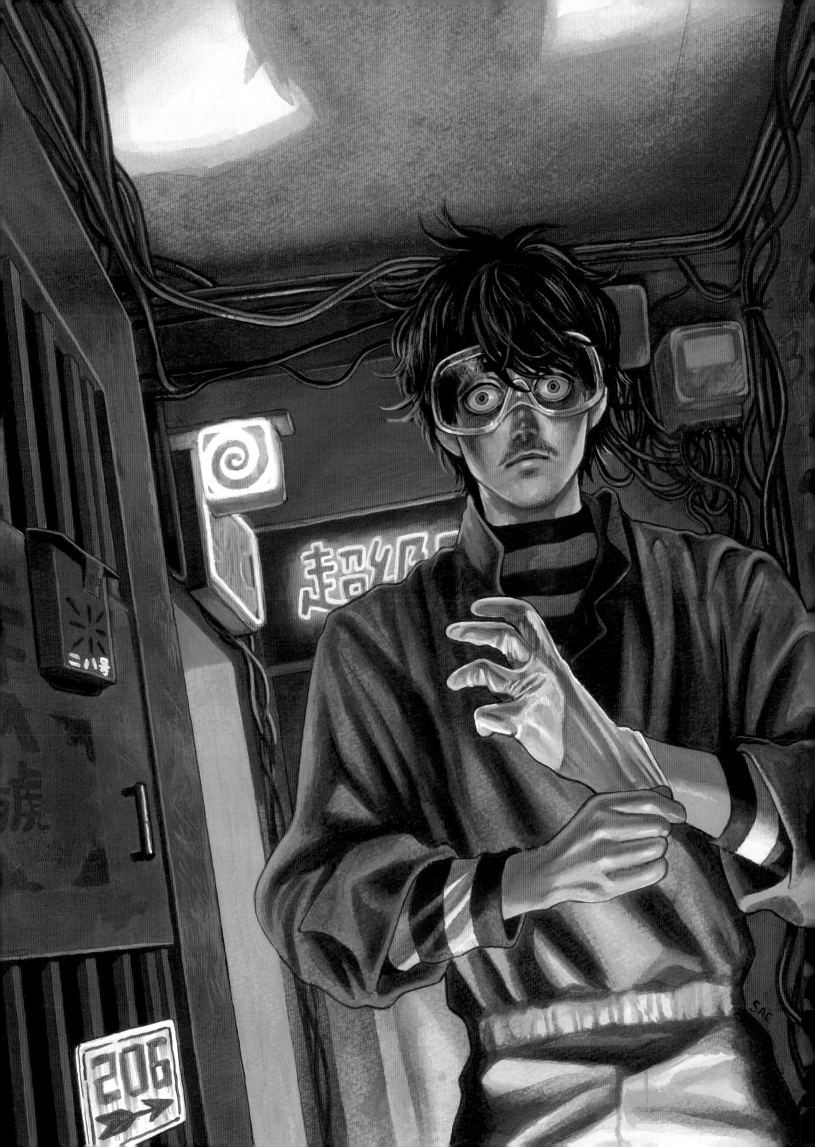

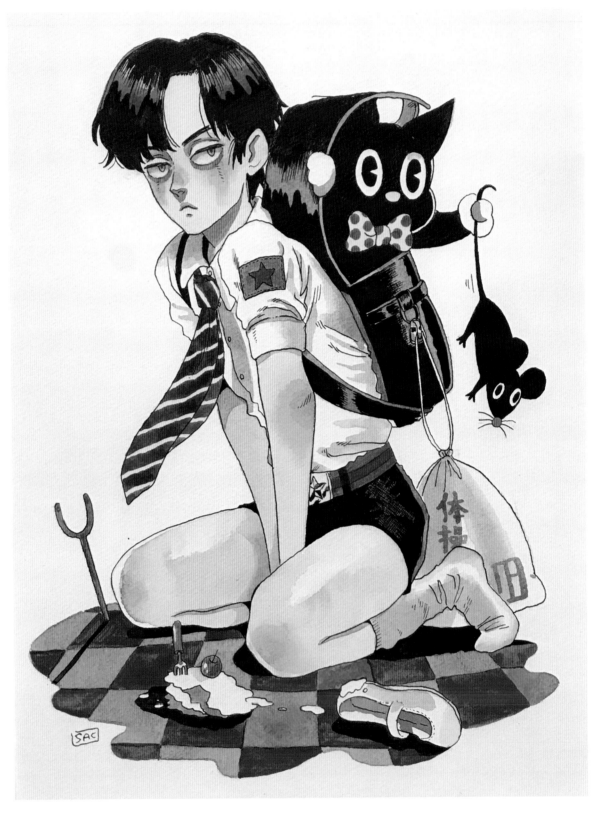

ランドセルの中は . . . *Secret*

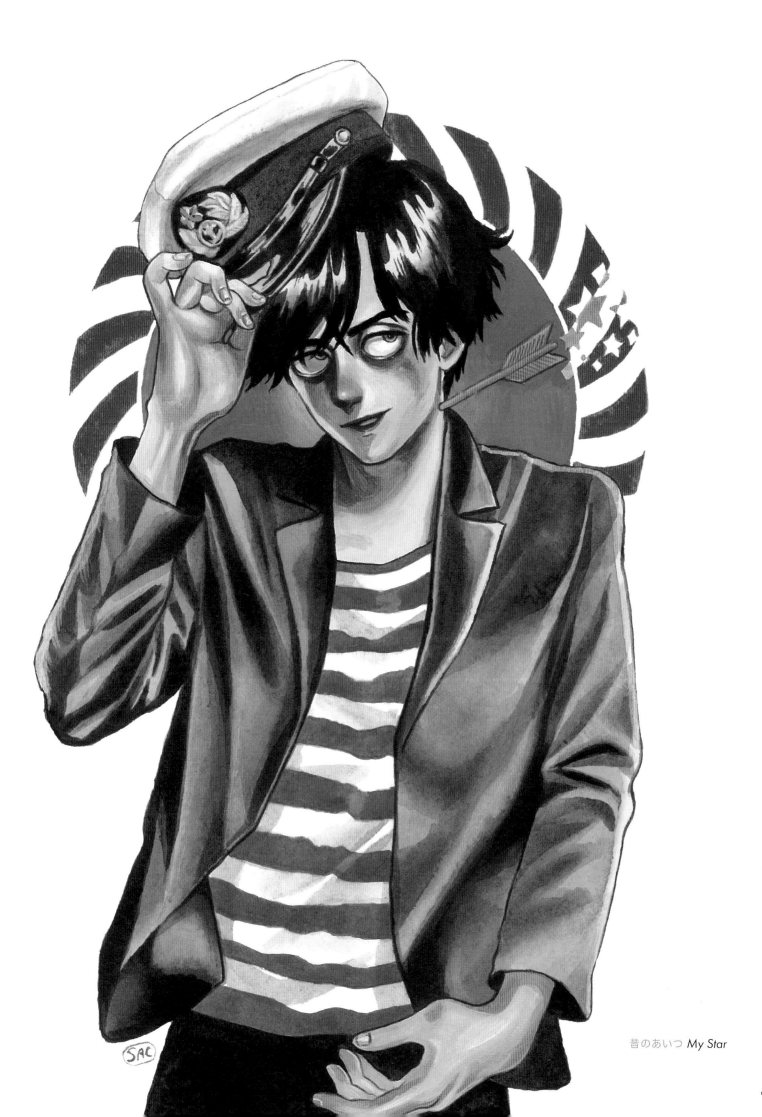

昔のあいつ *My Star*

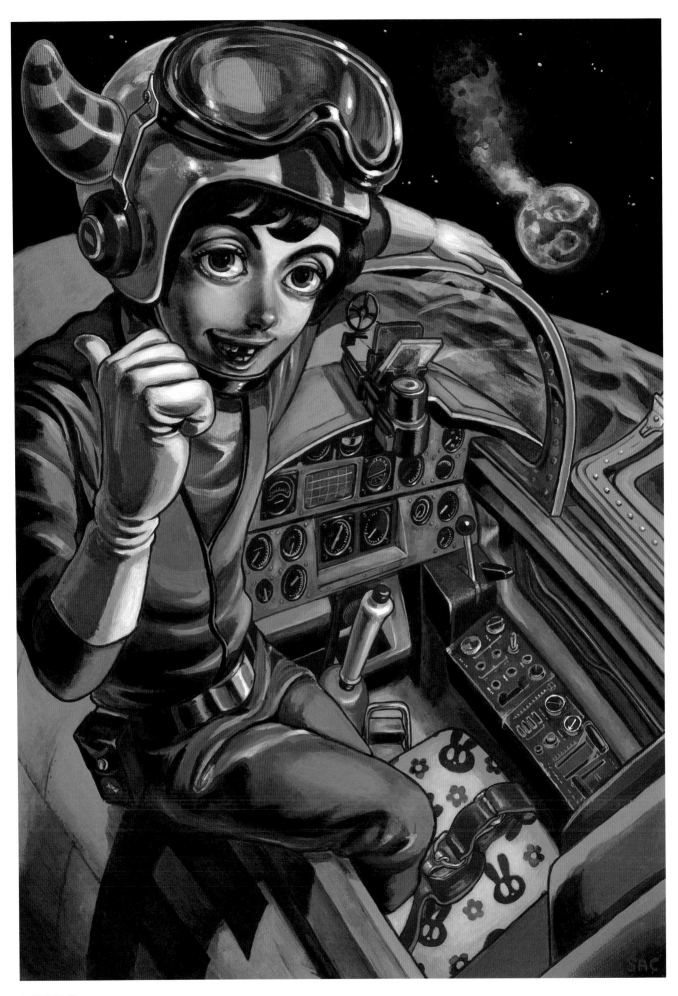

任務完了 Cosmos

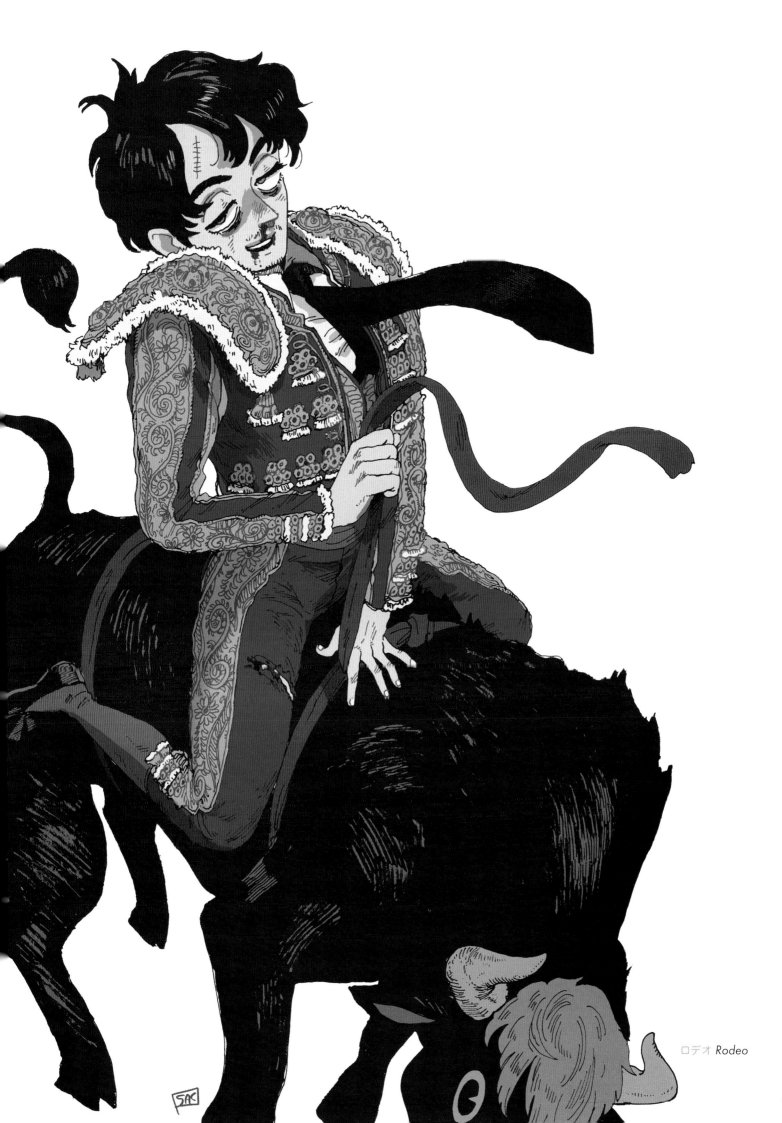

ロデオ Rodeo

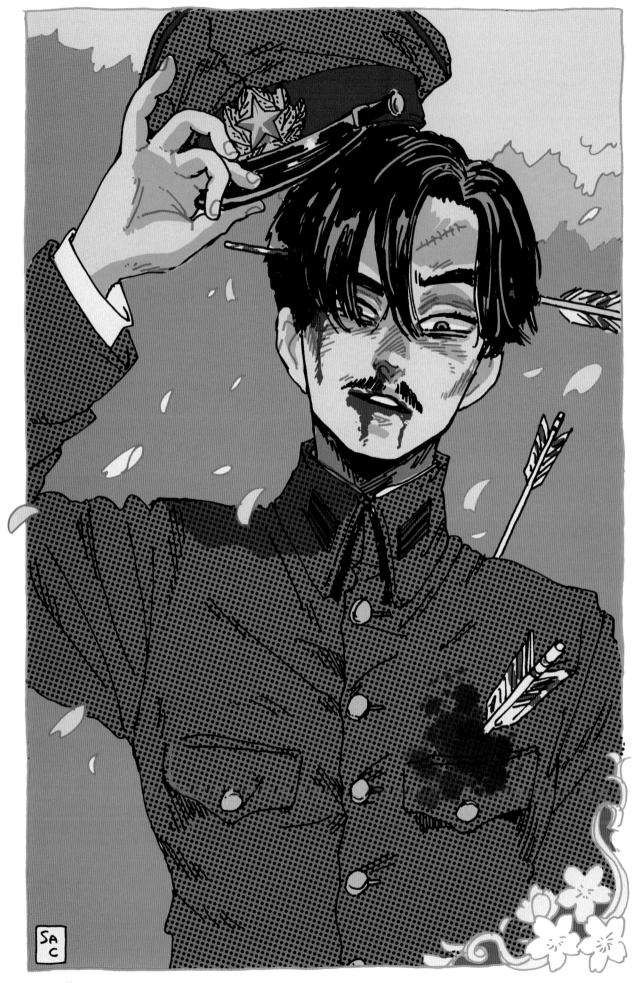

将校 Officer

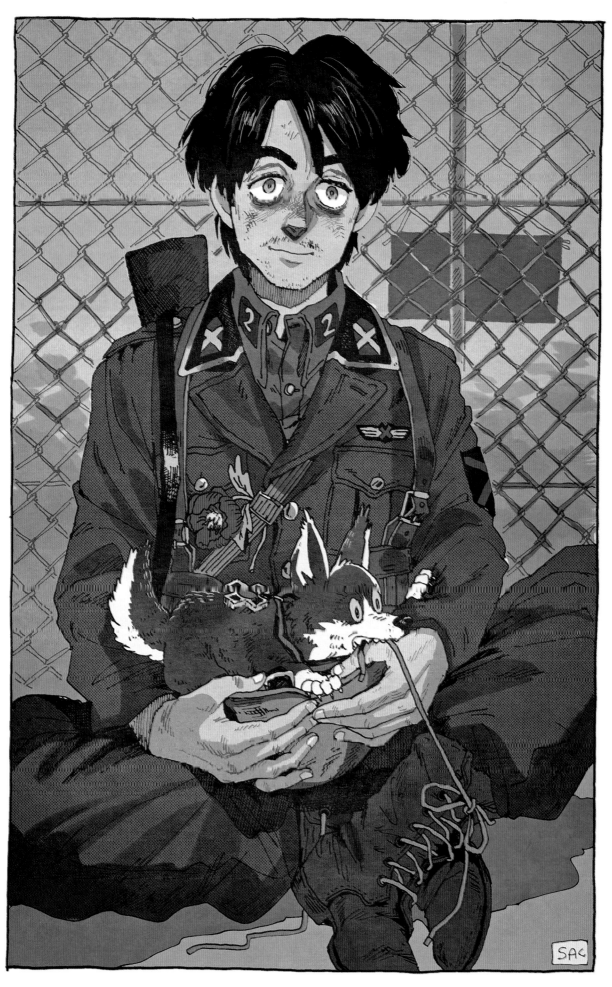

つかの間の急速 *Moving Rapidly For Just An Instant*

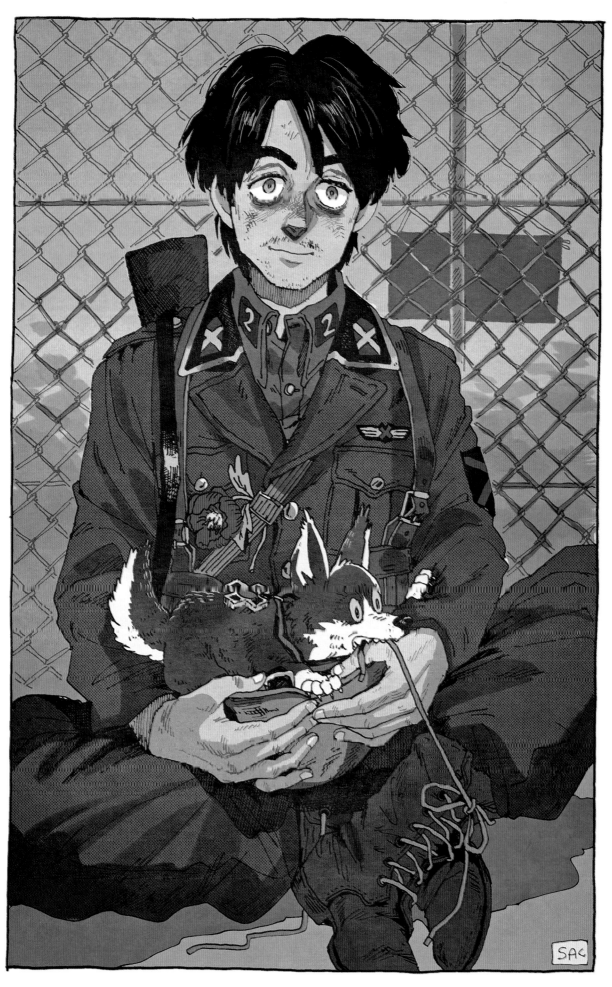

つかの間の急速 *Moving Rapidly For Just An Instant*

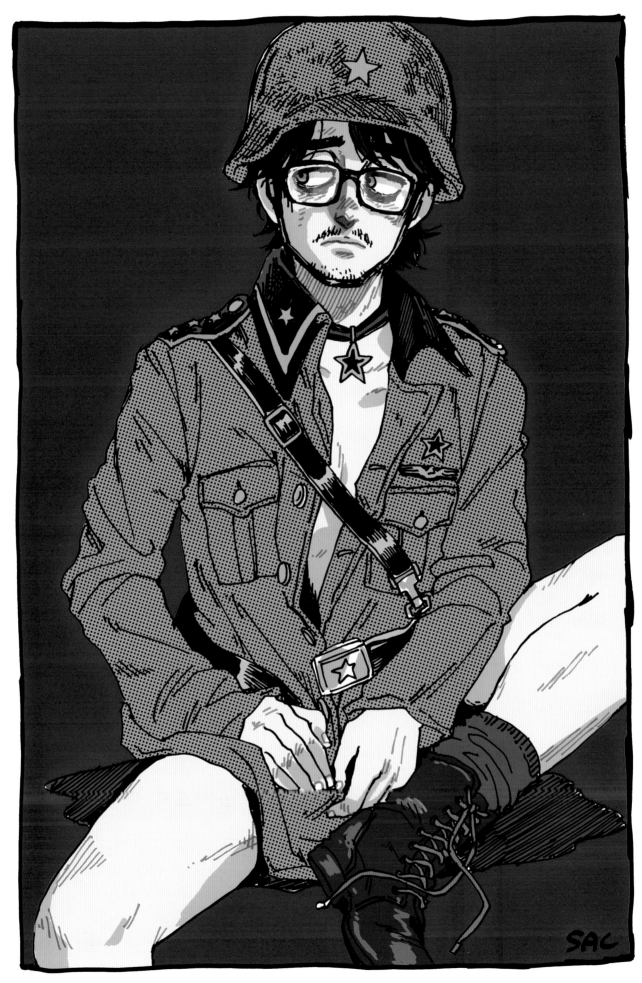

工兵 Engineer

CHAPTER 6
FANTASY

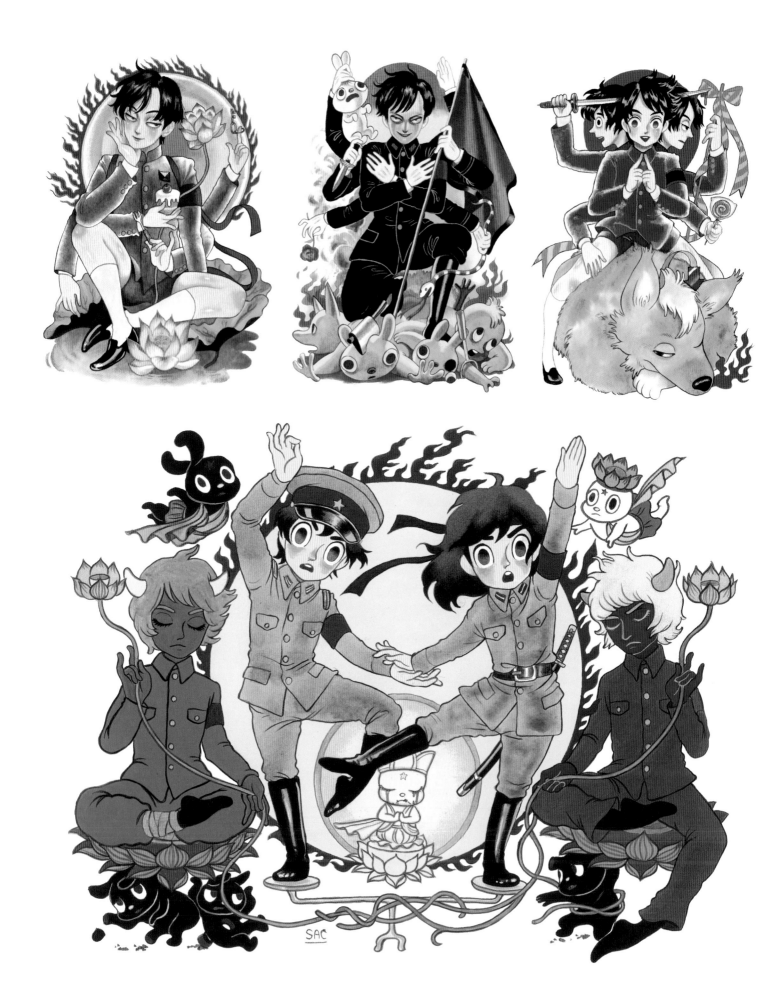

Clockwise from top: 如意輪君 *Nyoirin,* 軍荼利君 *Gundari,* 大威徳君 *Daiitoku,* 六根煩悩 *Six Worldly Desires*

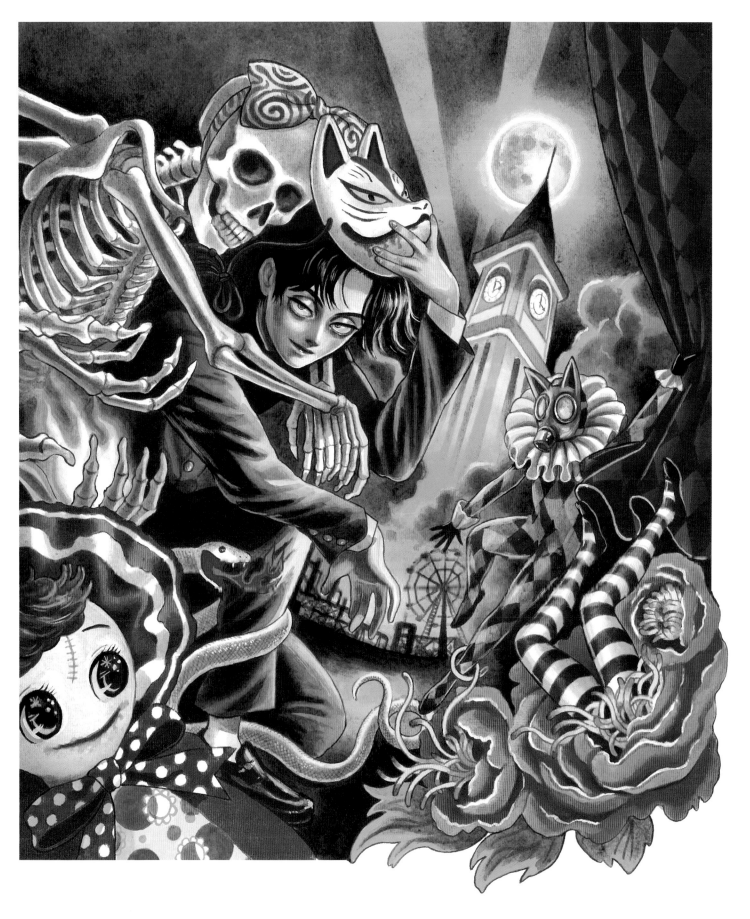

デロリ夜奏ジャケット画 Derori

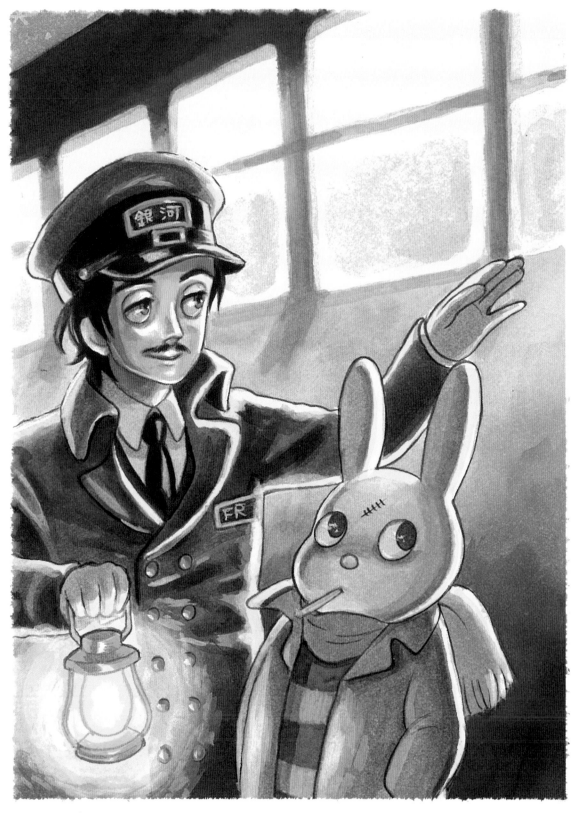

銀河鉄道 *Galaxy Express*

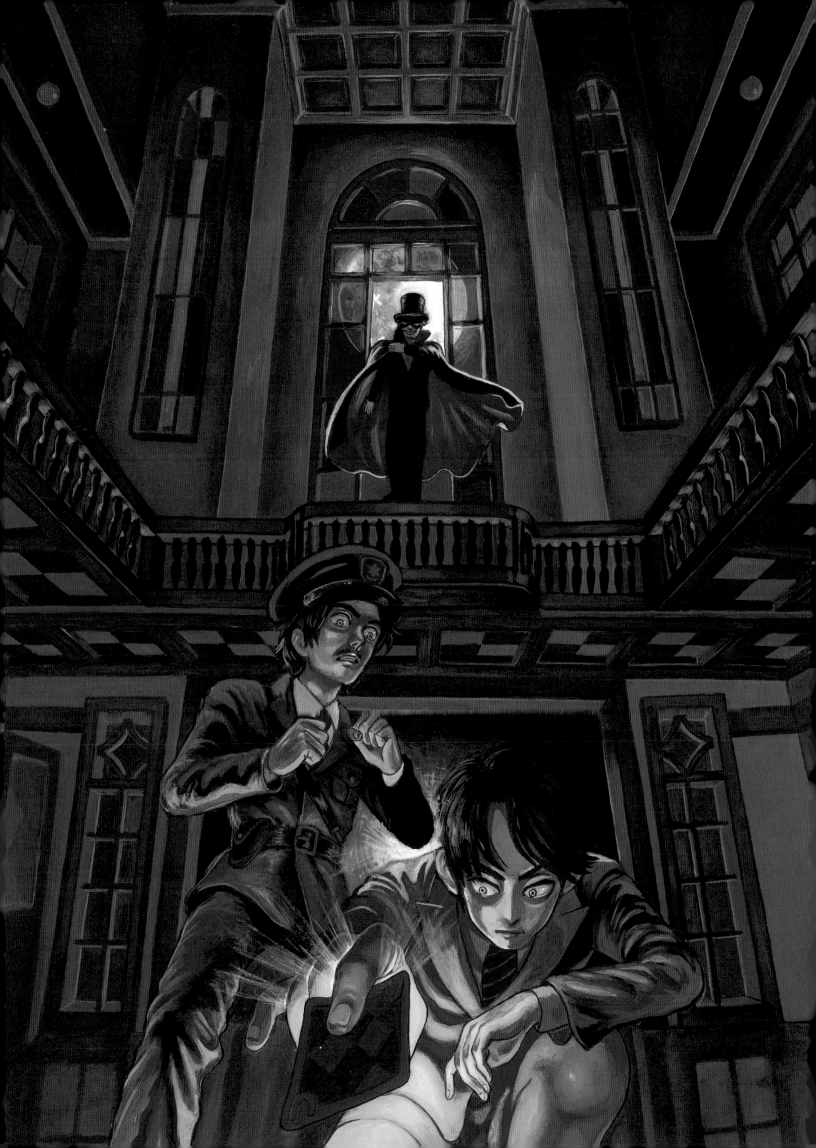

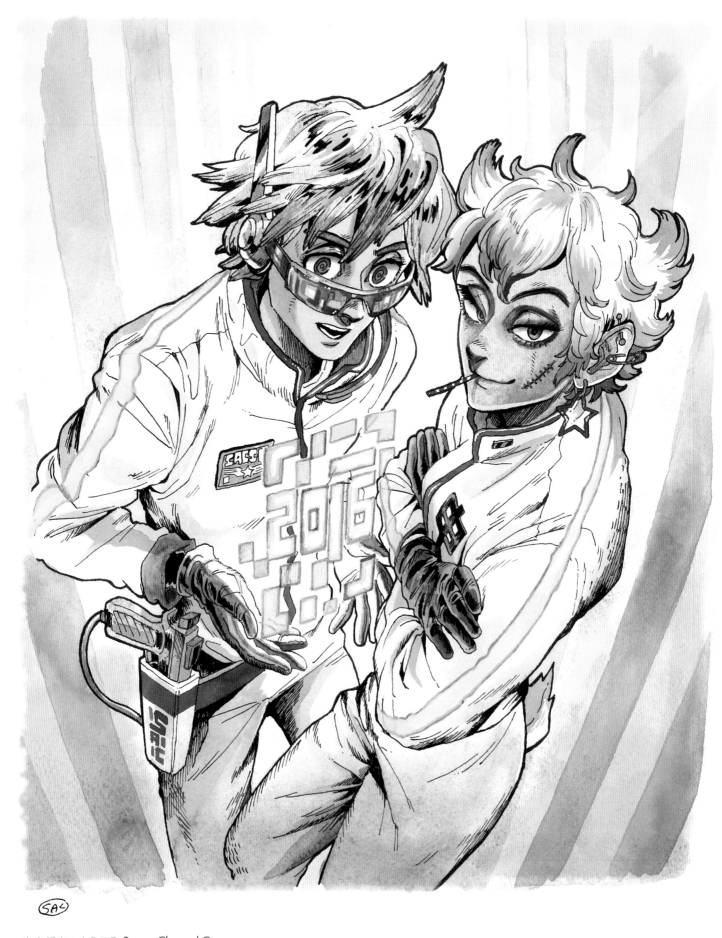

未来都市へようこそ Space Channel Cosmos

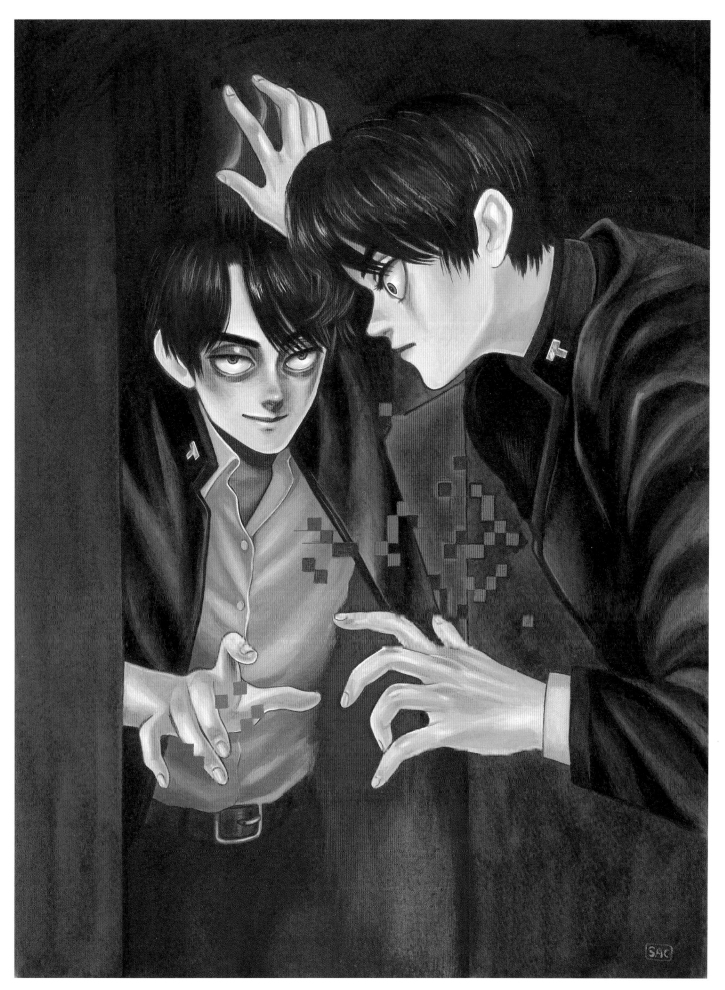

お前は誰だ？ *Mirror*

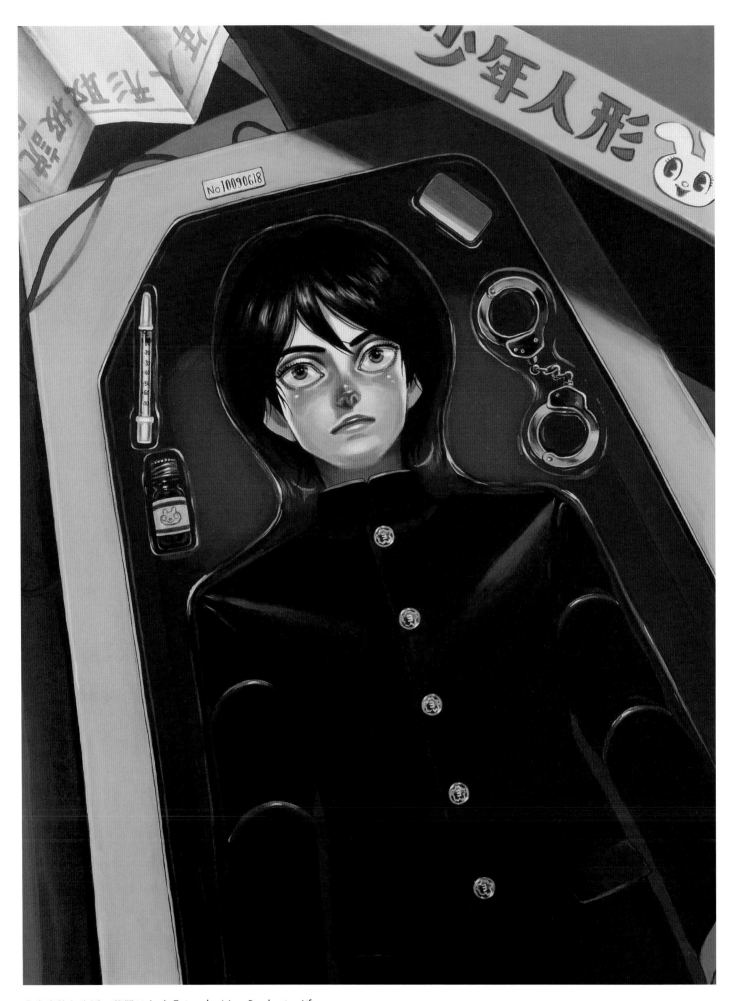

非生産的な生活の幕開け *Let's Enjoy the Non-Productive Life*

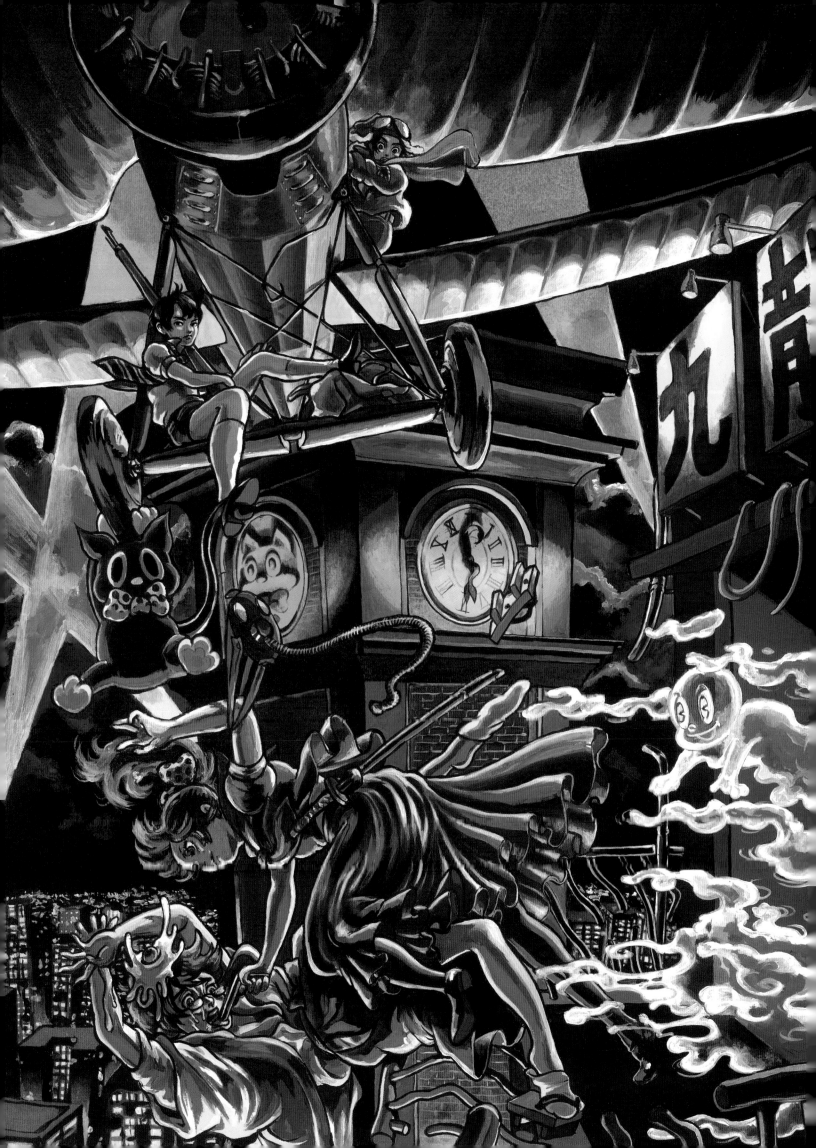

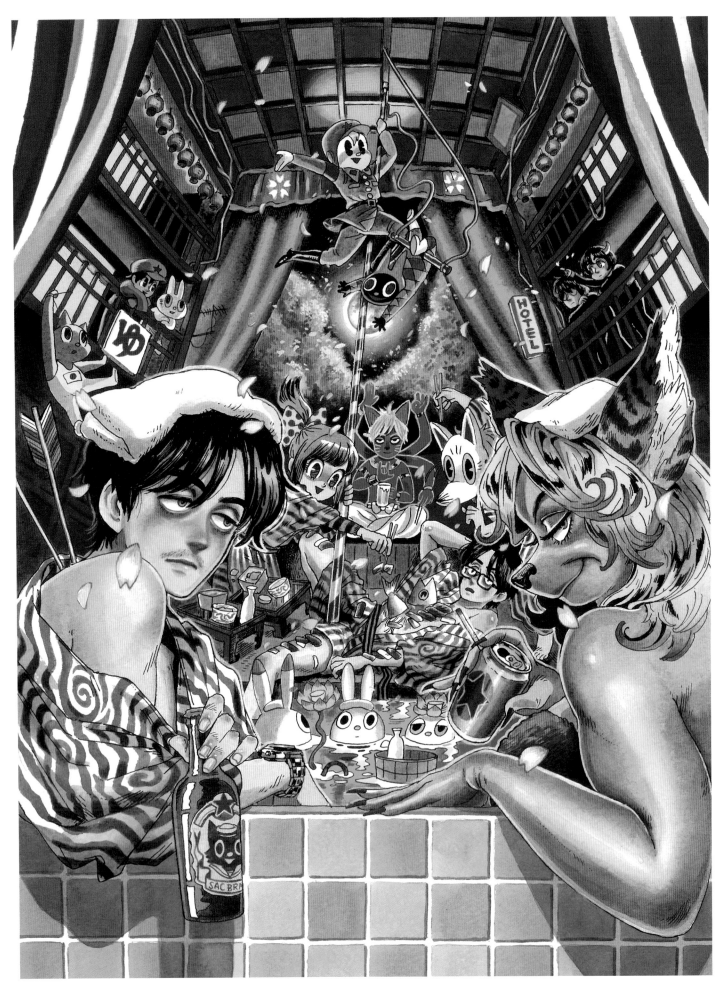

サディスティックサーカス2014 Sadistic Circus Flyer 2014

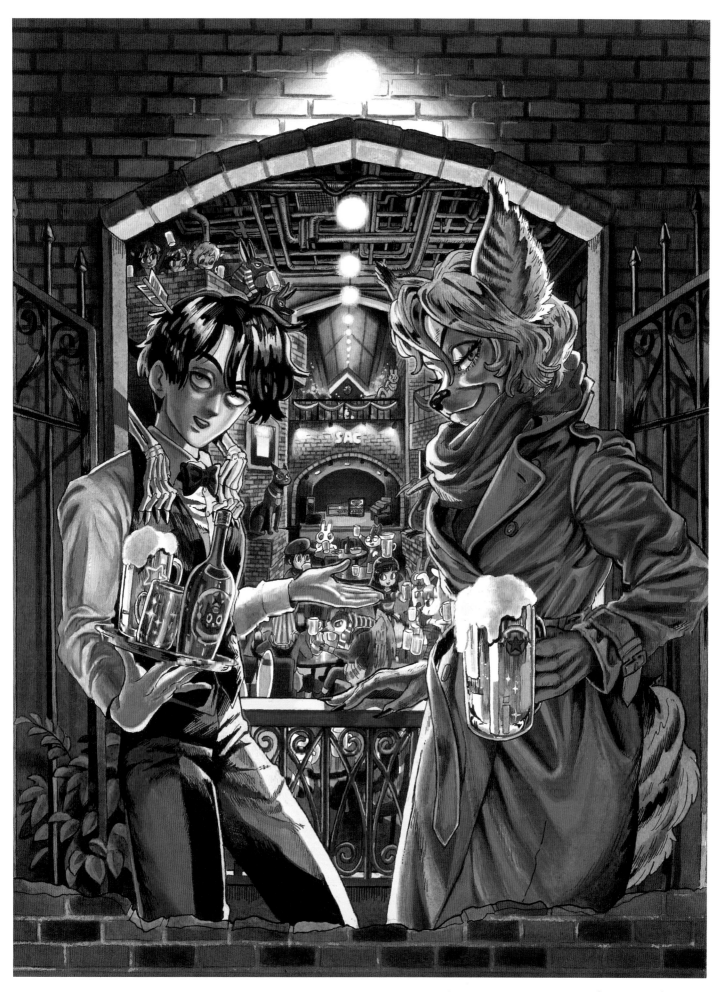

サディスティックサーカス 2015 *Sadistic Circus Flyer 2015*

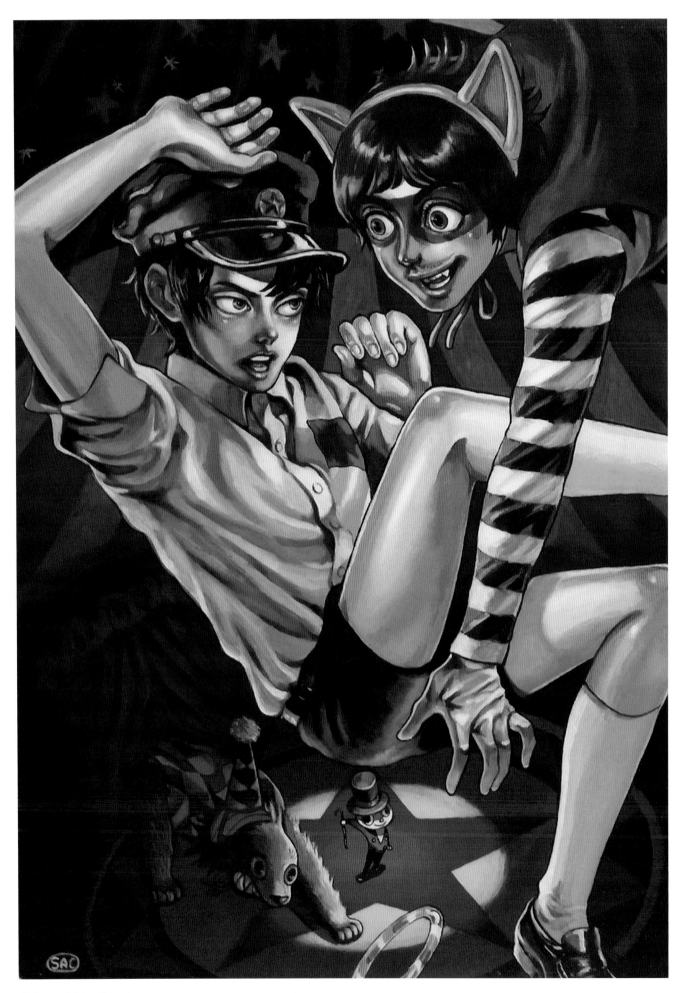

巡業へのお誘い Scouting

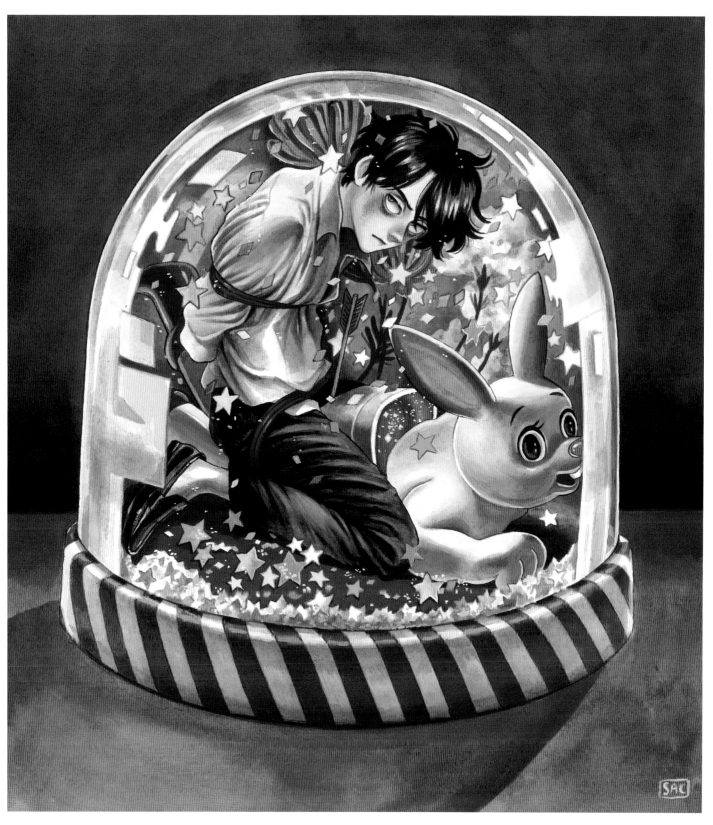

アクアリストの密かな楽しみ *Snow Globe*

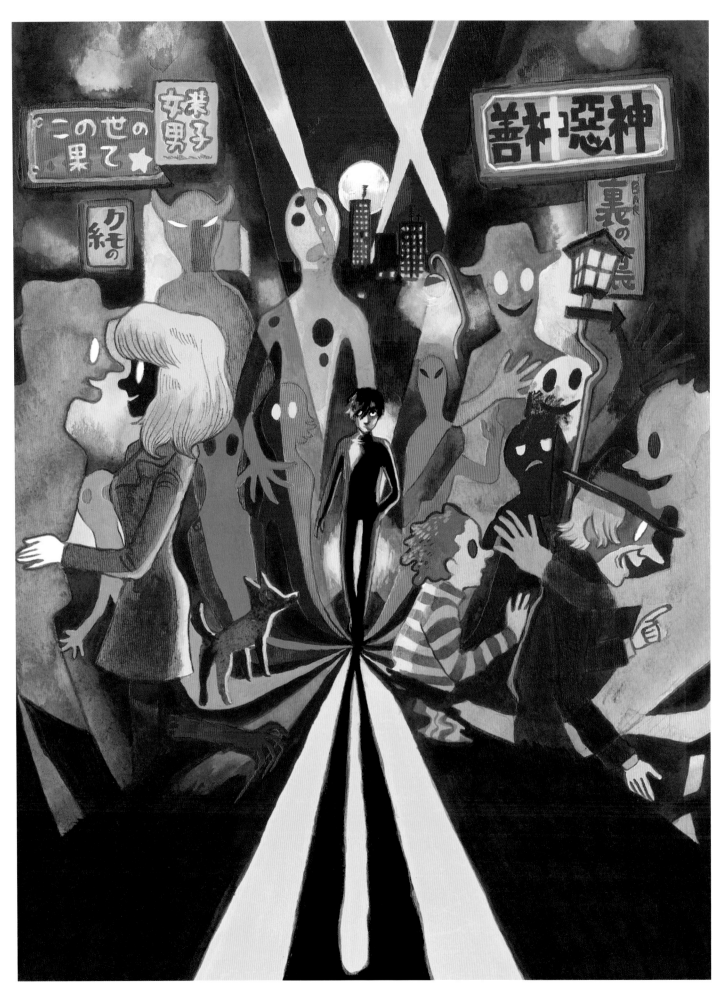

影男 *Shadowman*

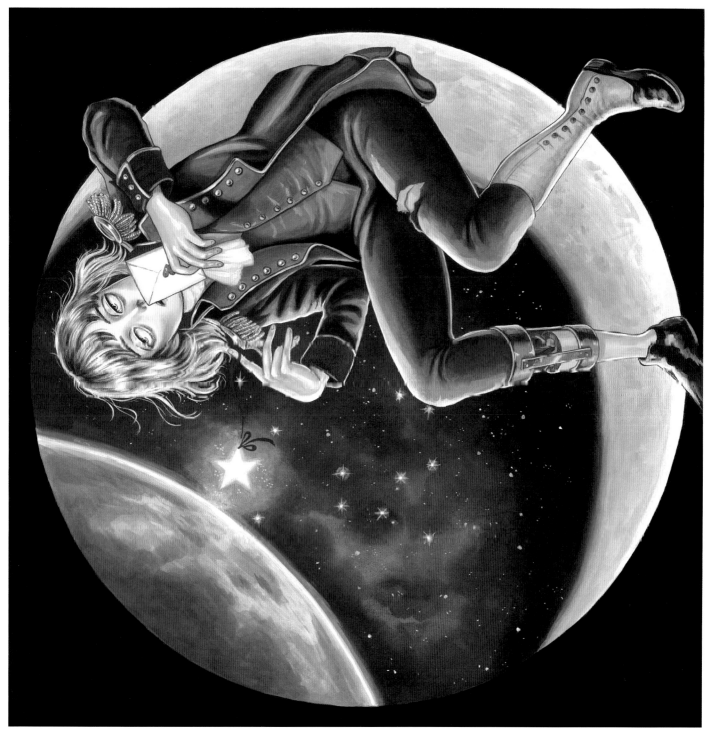

星の王子様 *The Prince of Fools*

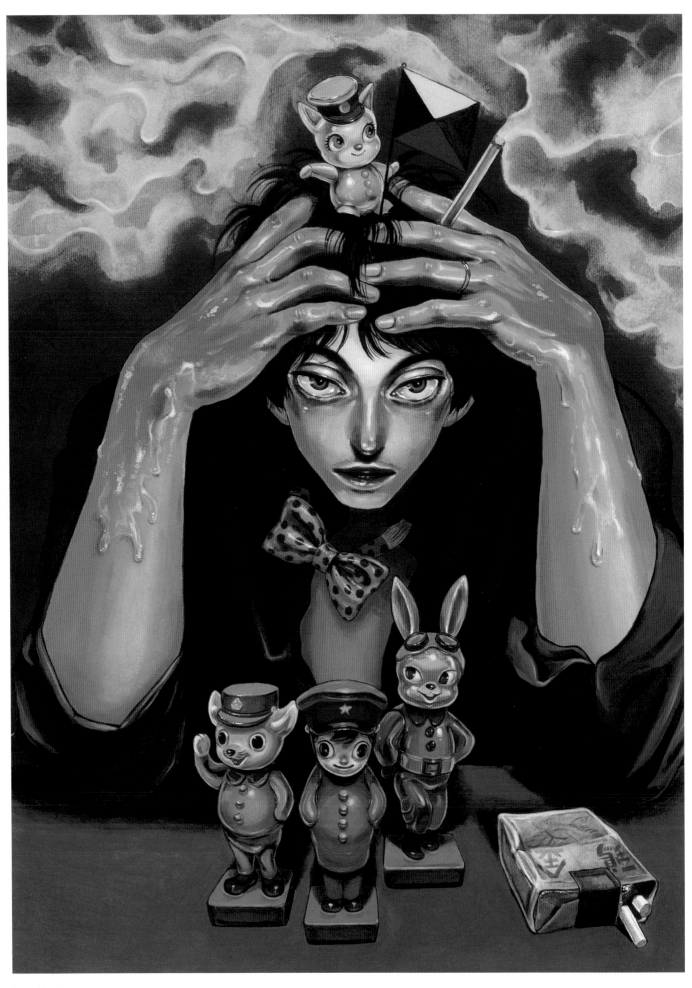

戦略 *Tactics*

CHAPTER 7
PORTRAIT

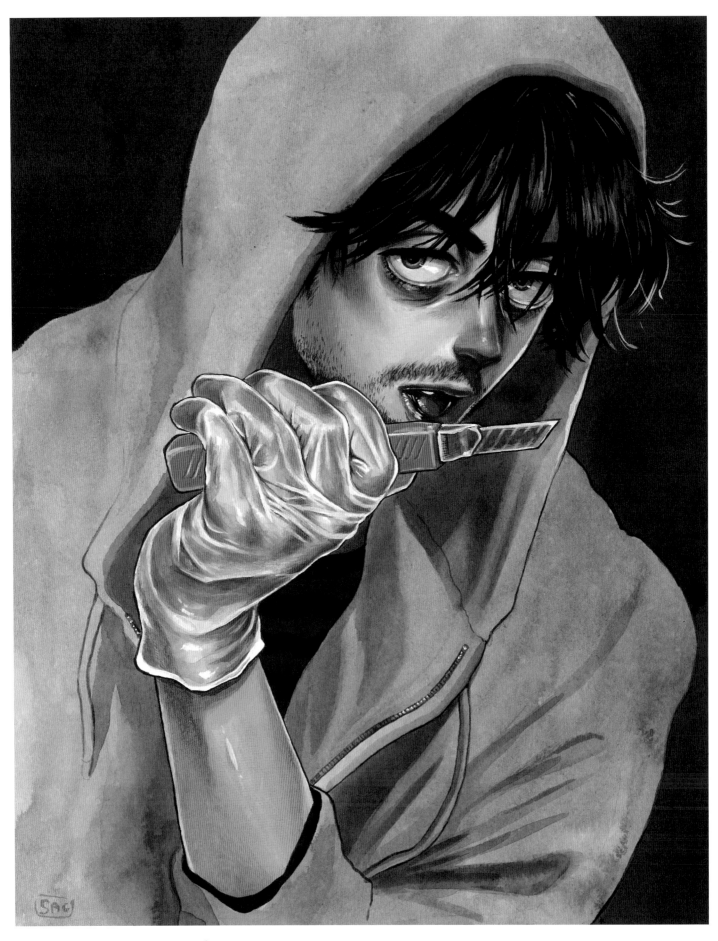

消しゴムはんこ職人 Eraser Stamp Craftsman

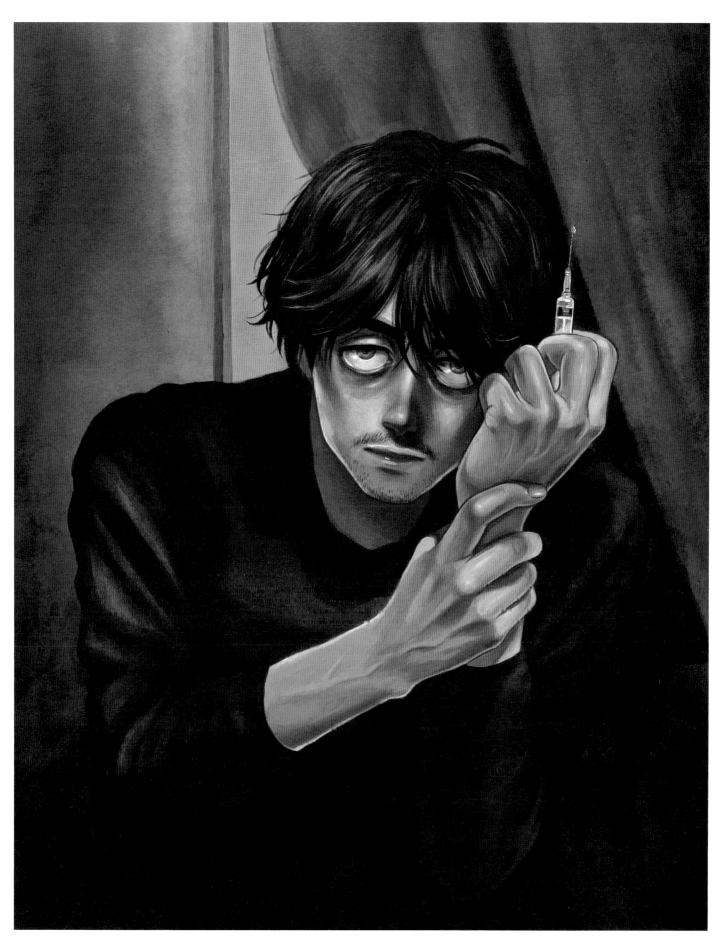

生き辛い男 *Highly Sensitive Person*

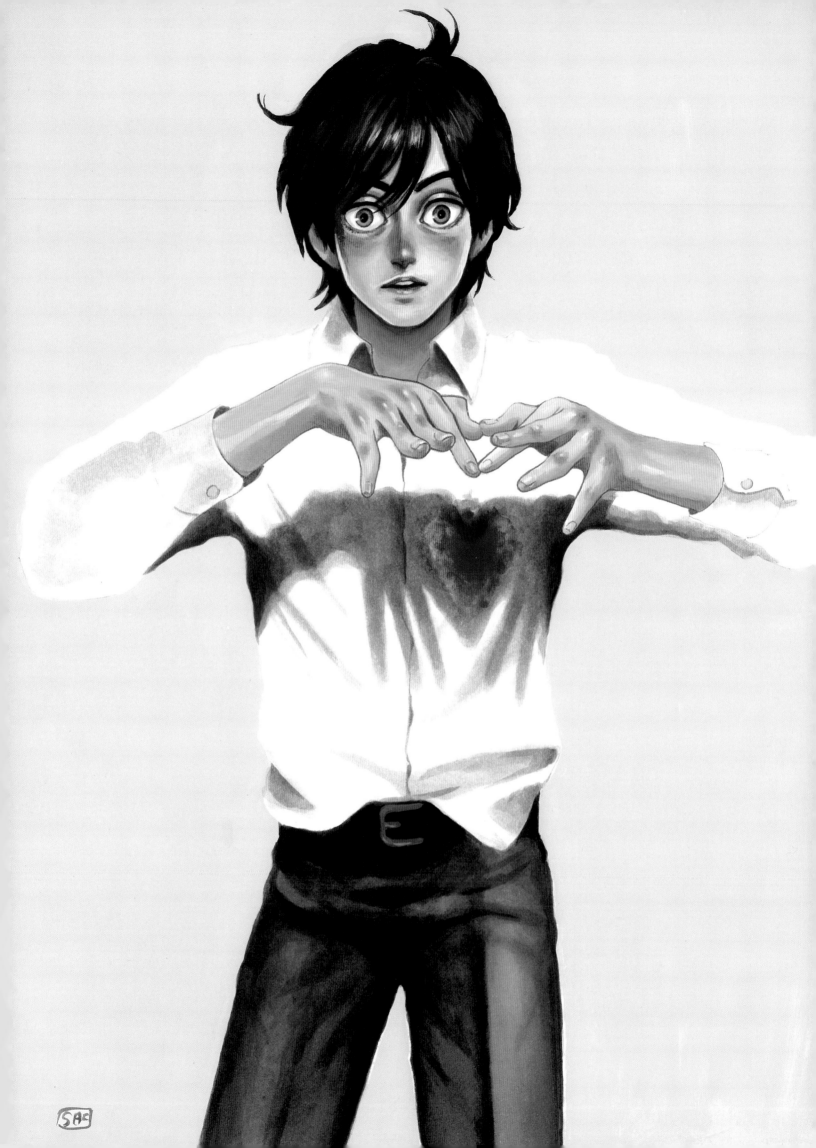

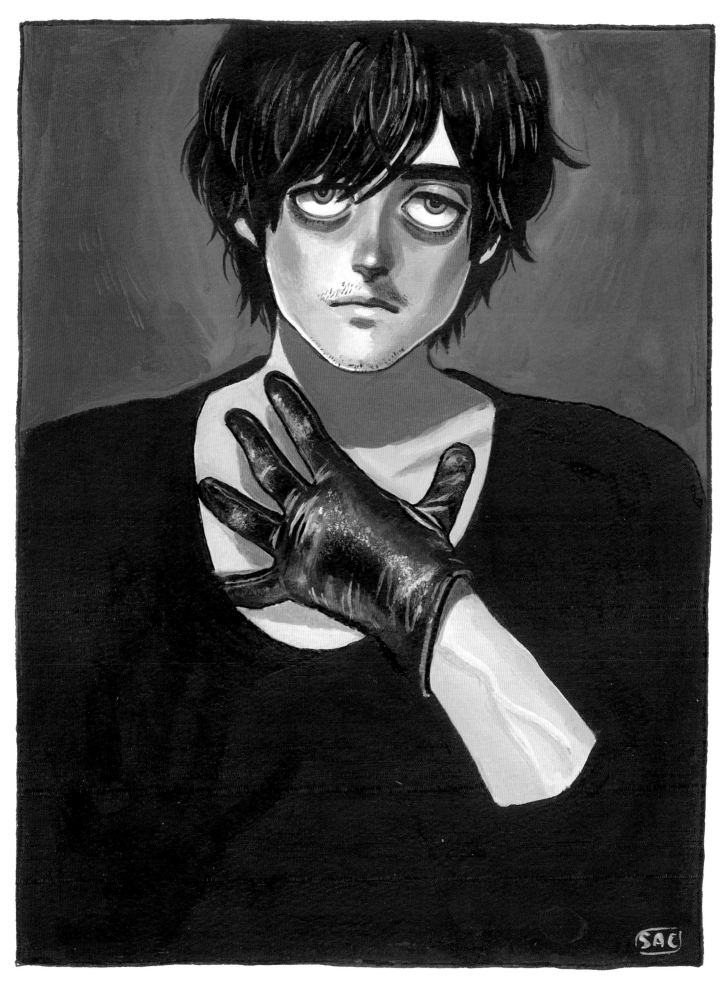

革手袋の男 *Man with Leather Glove*

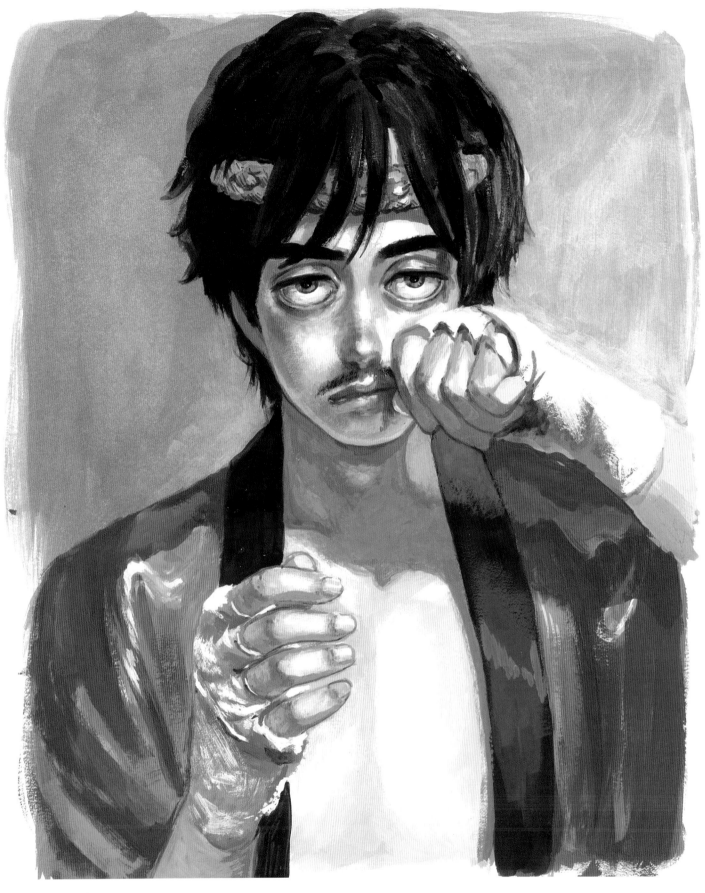

闘う男 Kick Boxer

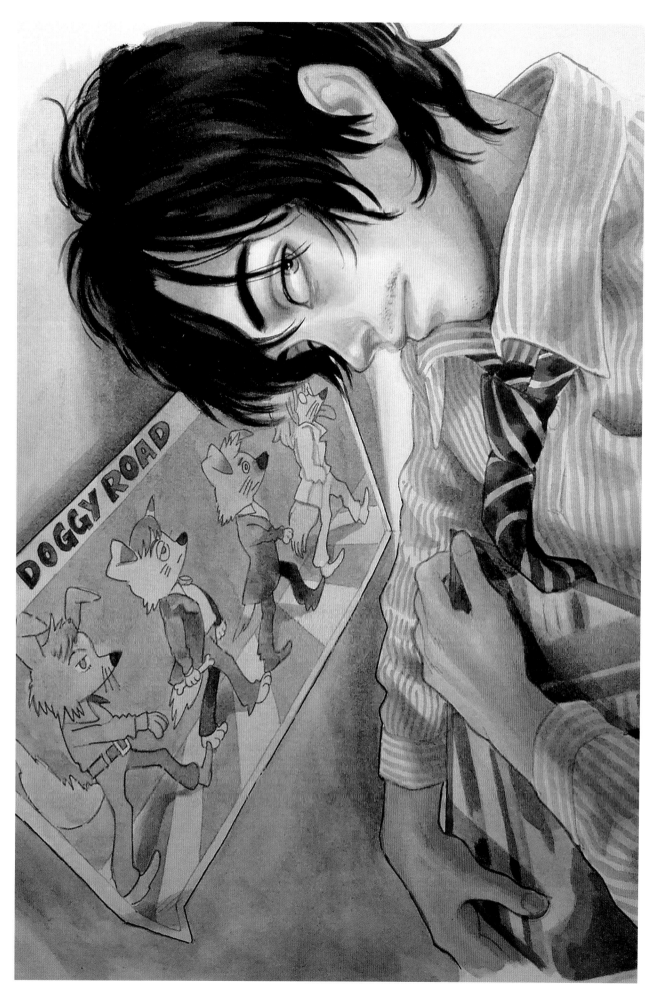

彼のお気に入り *His Favorite*

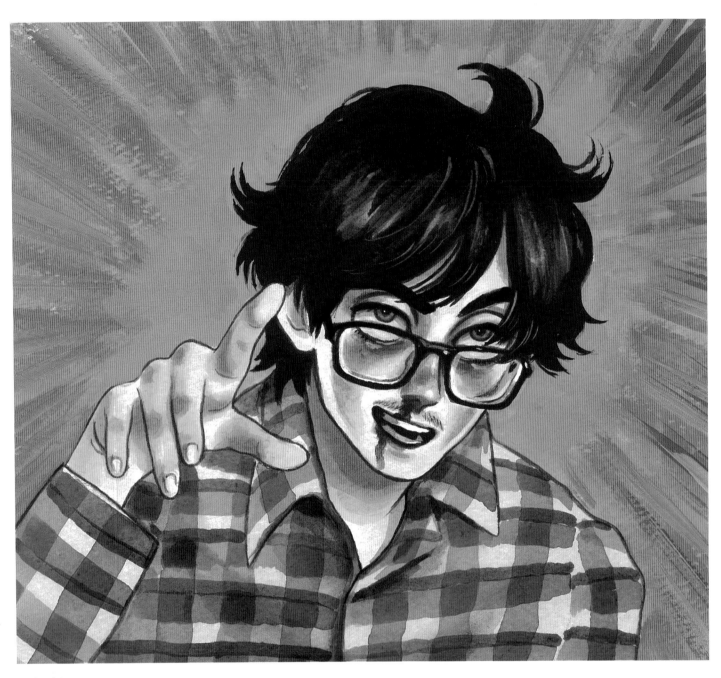

メガネ Megane

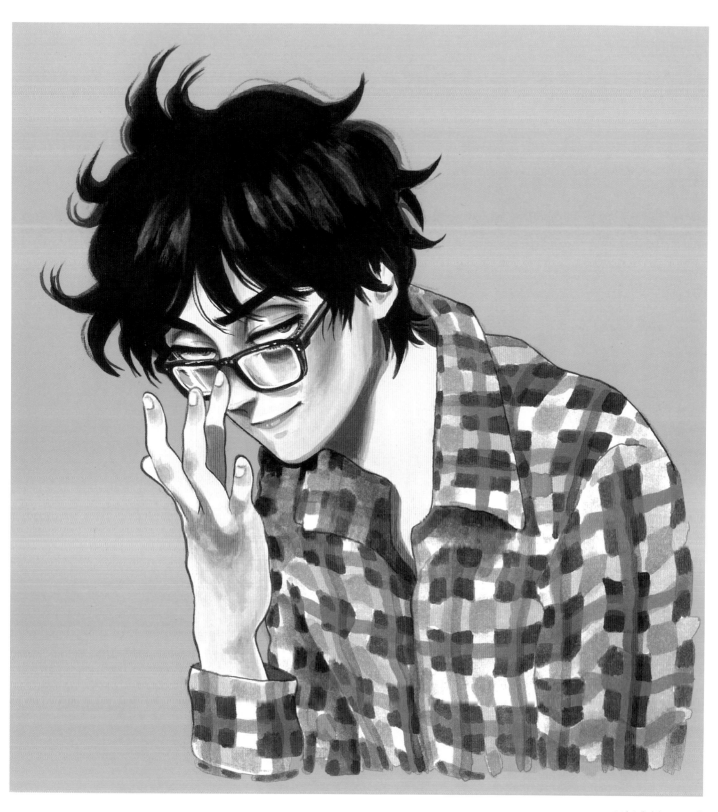

メガネ2 Megane 2

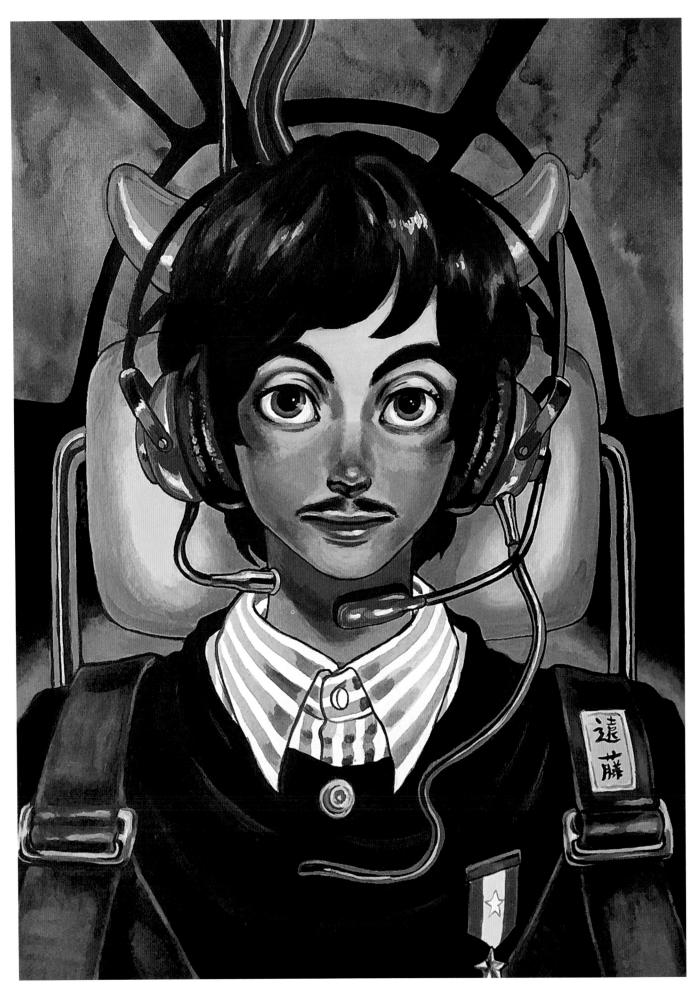

搭乗完了 Mr. Endo

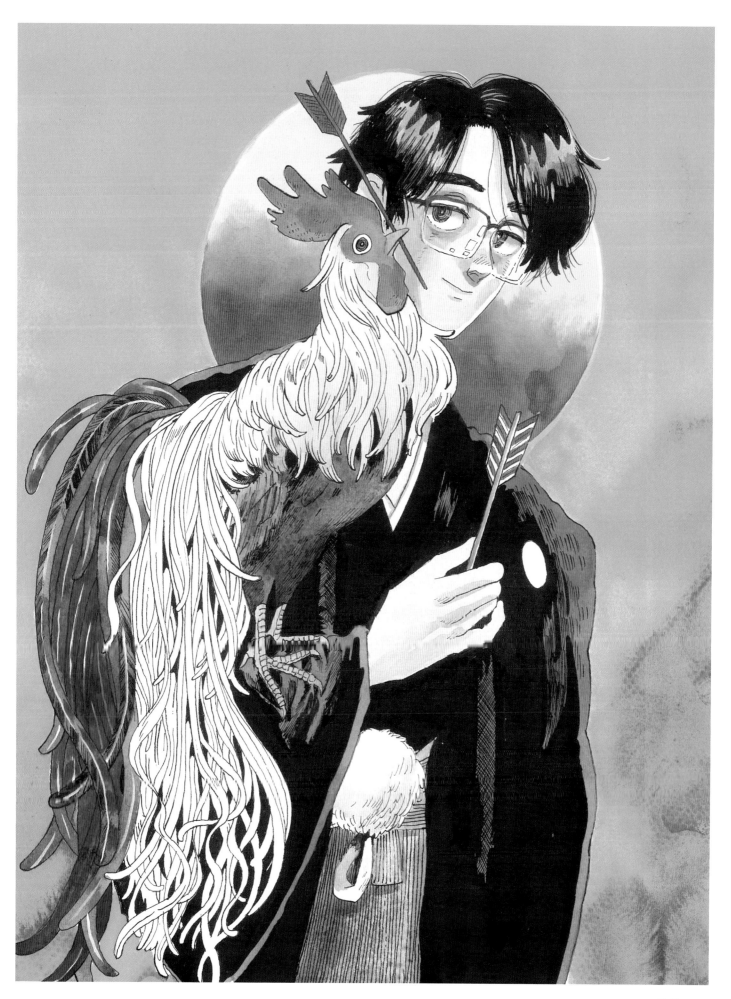

酉 *Rooster*

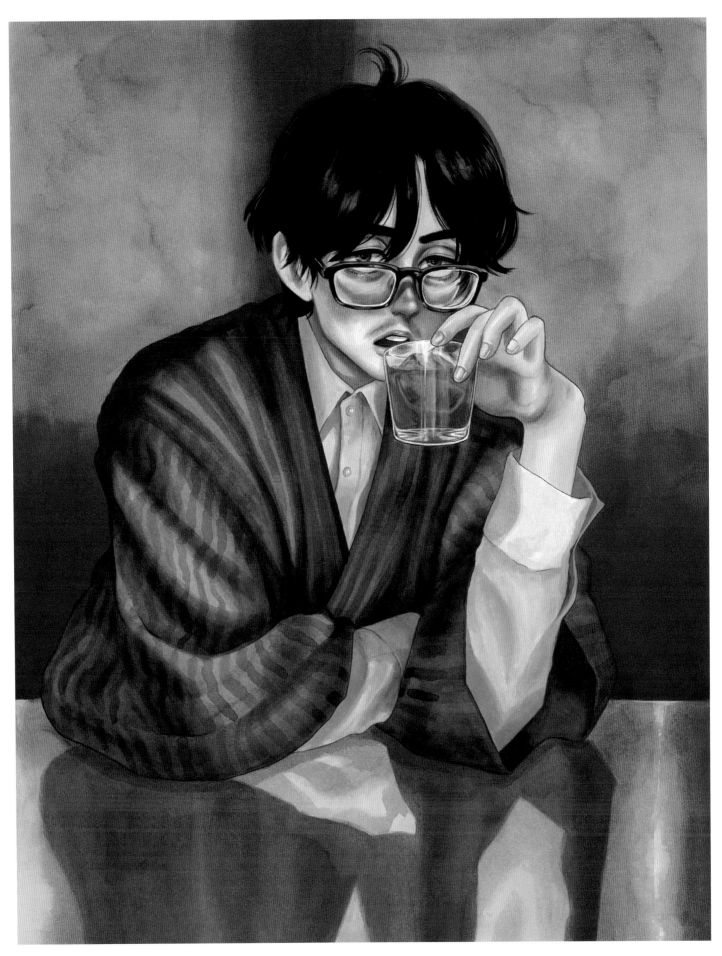

漠然 *Ruin Desire*

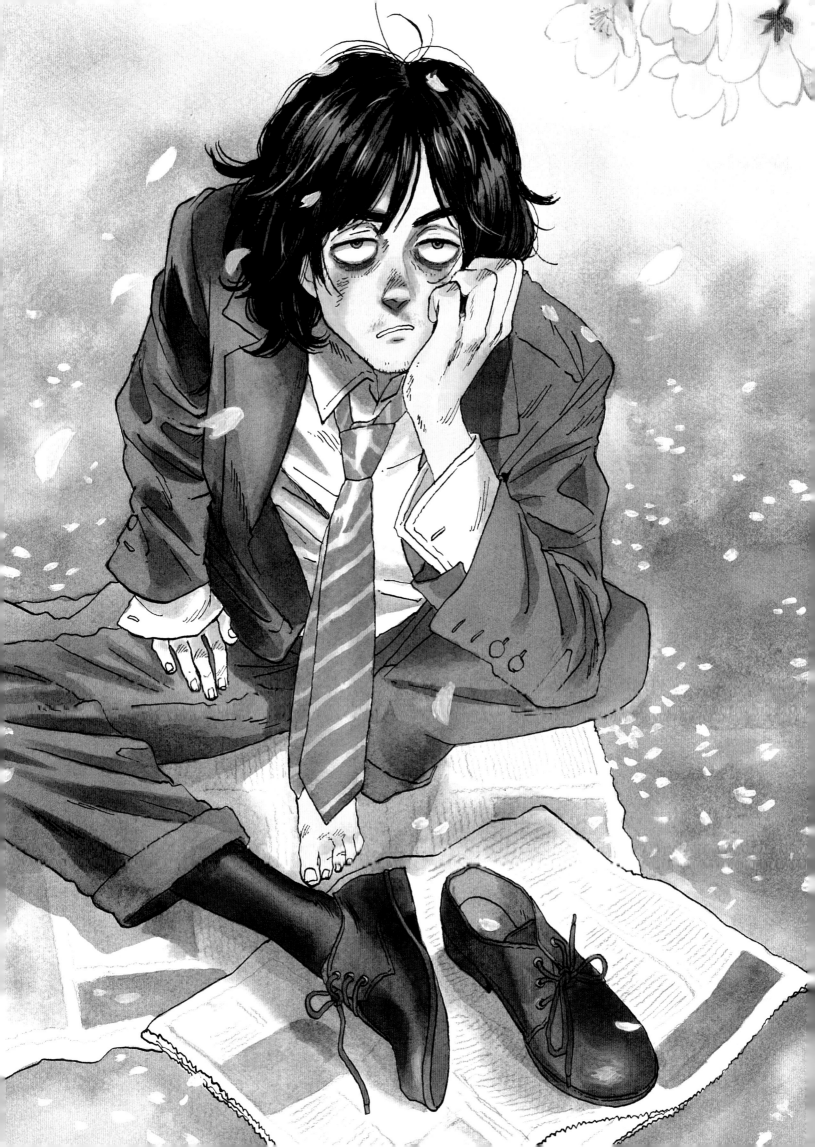

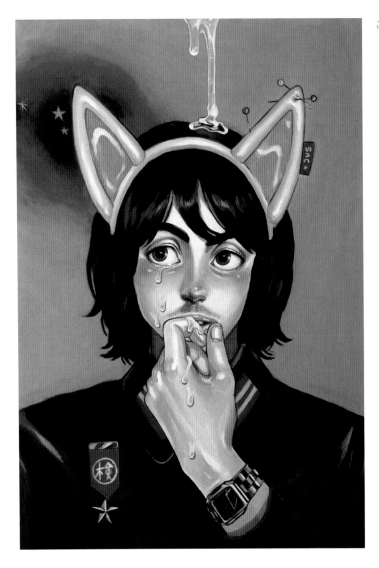

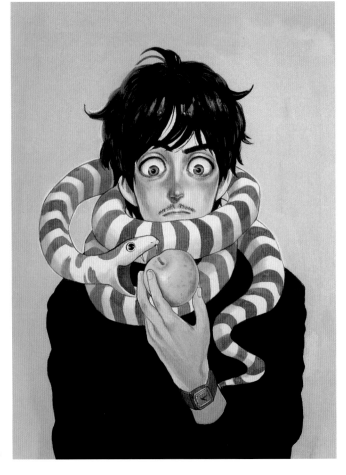

蛇 *Forbidden Fruit*

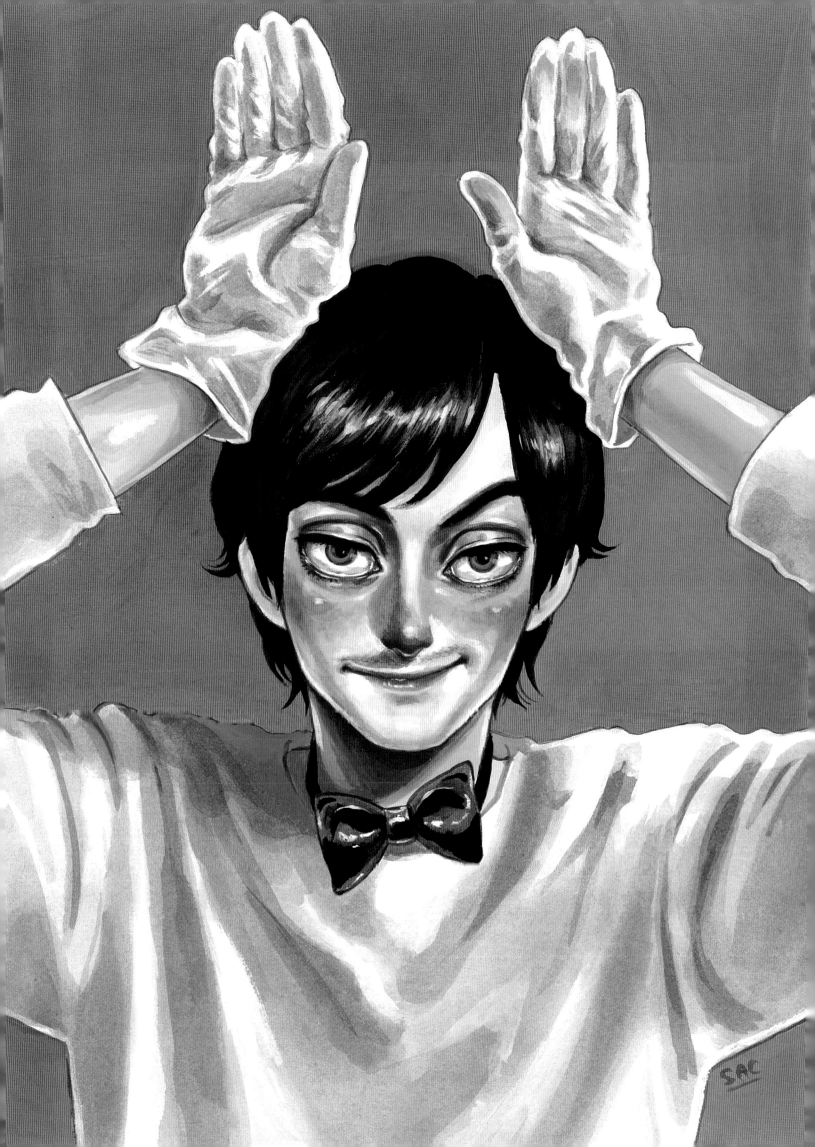

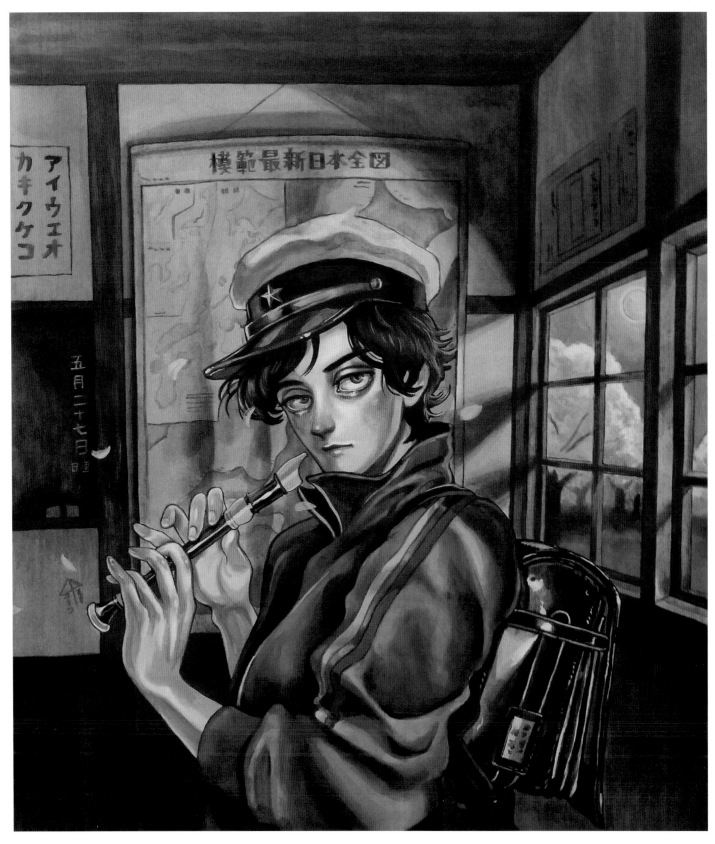

無題2 *Untitled 2*

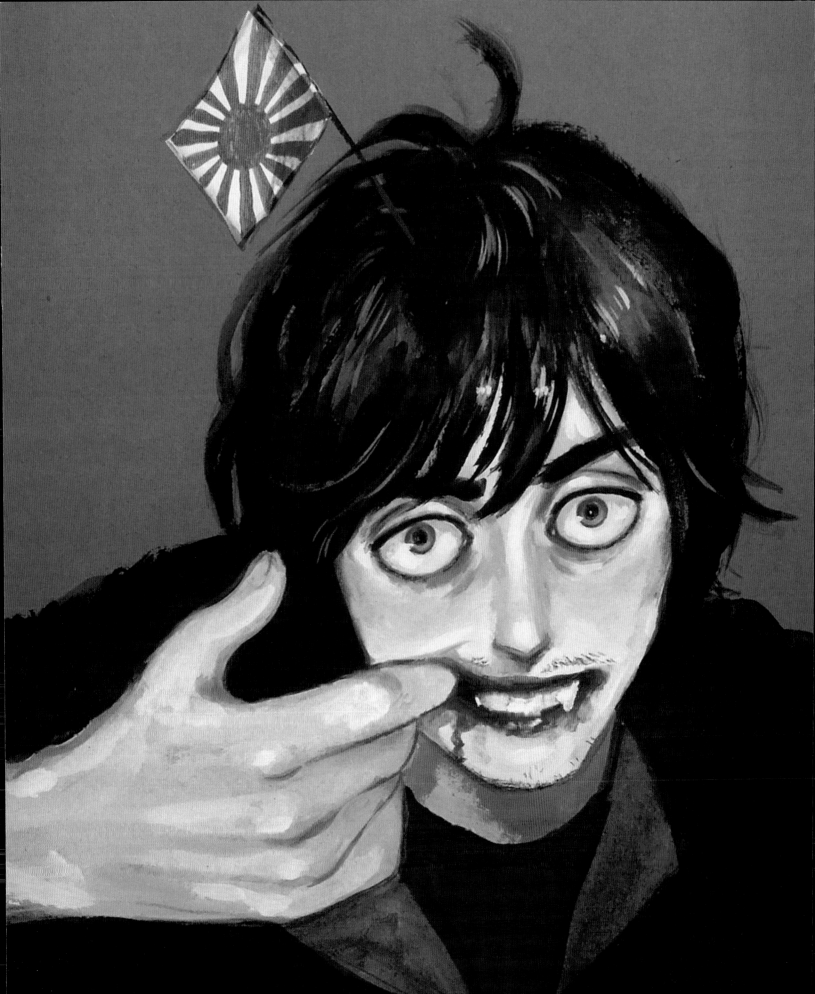

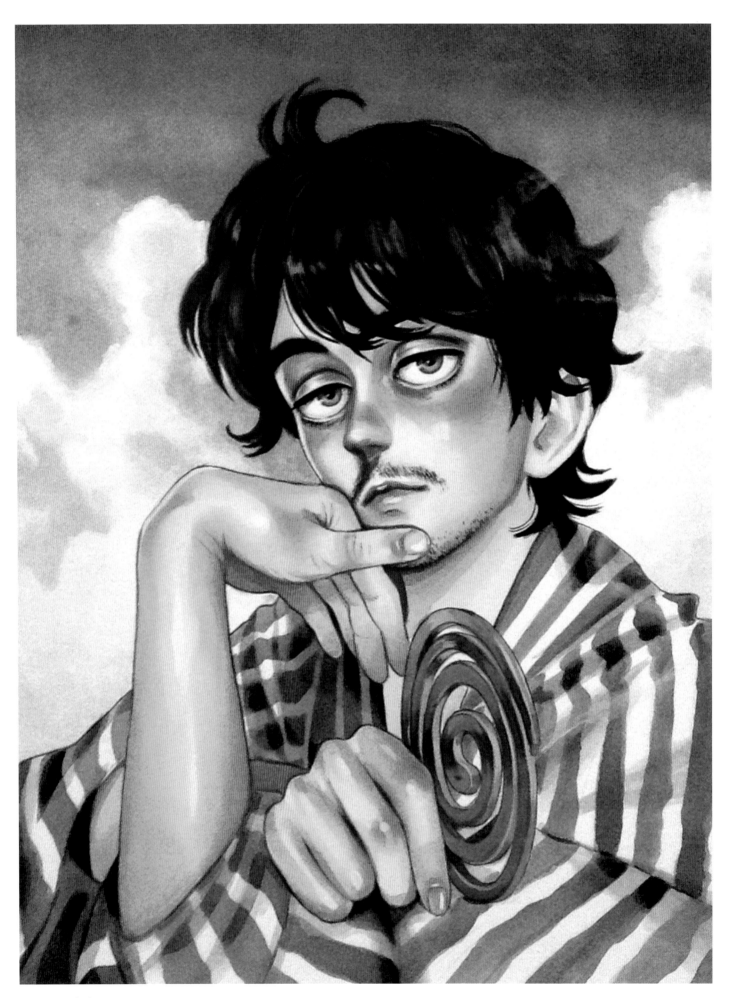

無題4 *Untitled 4*

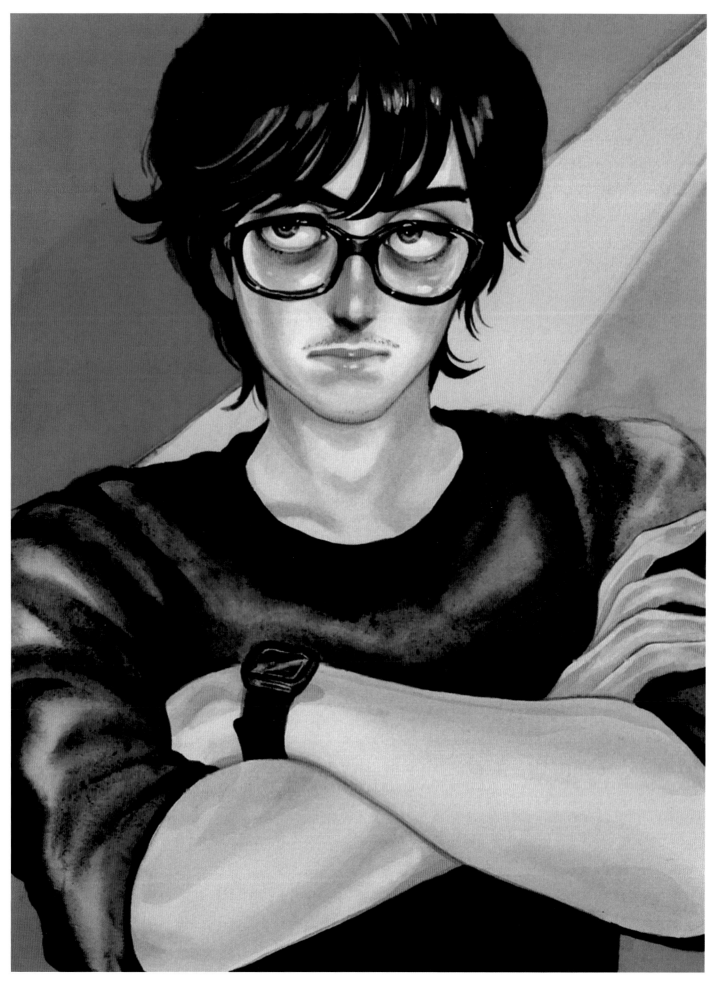

無題5 *Untitled 5*

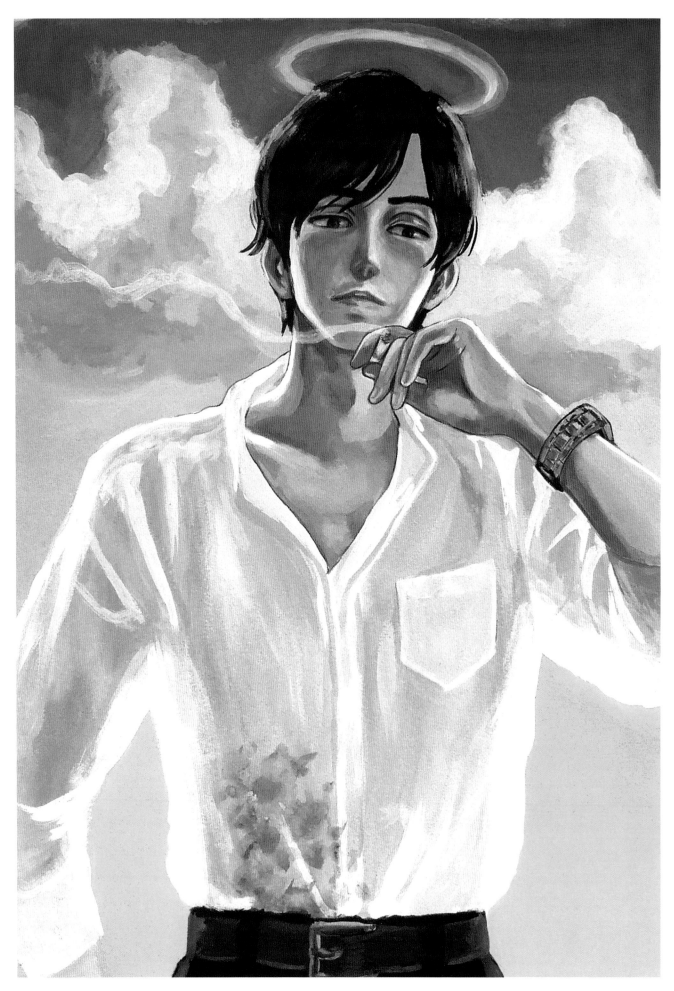

無題6 Untitled 6

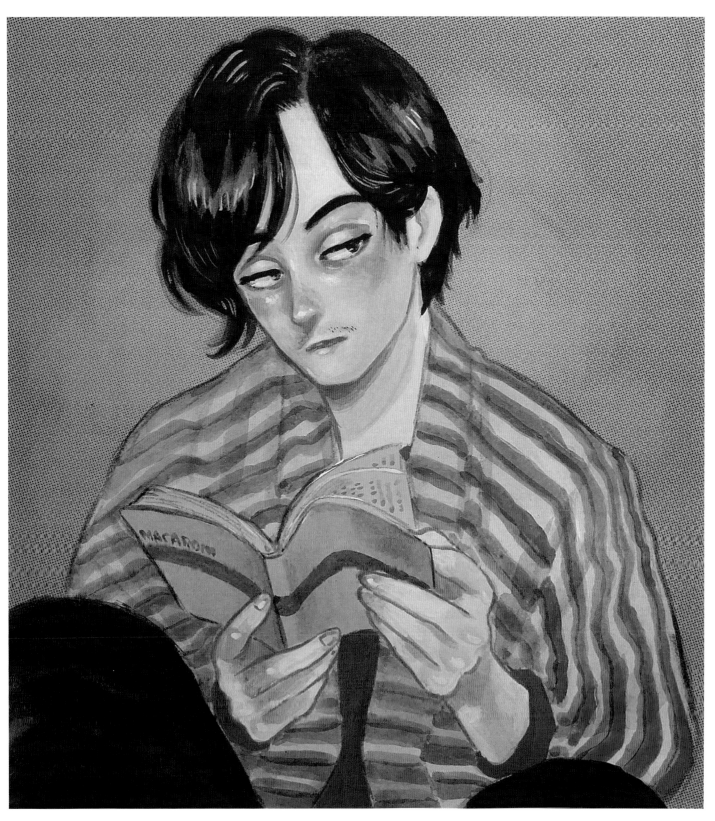

無題7 *Untitled 7*

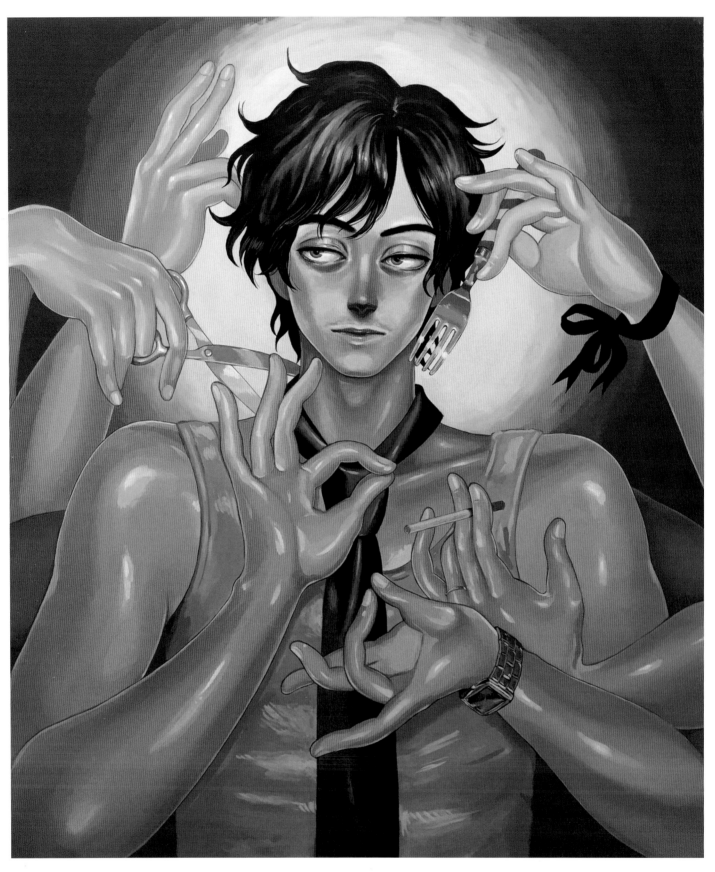

無題8 *Untitled 8*

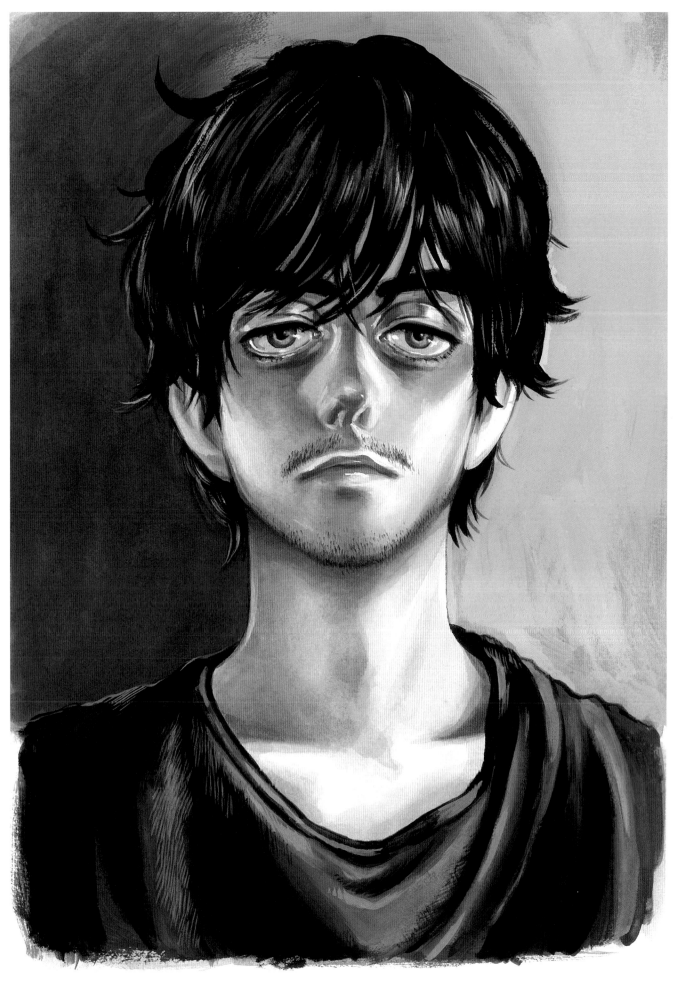

無題9 Untitled 9

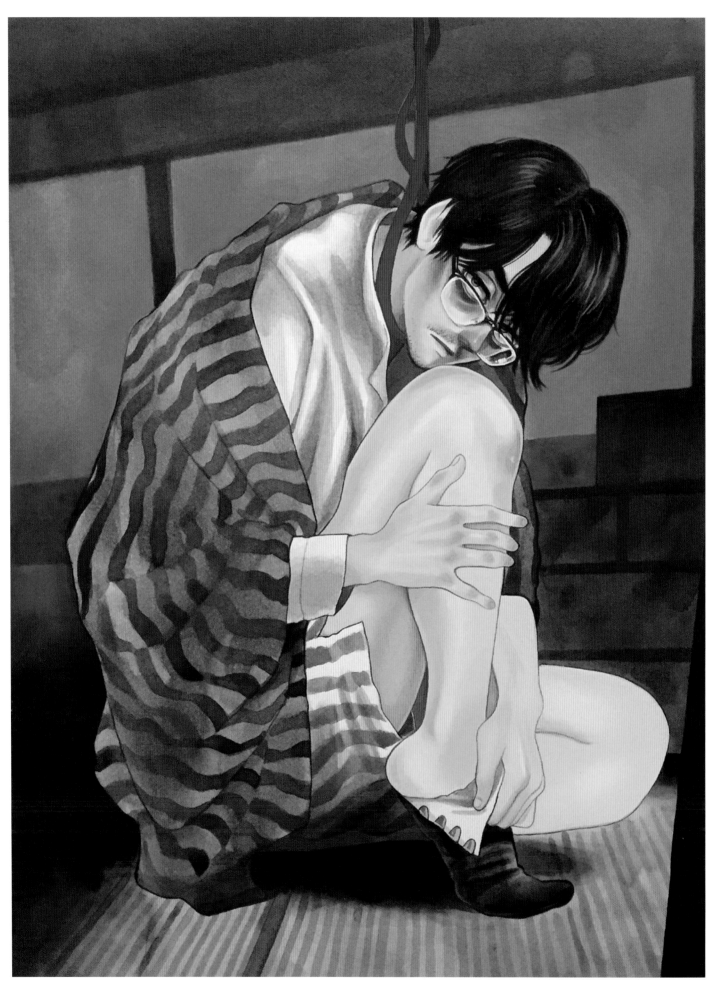

無題10 *Untitled 10*

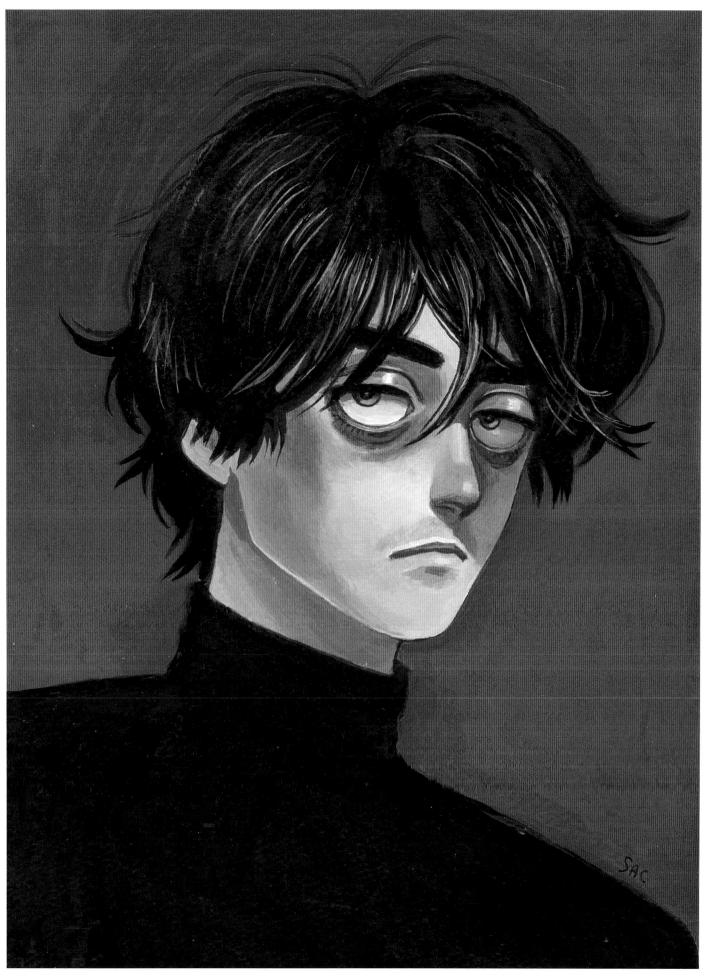

或る男

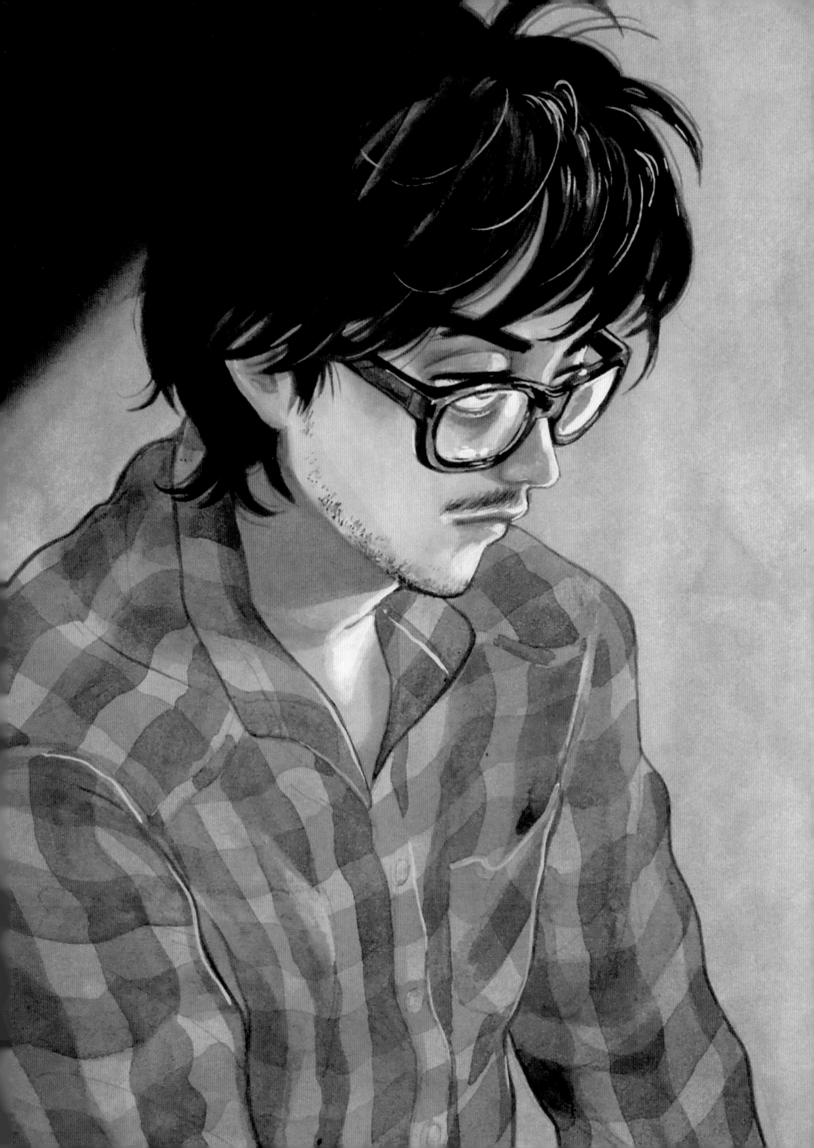

夏の幻影 *Phantom of Summer*

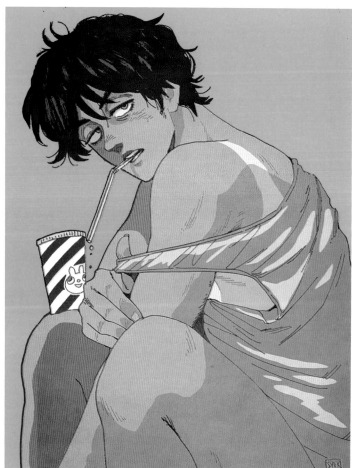

煙草を吸う男 *Wakaba*

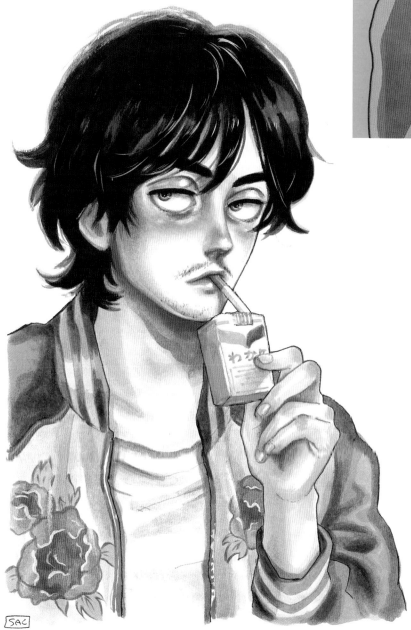

先延ばし症候群の男 *A Man With Procrastination Syndrome*

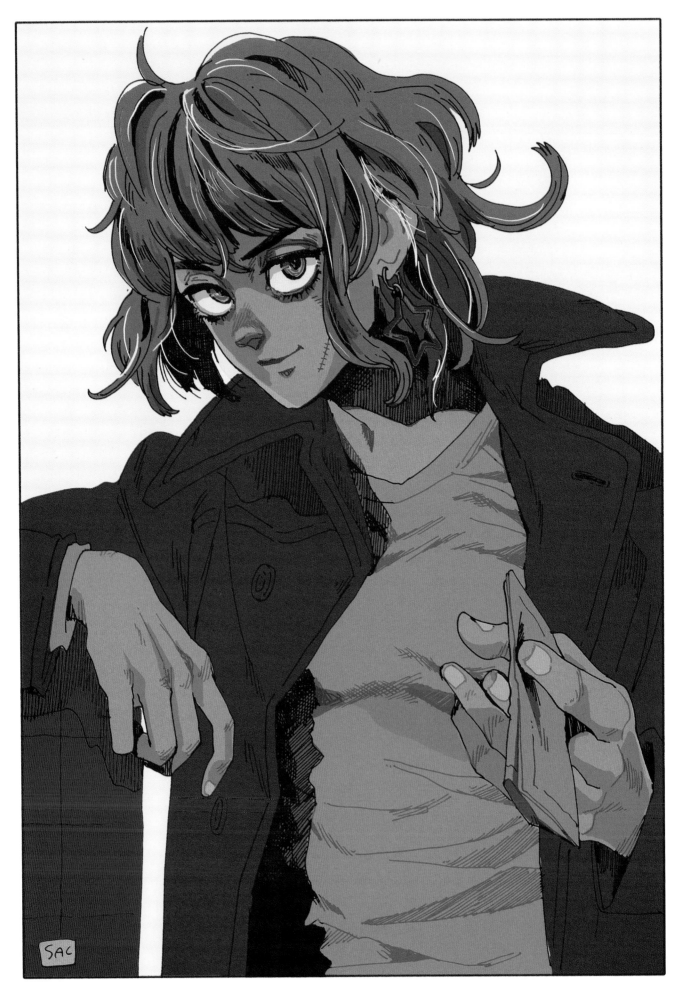

買い手 Buyer

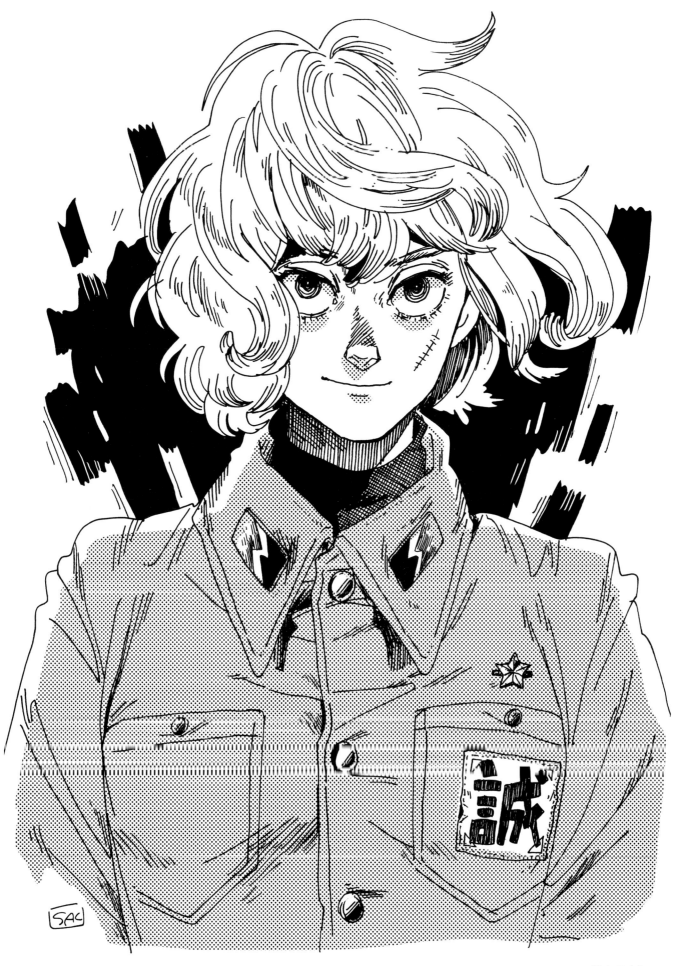

軍人 *Soldier*

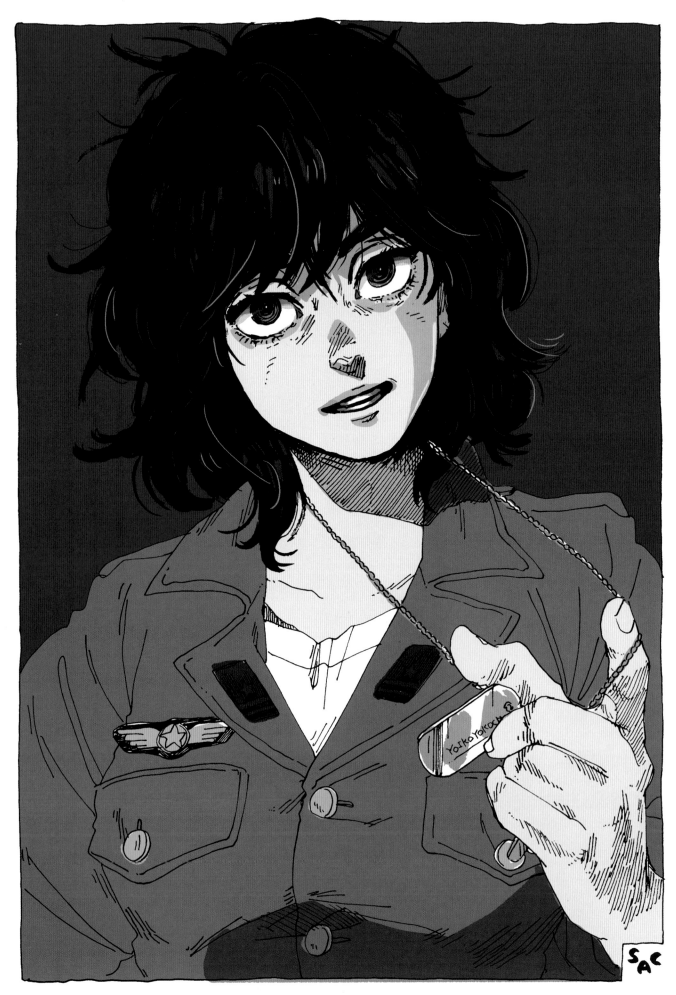

兵士 A Soldier

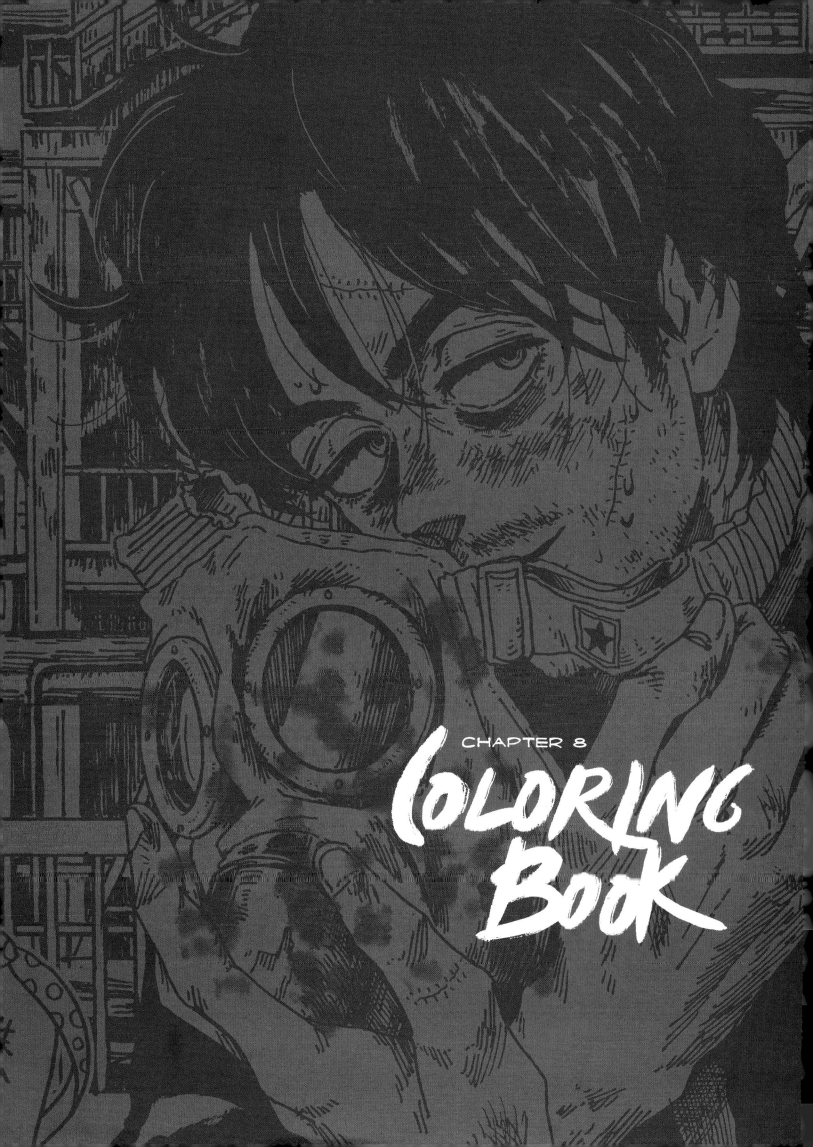

CHAPTER 8

COLORING BOOK

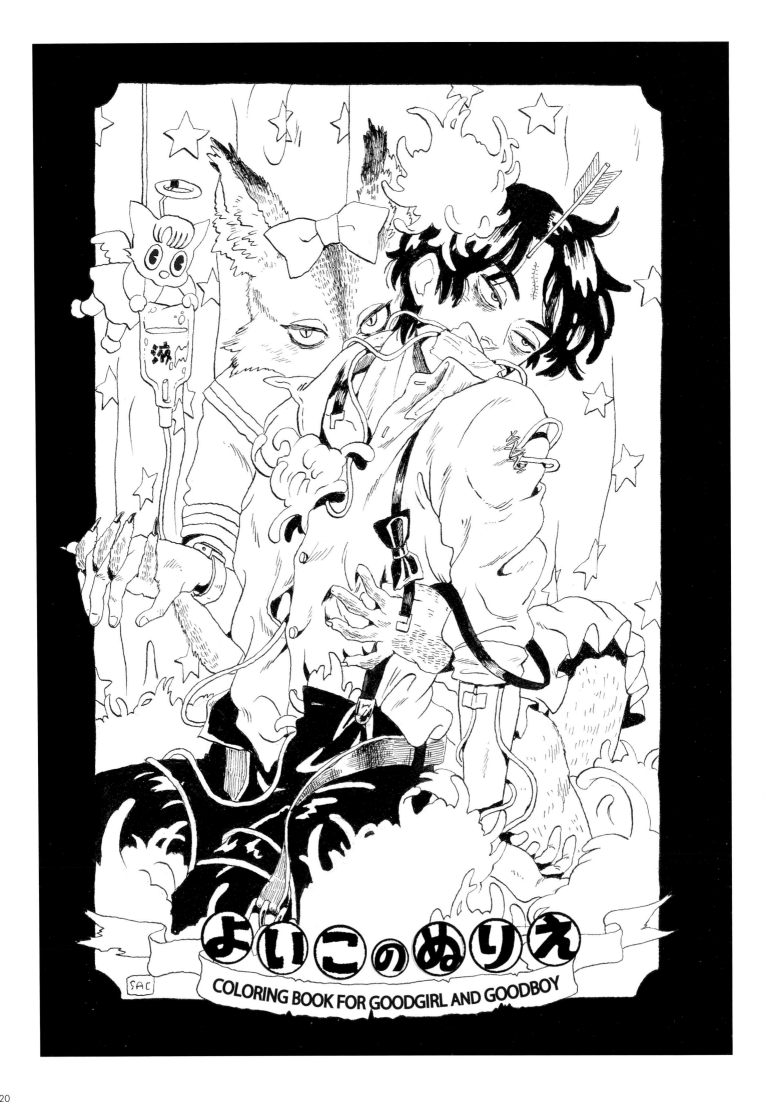

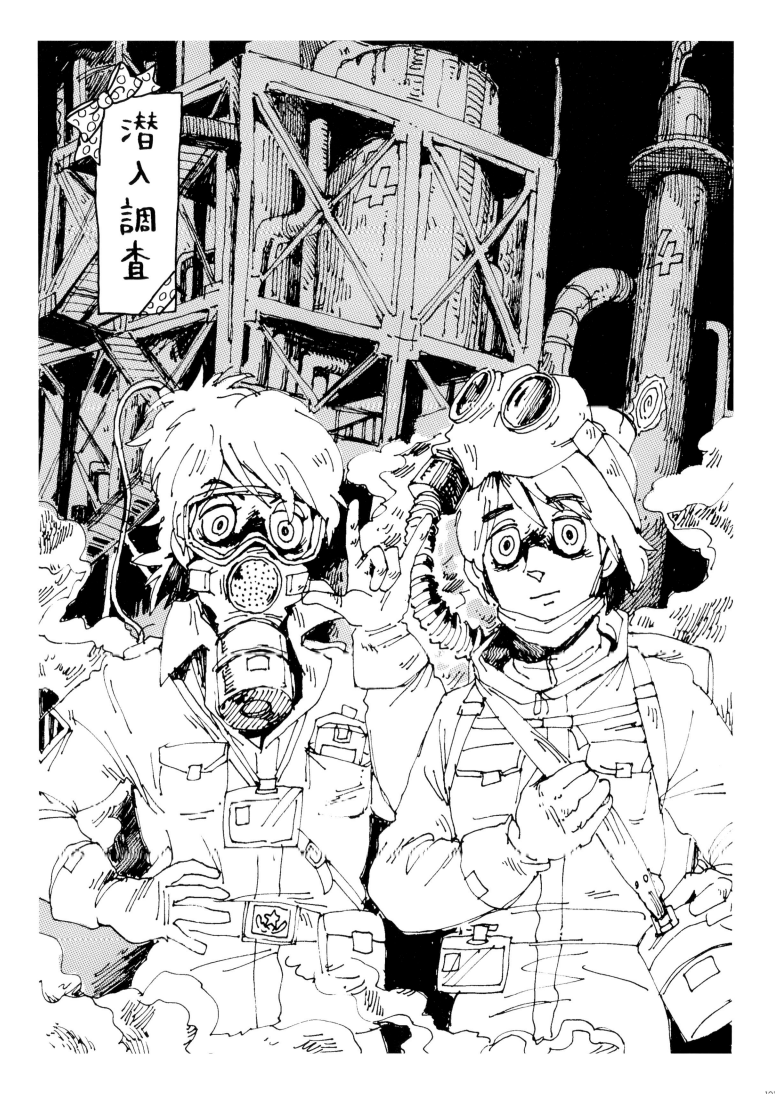

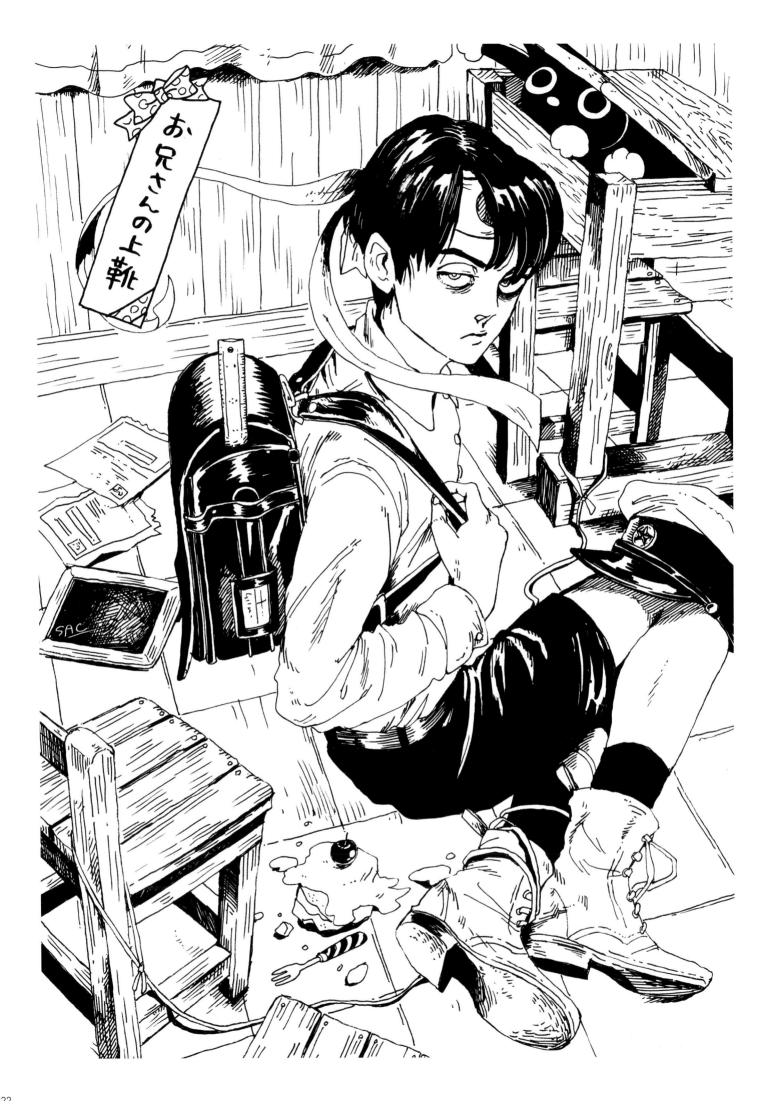

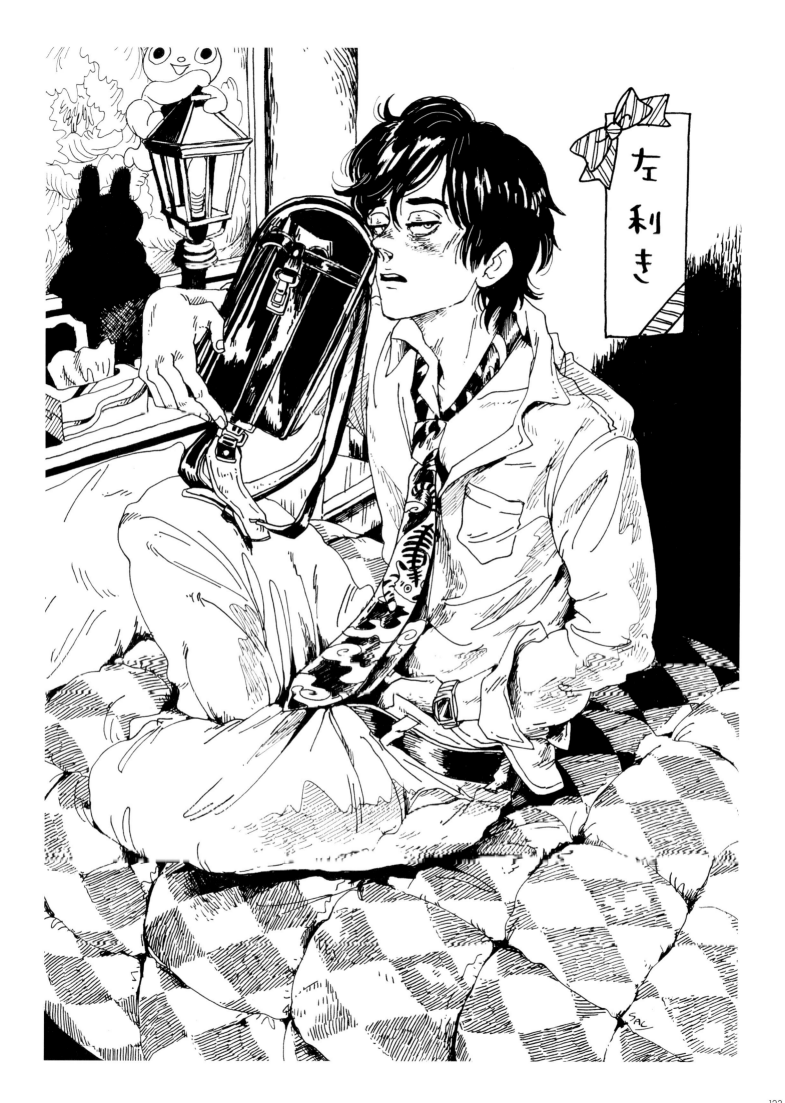

左利き

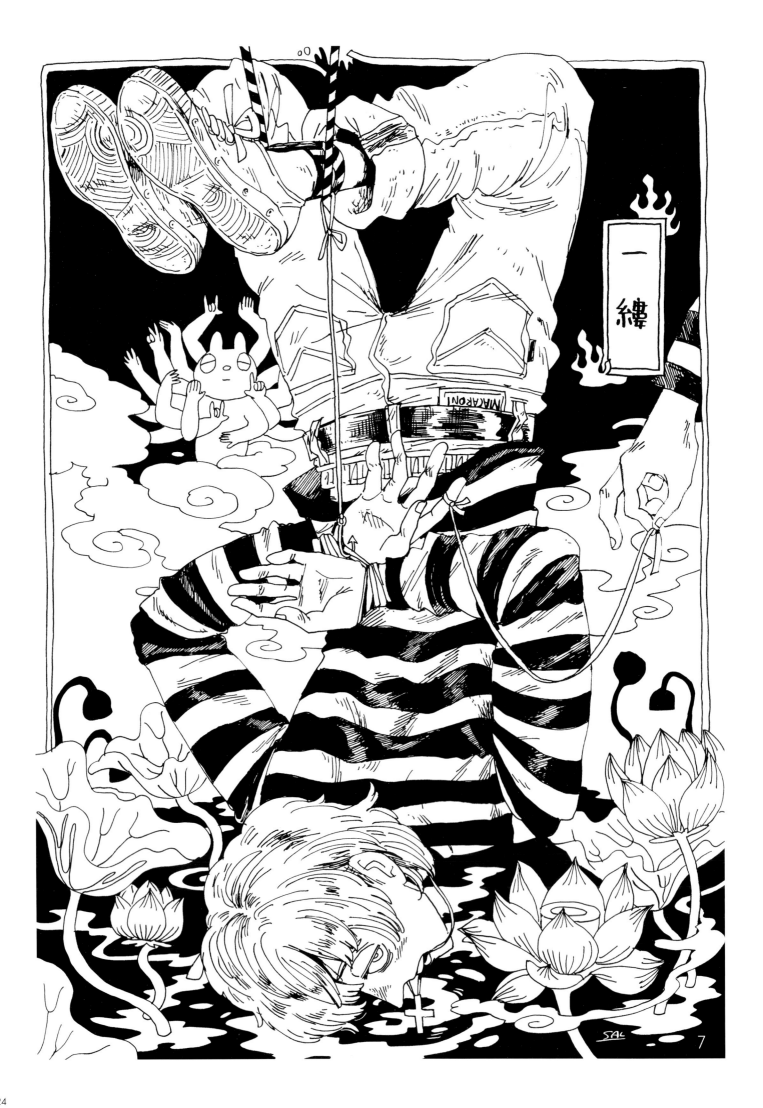

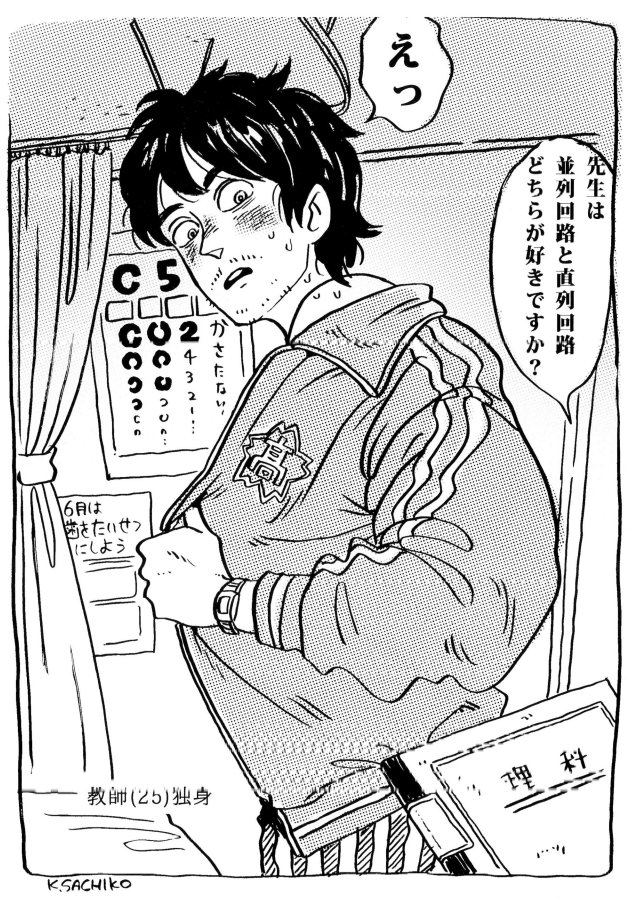

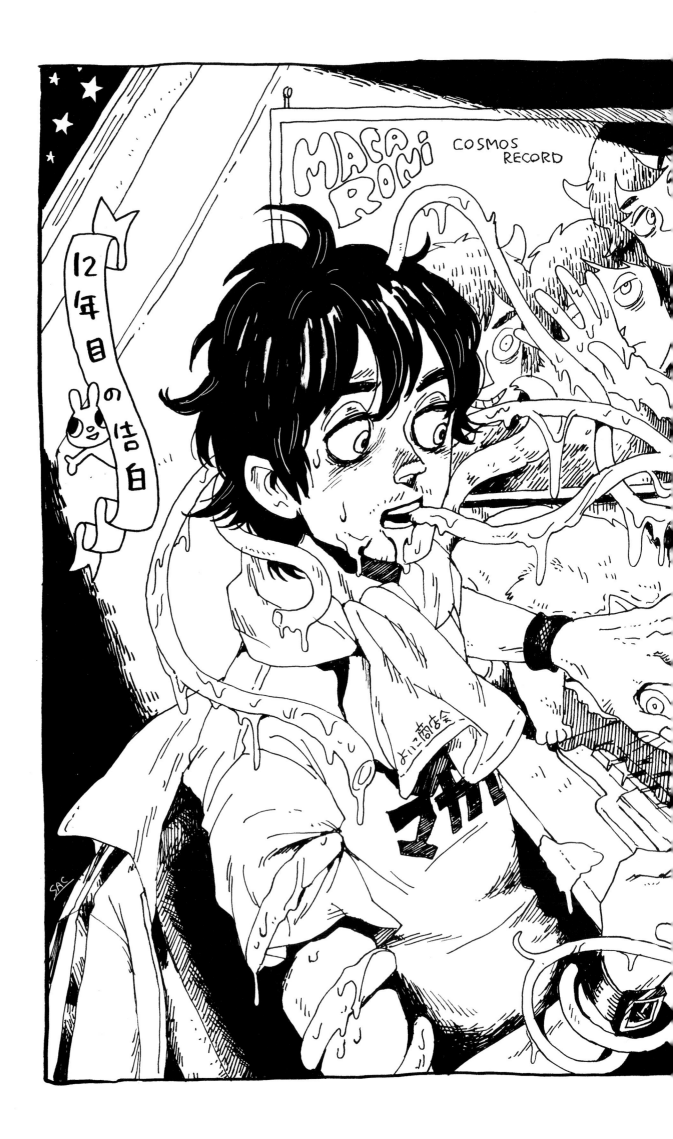

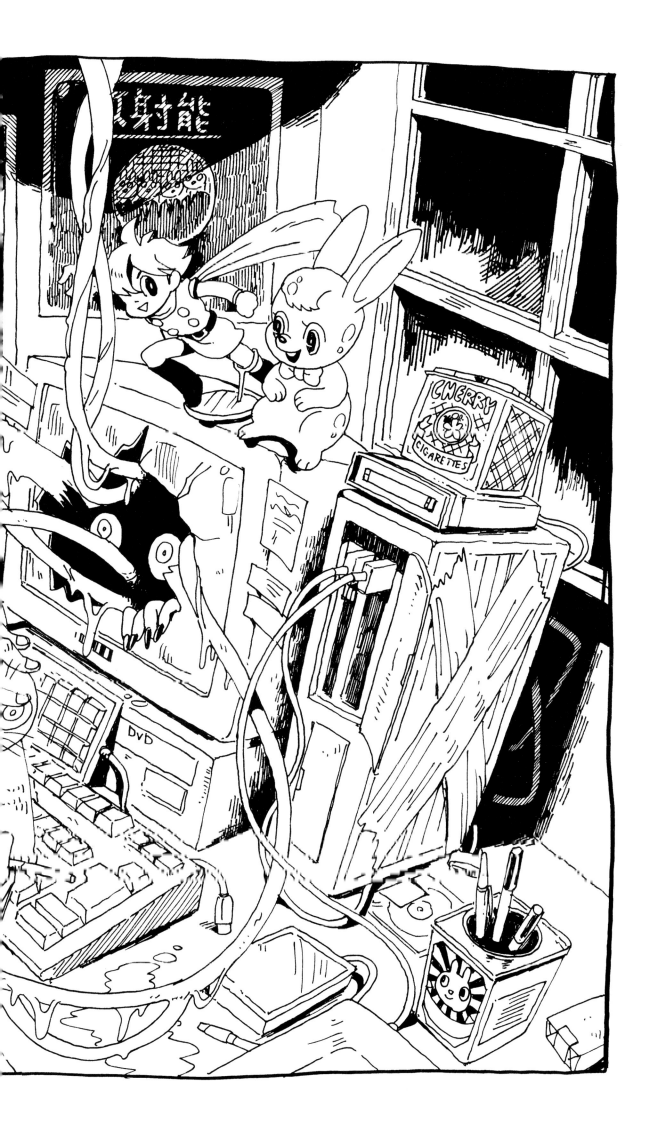

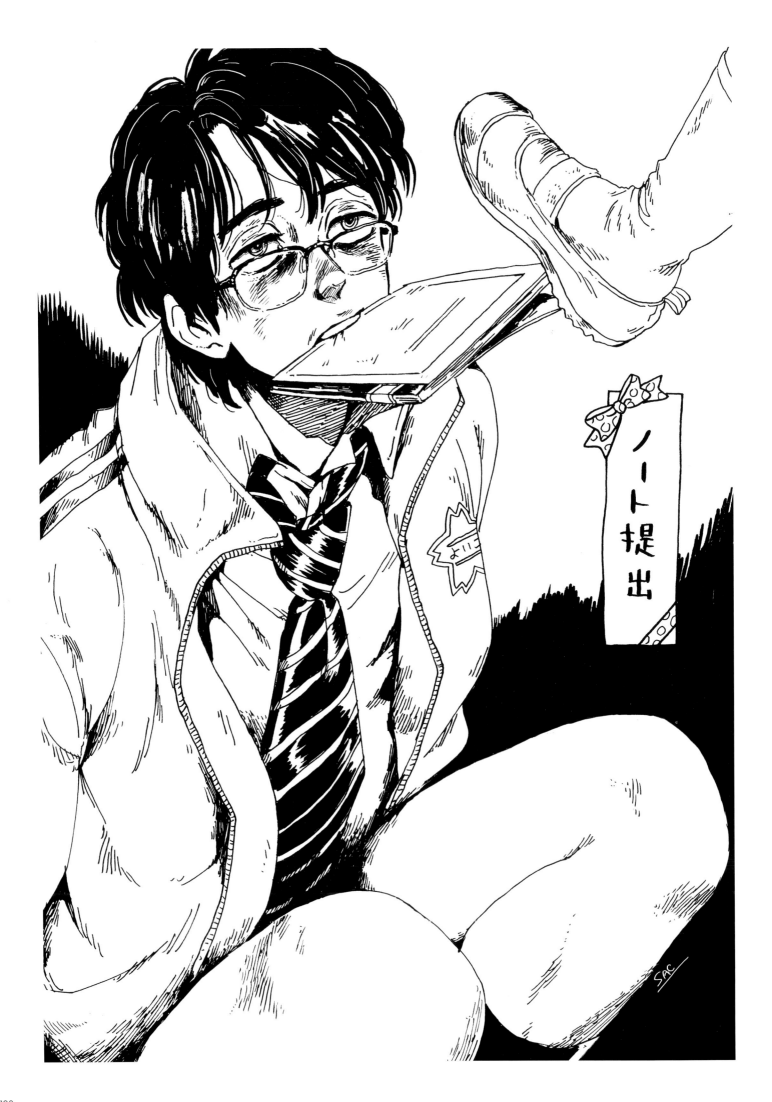

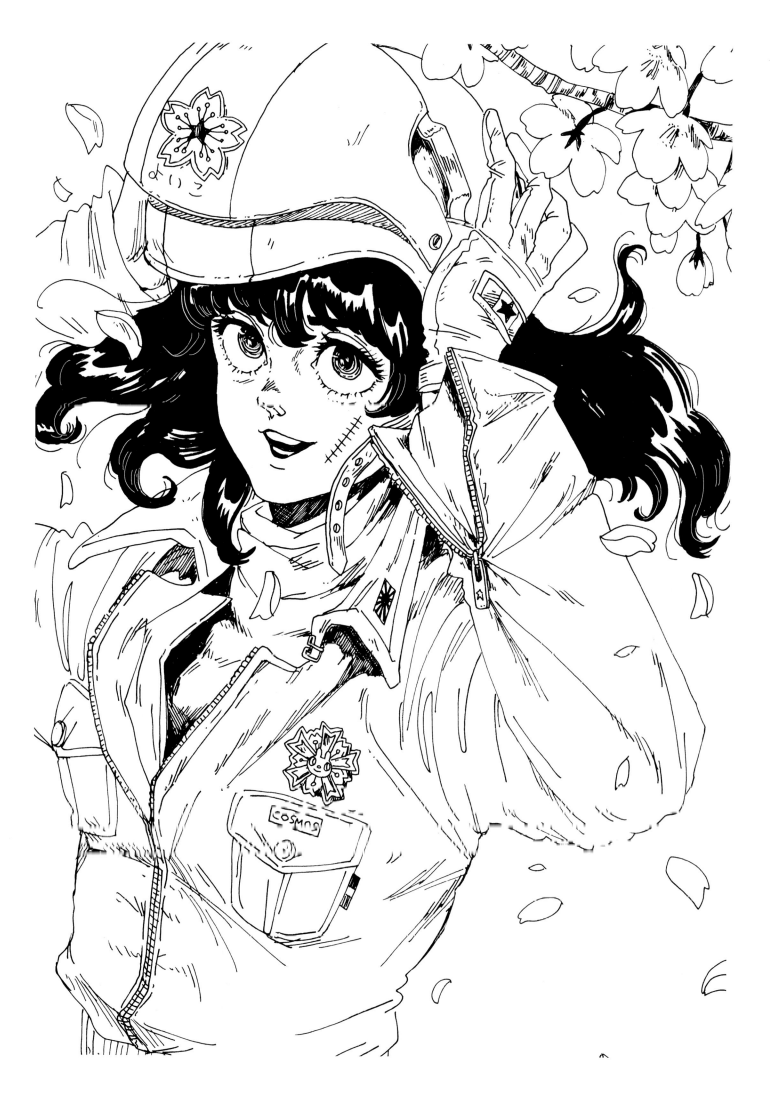

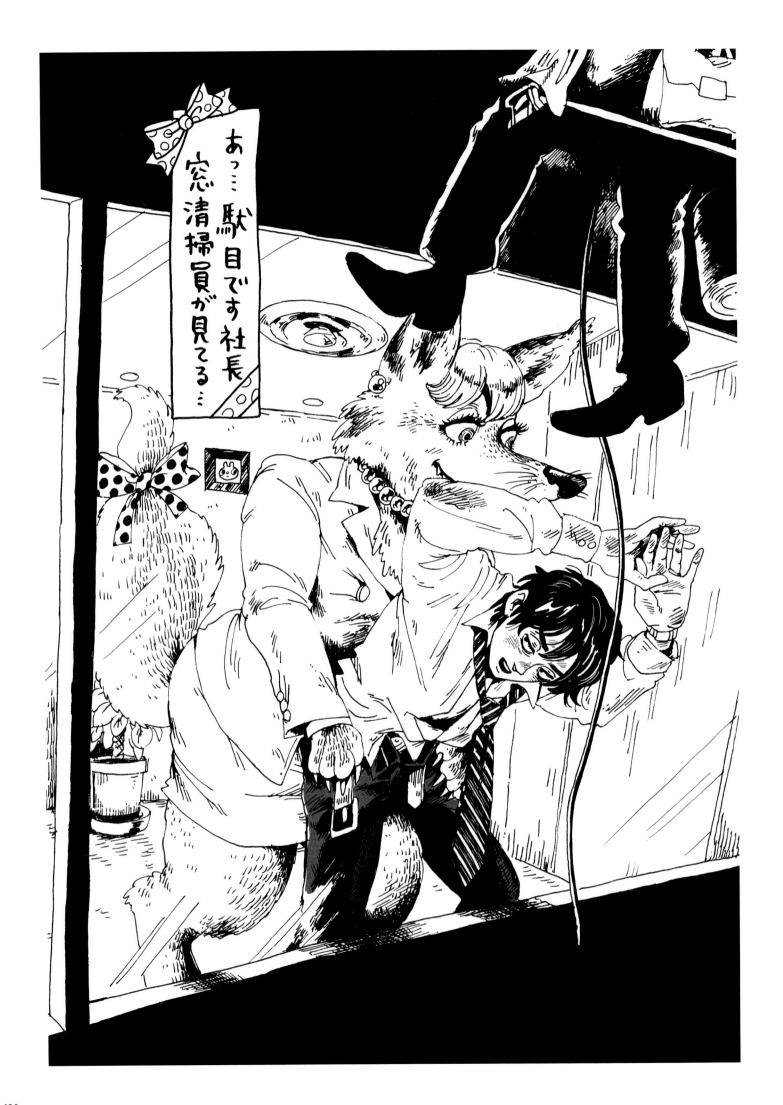

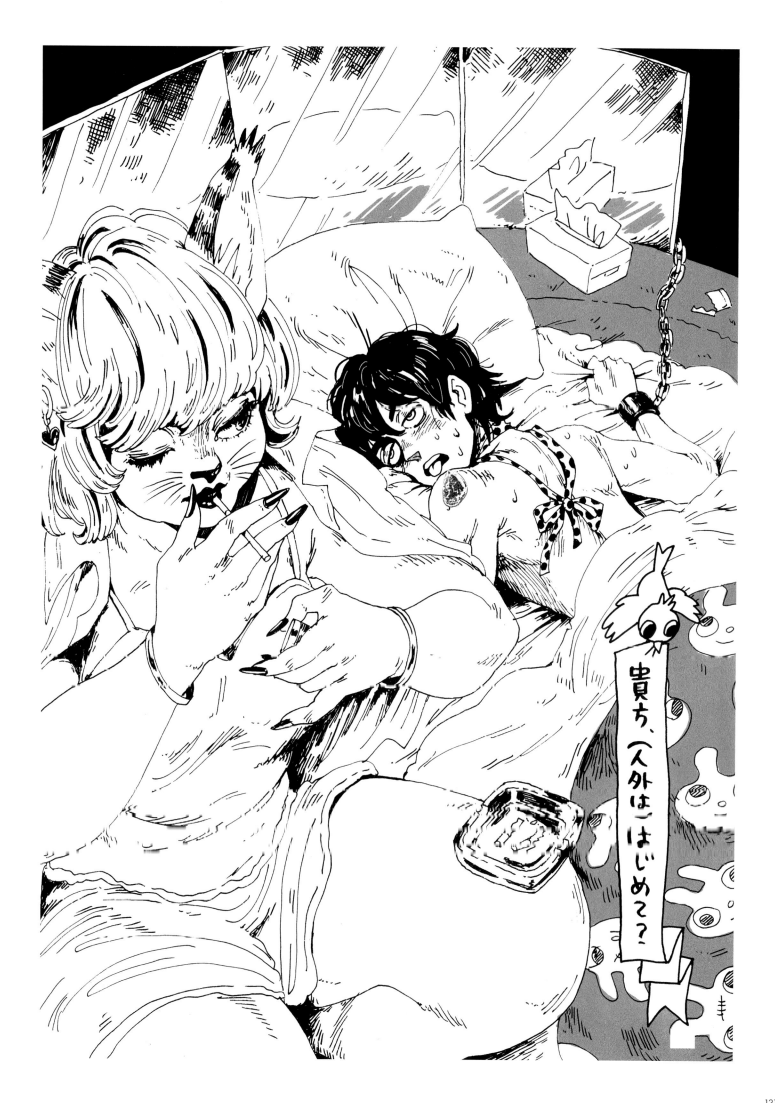

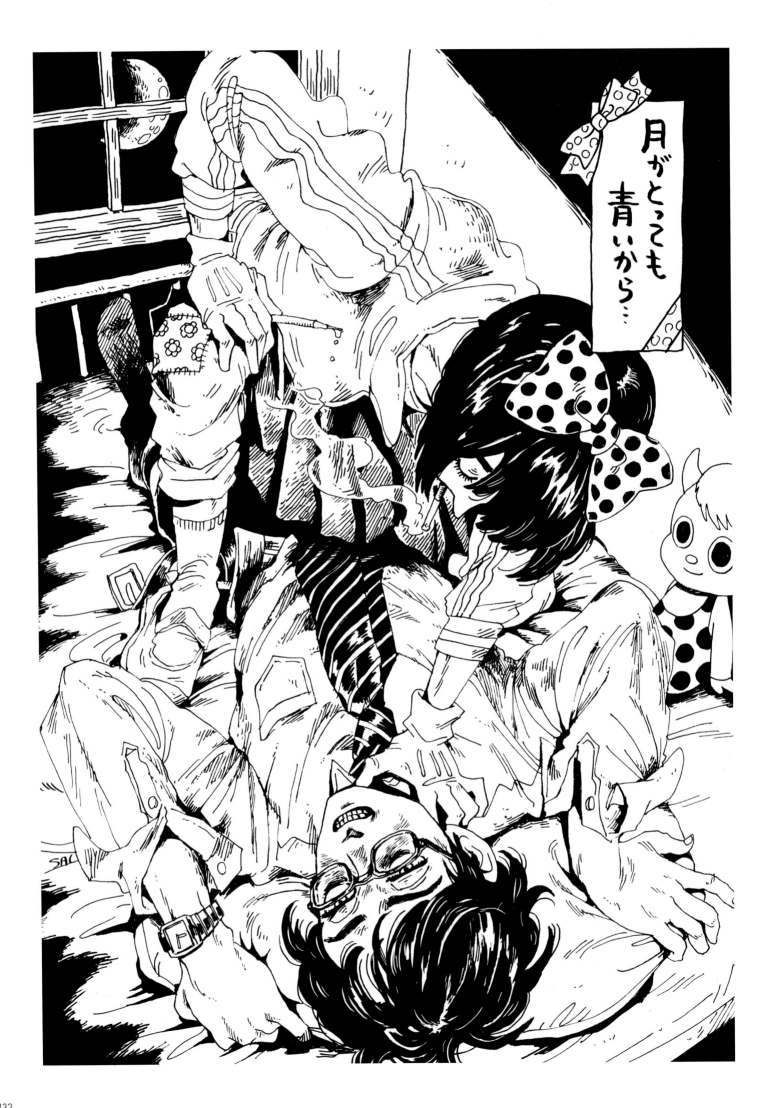

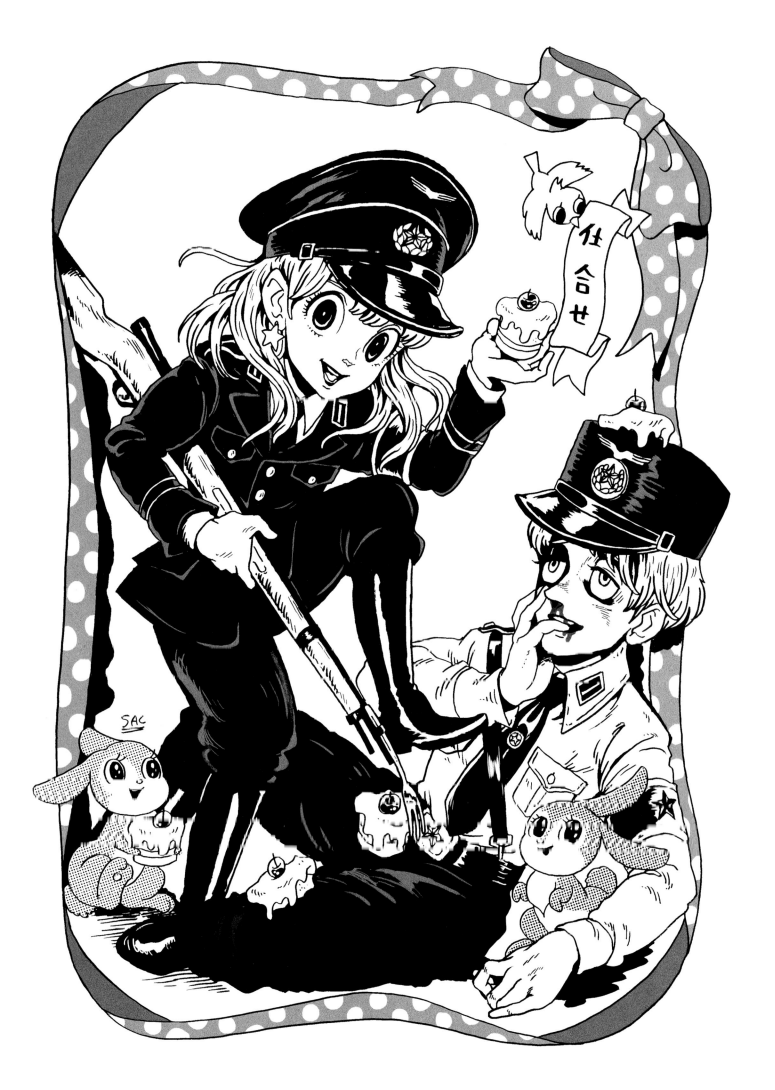

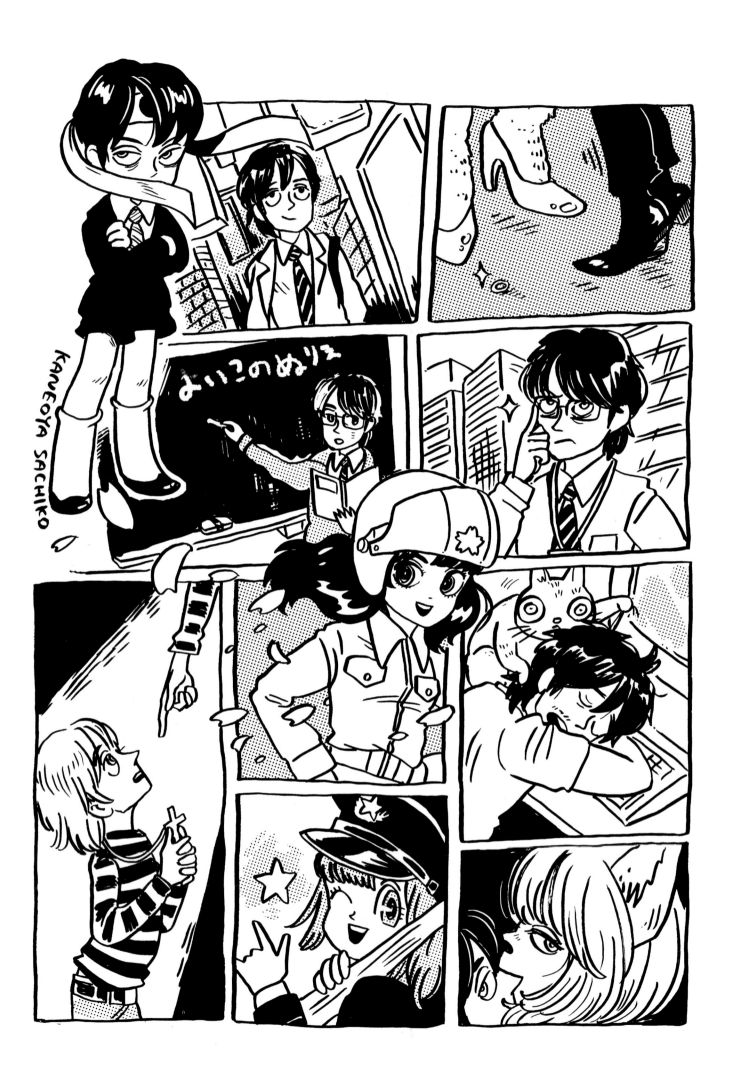

KANEOYA SACHIKO

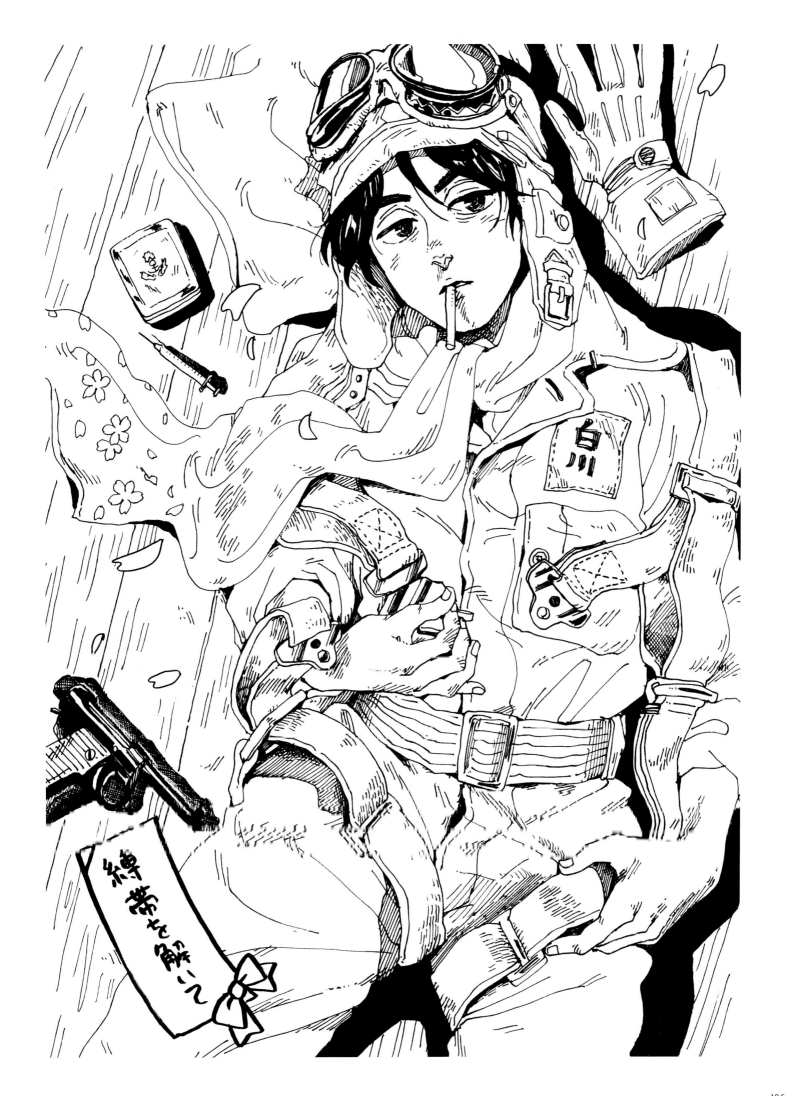

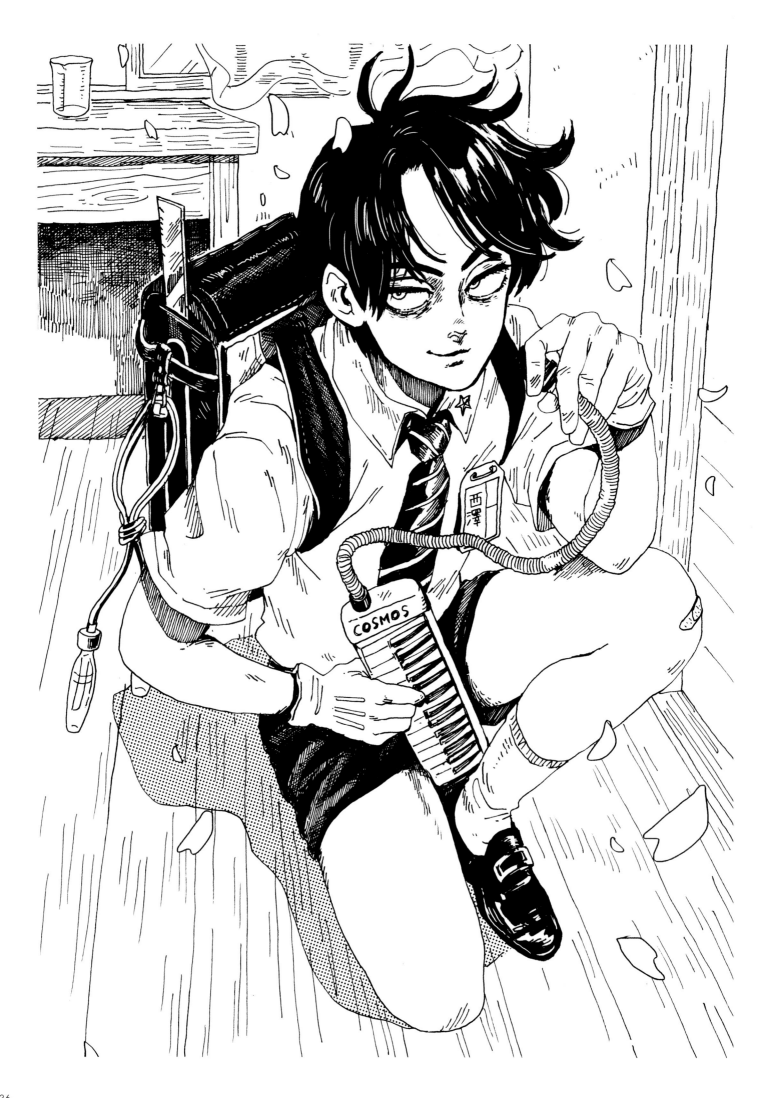

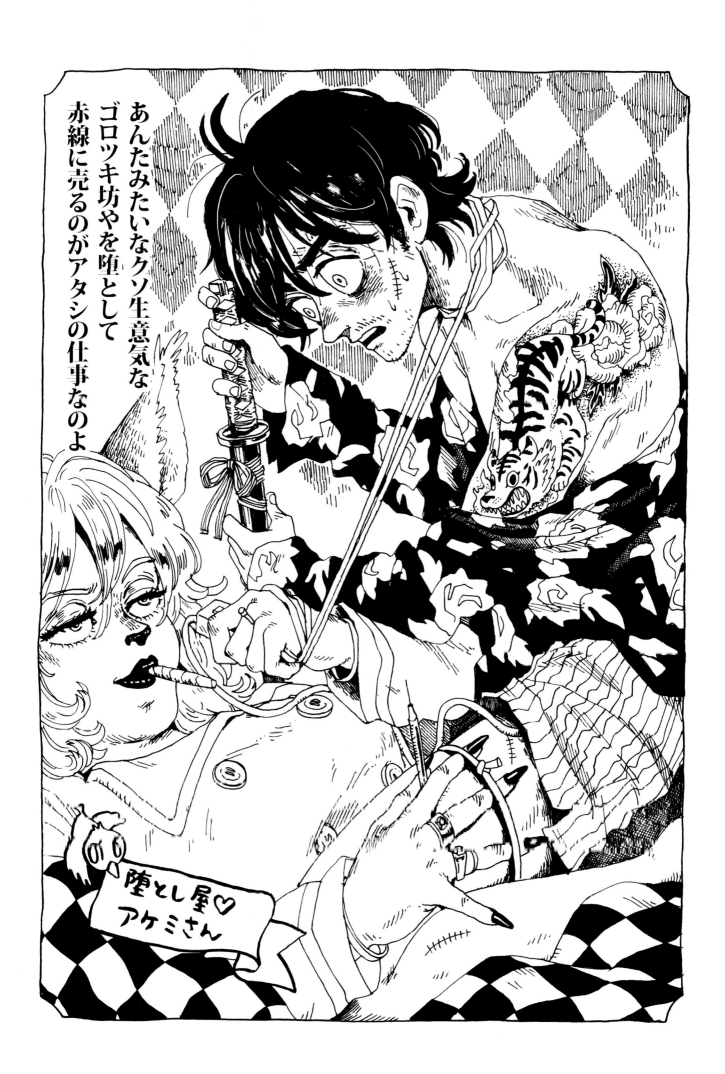

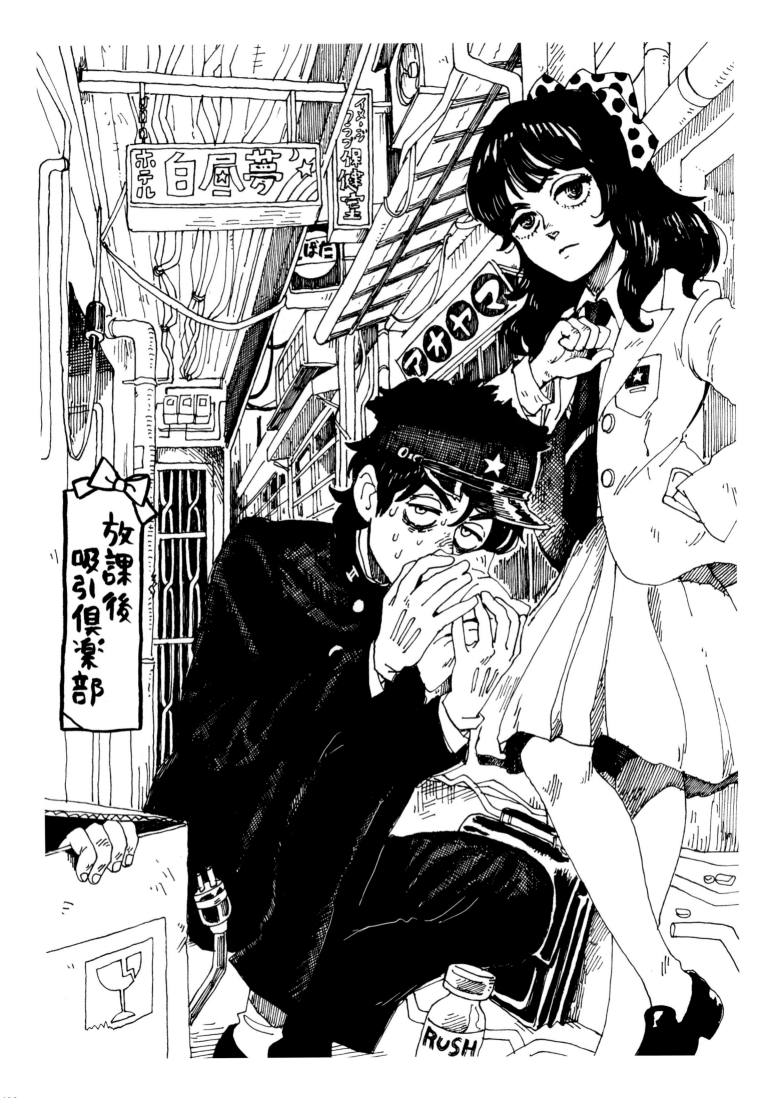

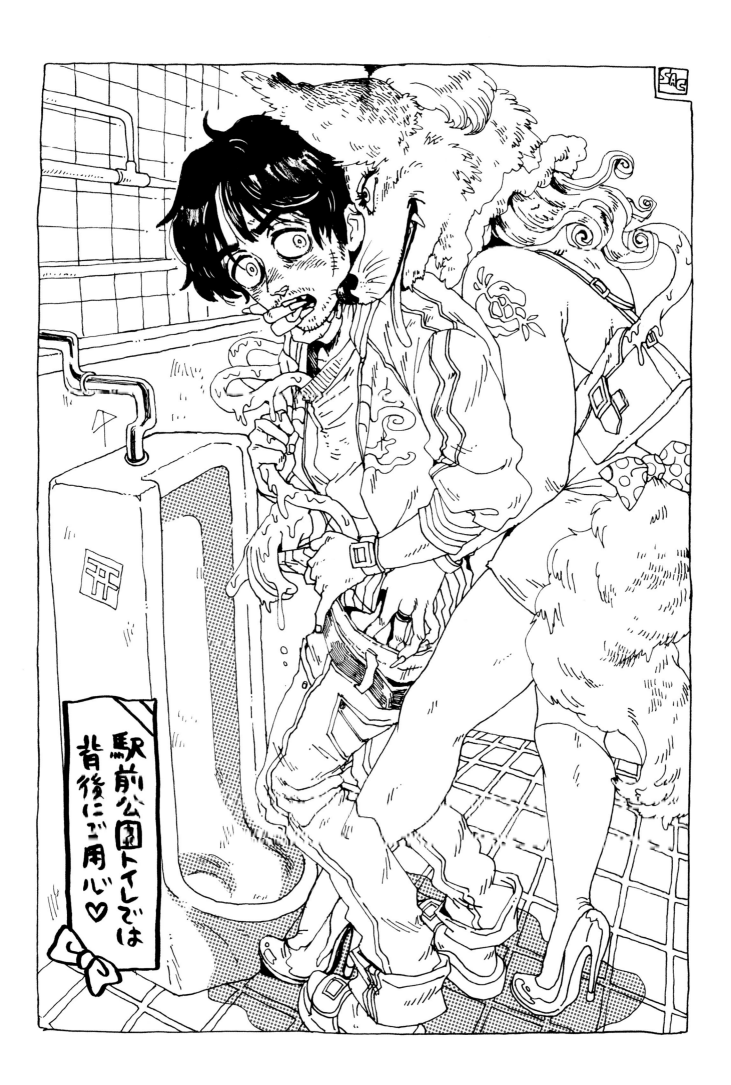

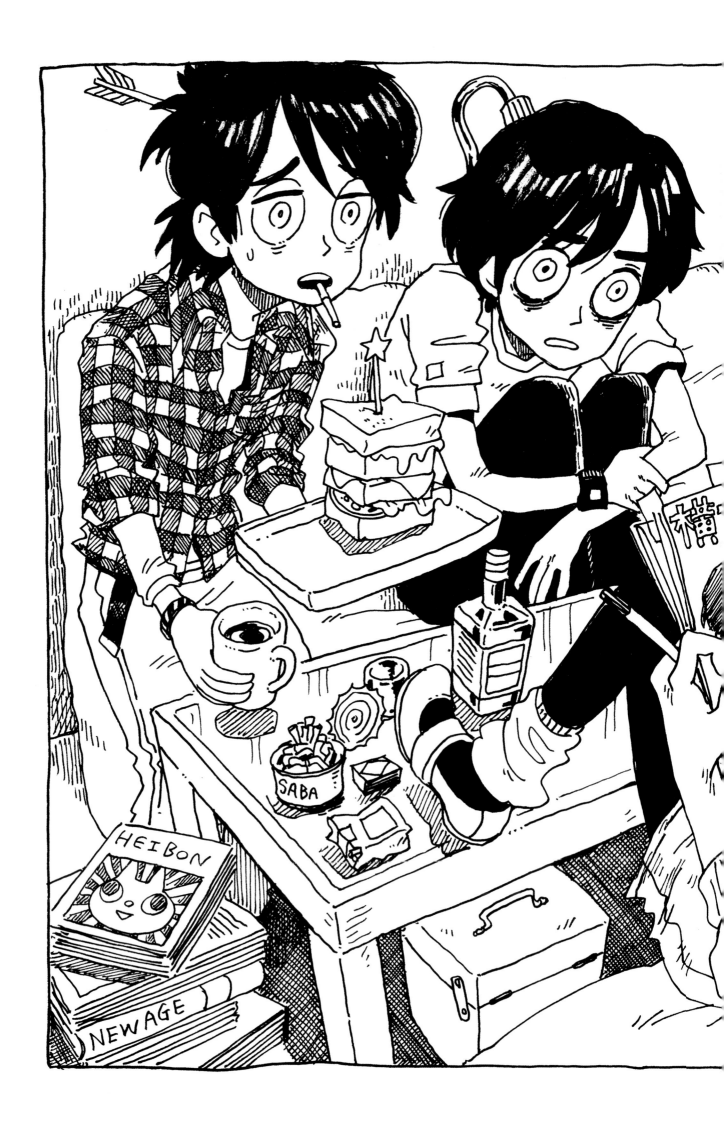

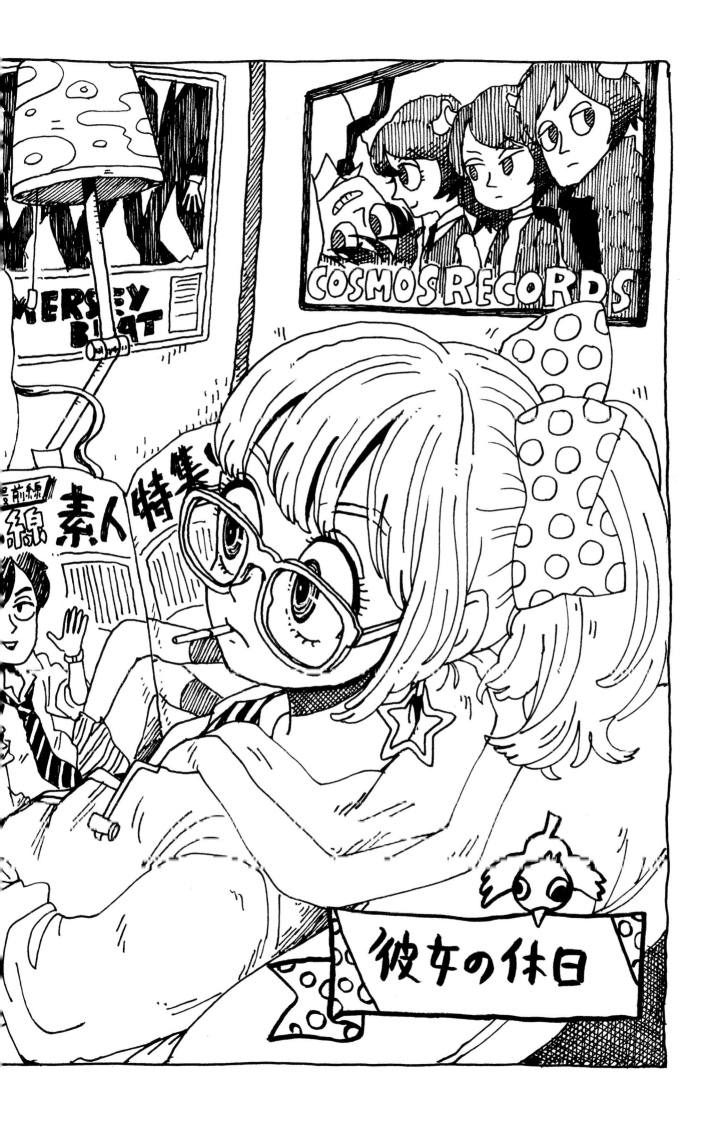

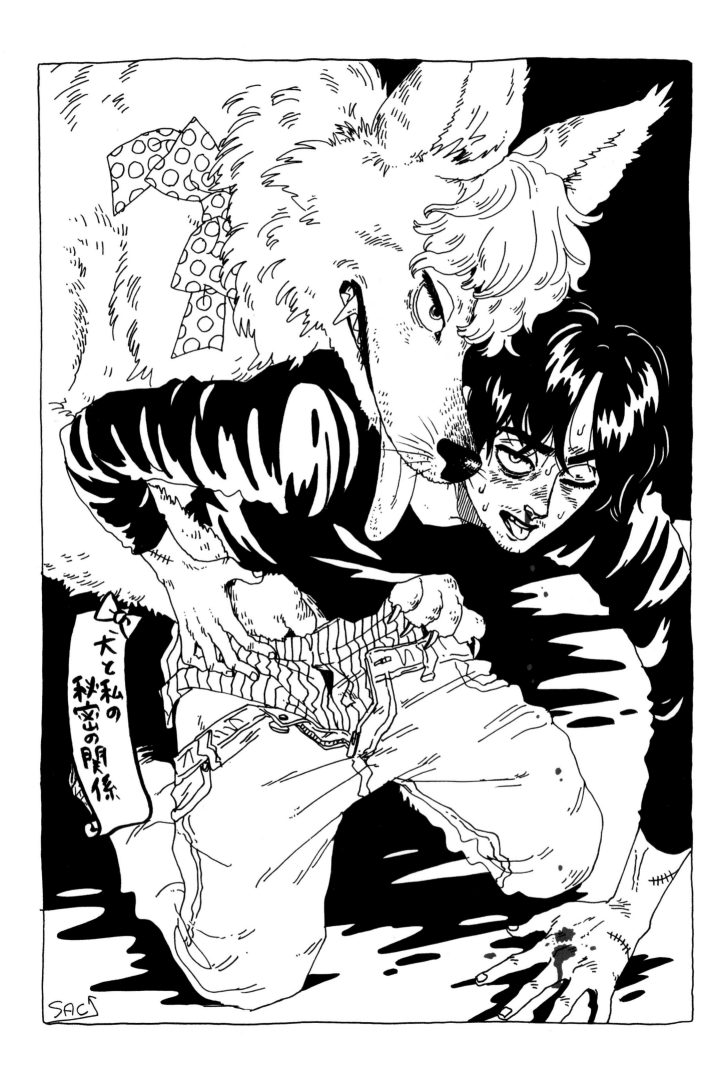

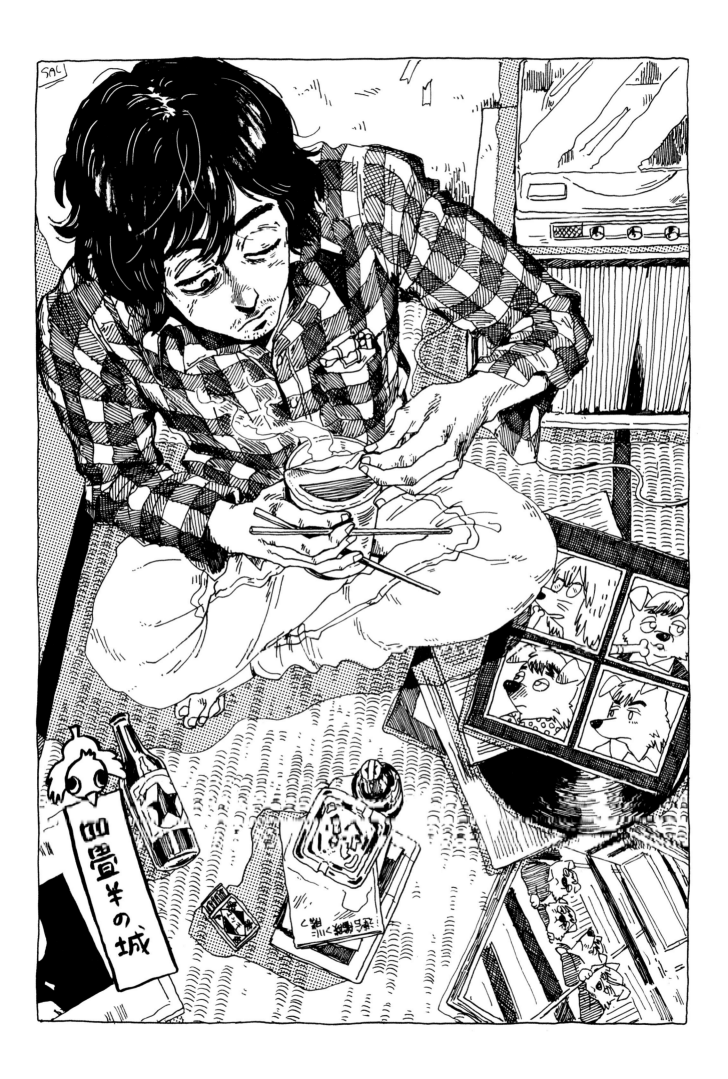

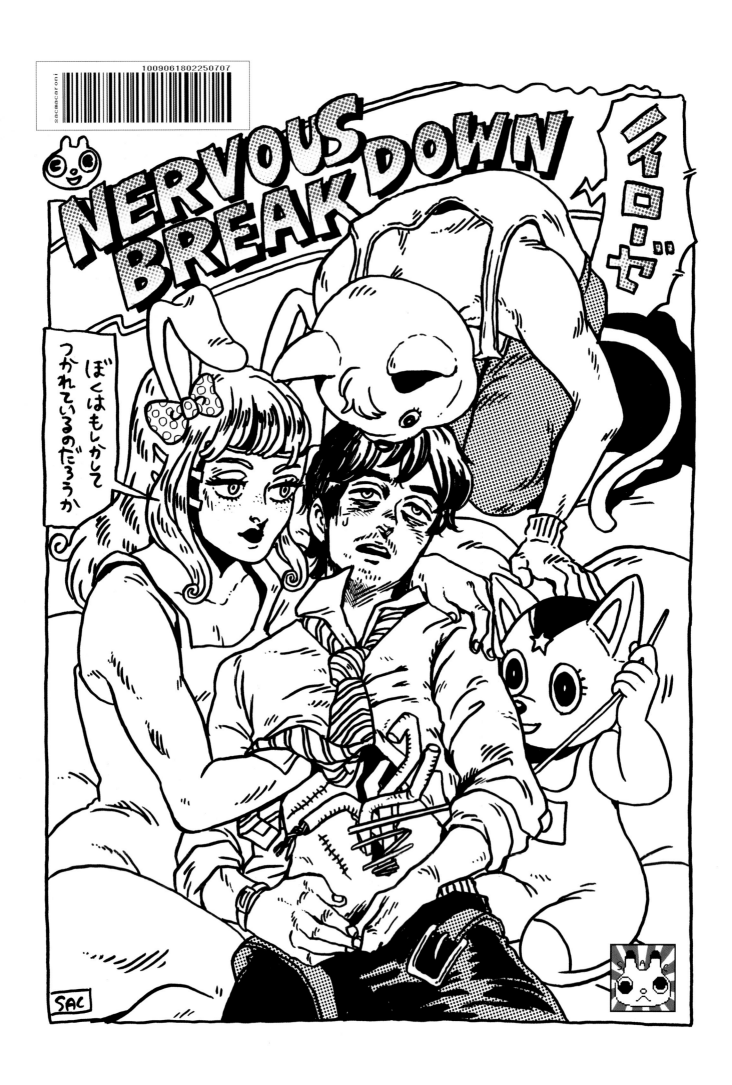

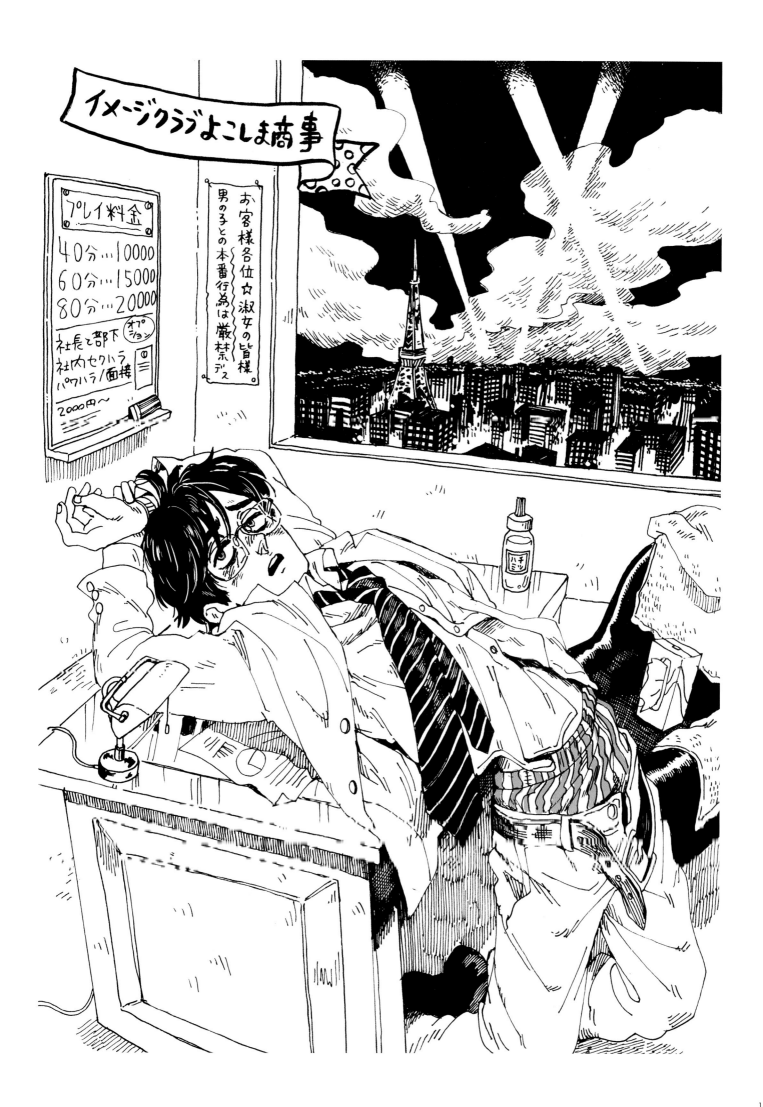

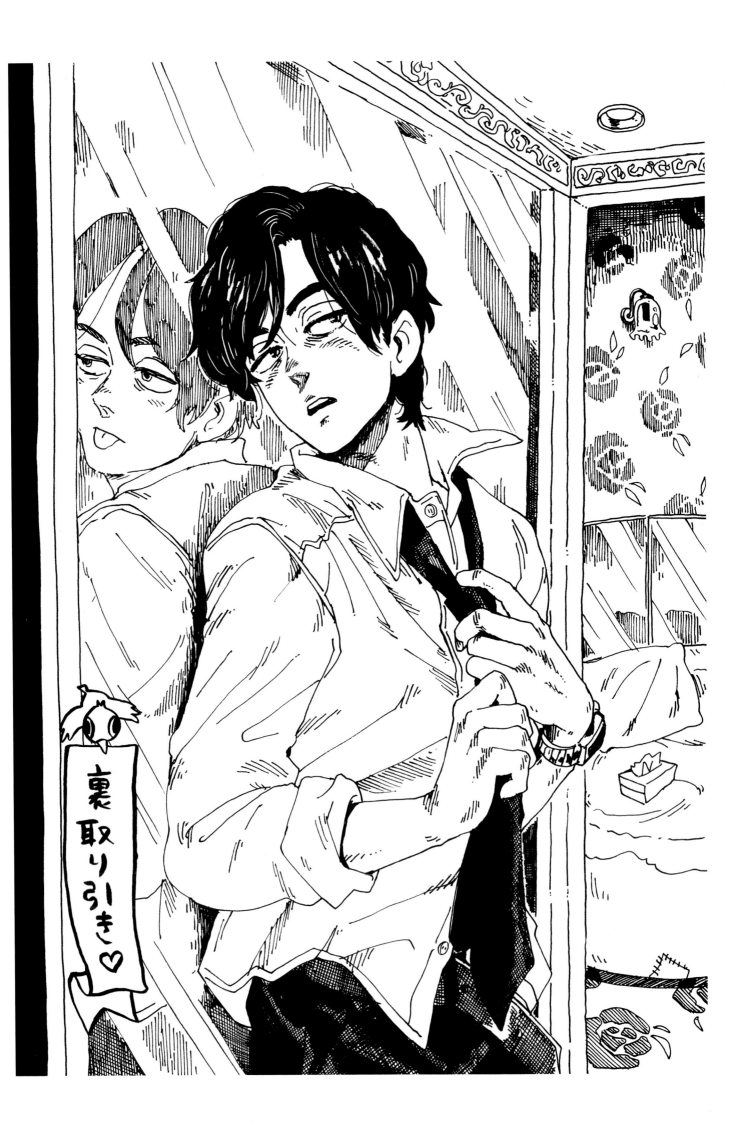

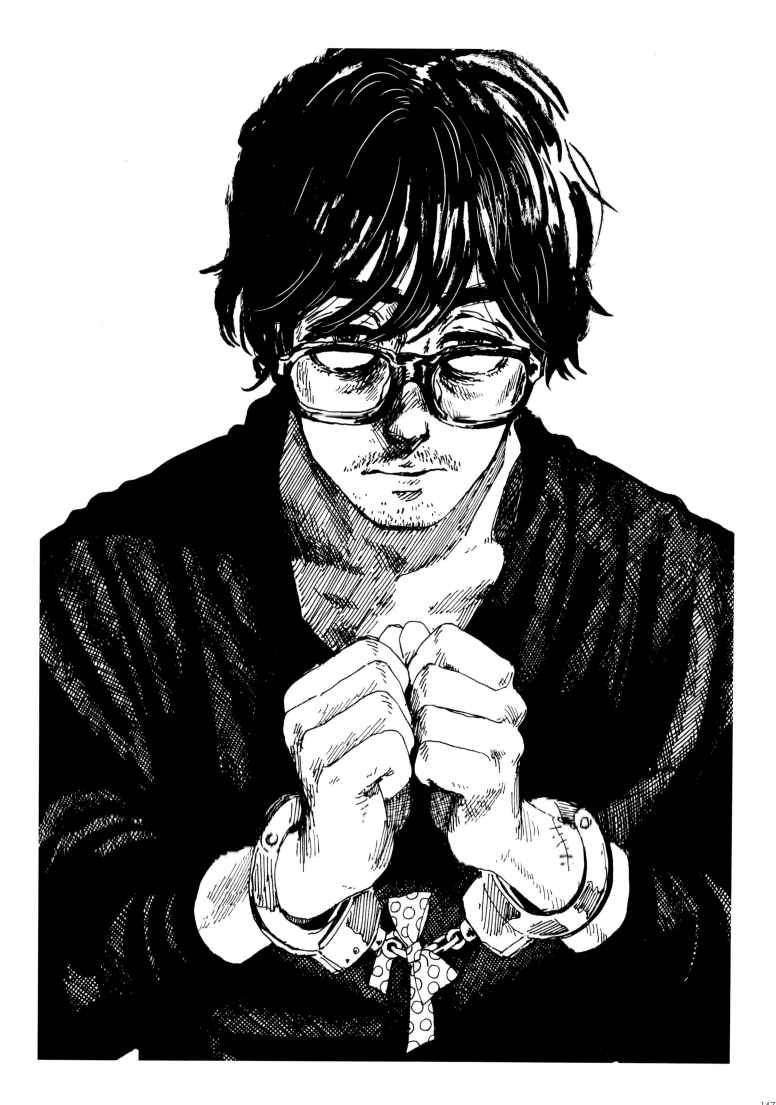

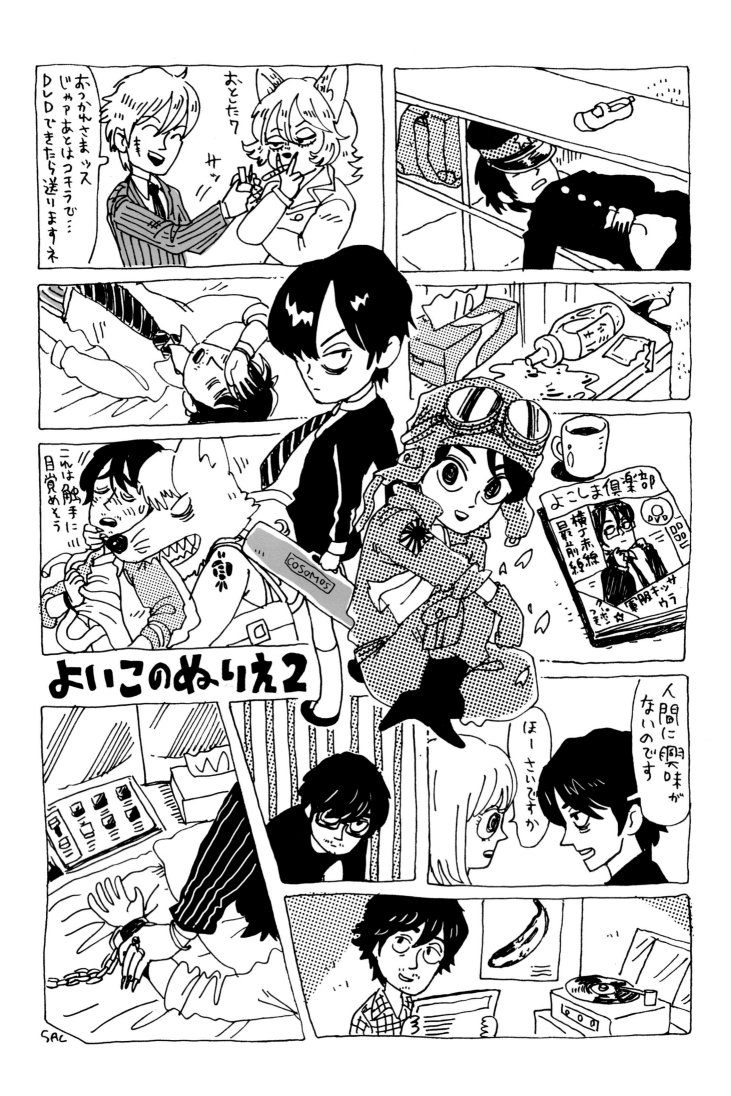

よいこのぬりえ2

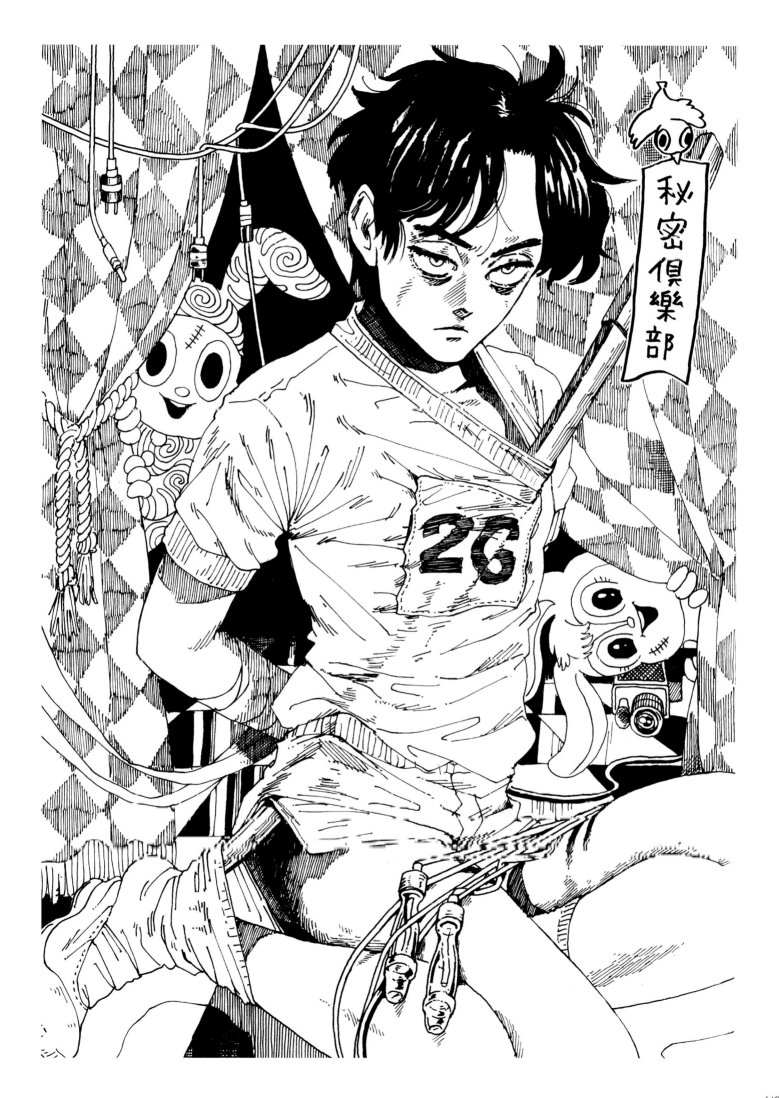

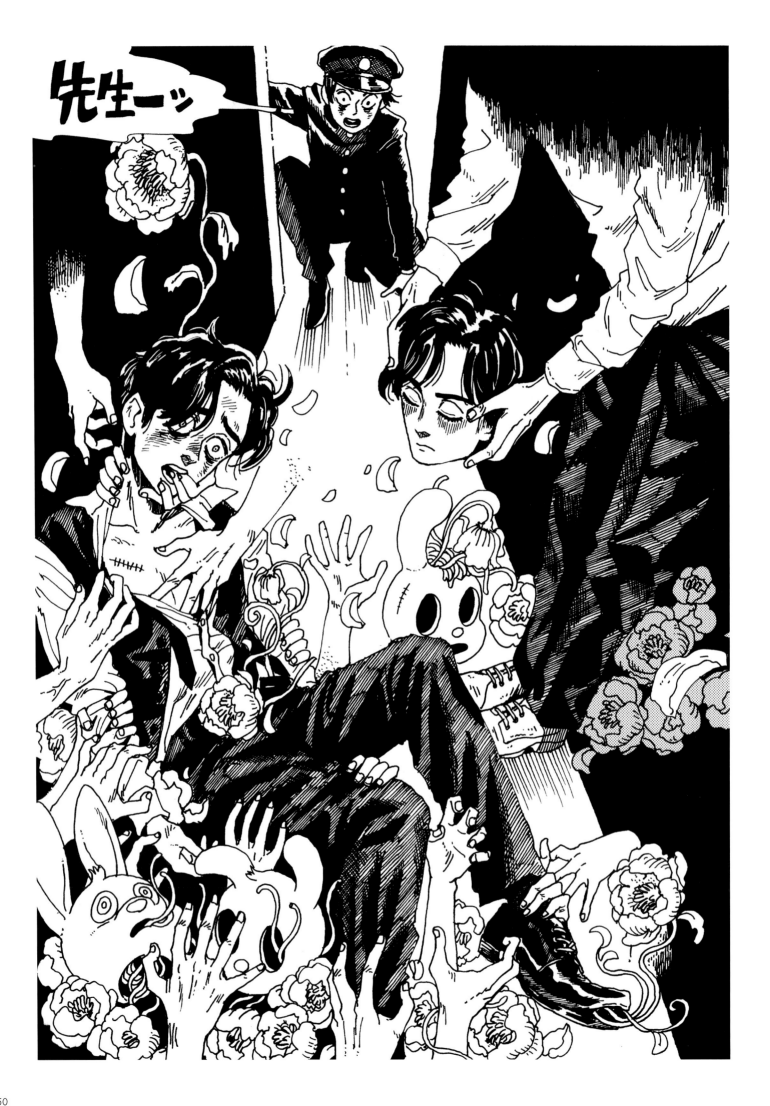

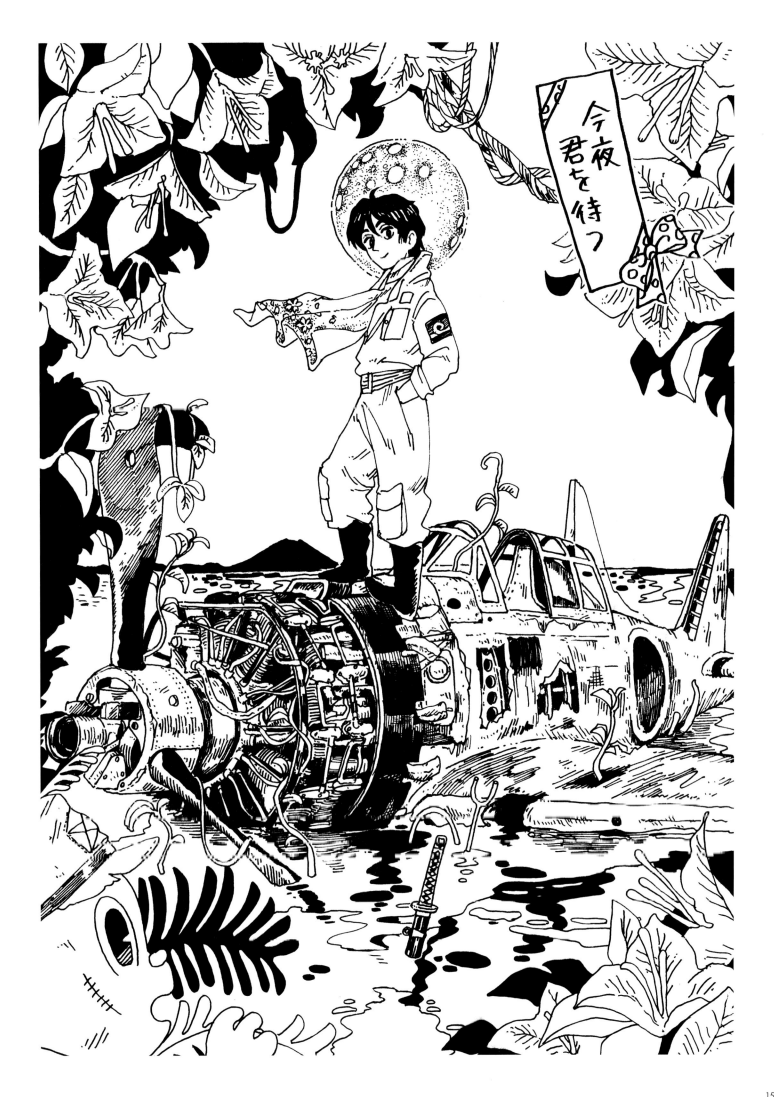

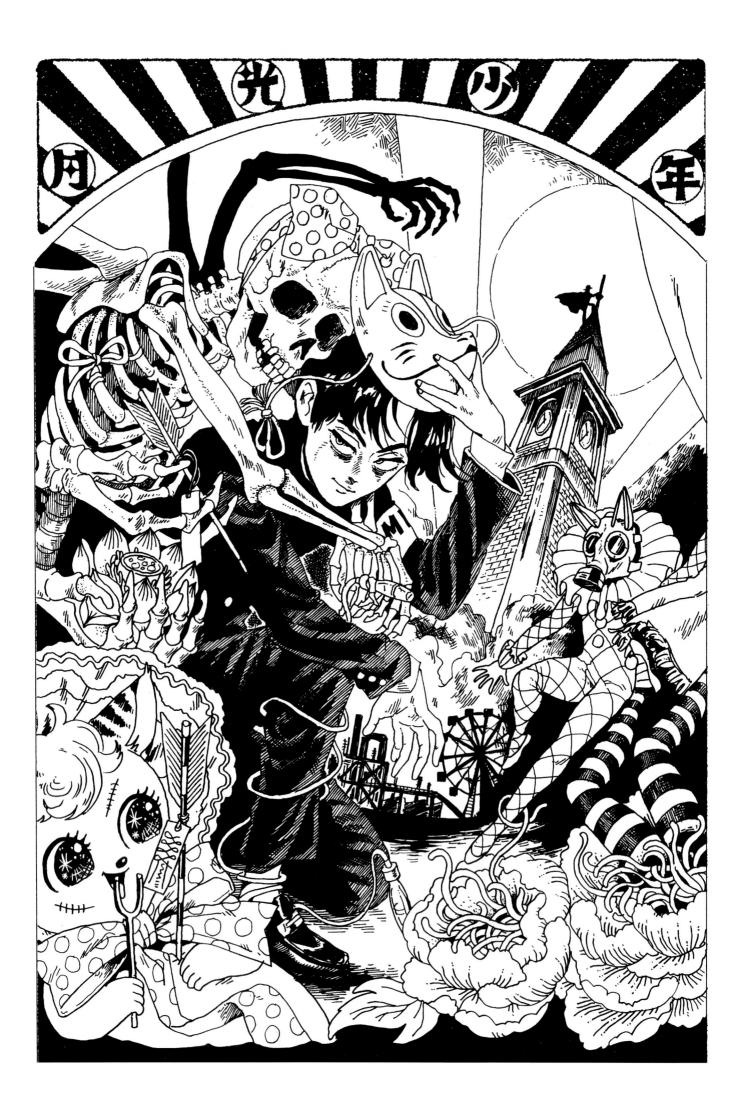

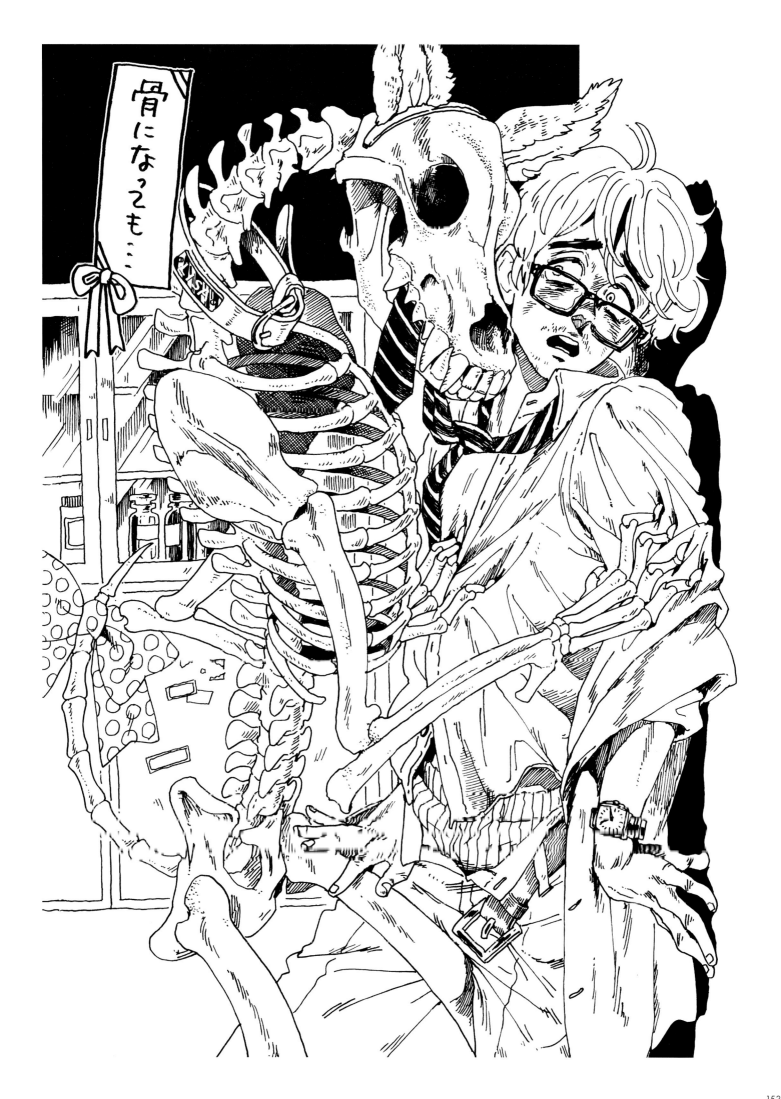

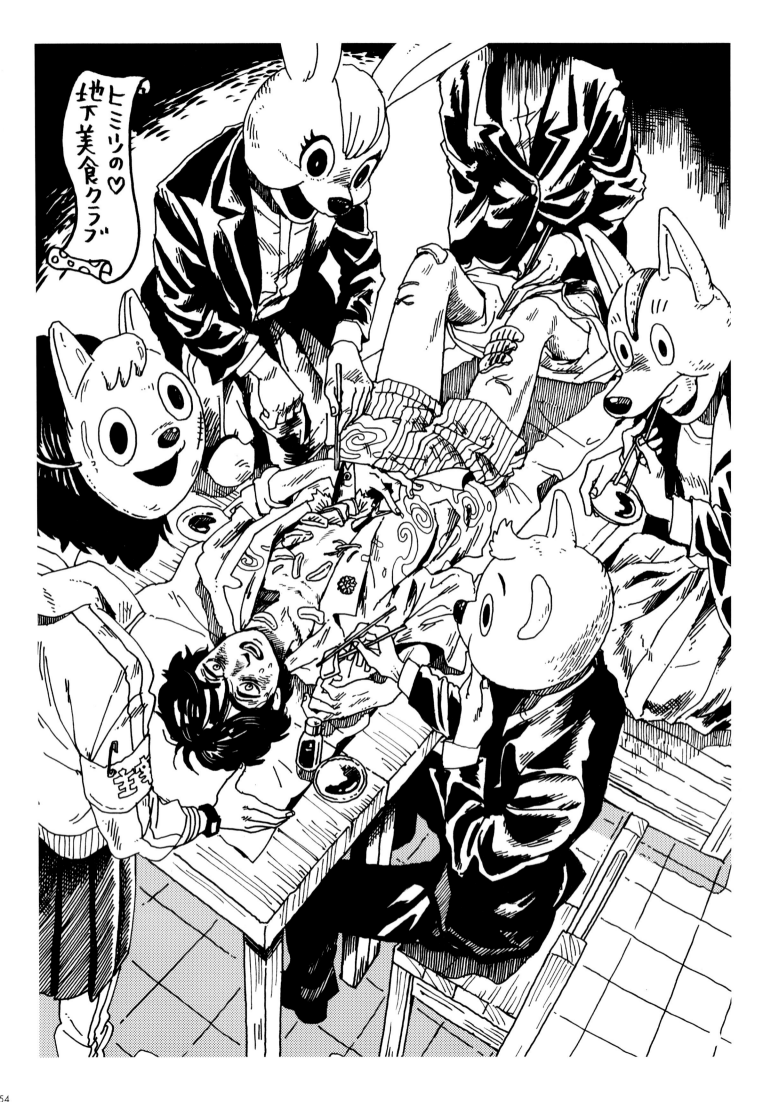

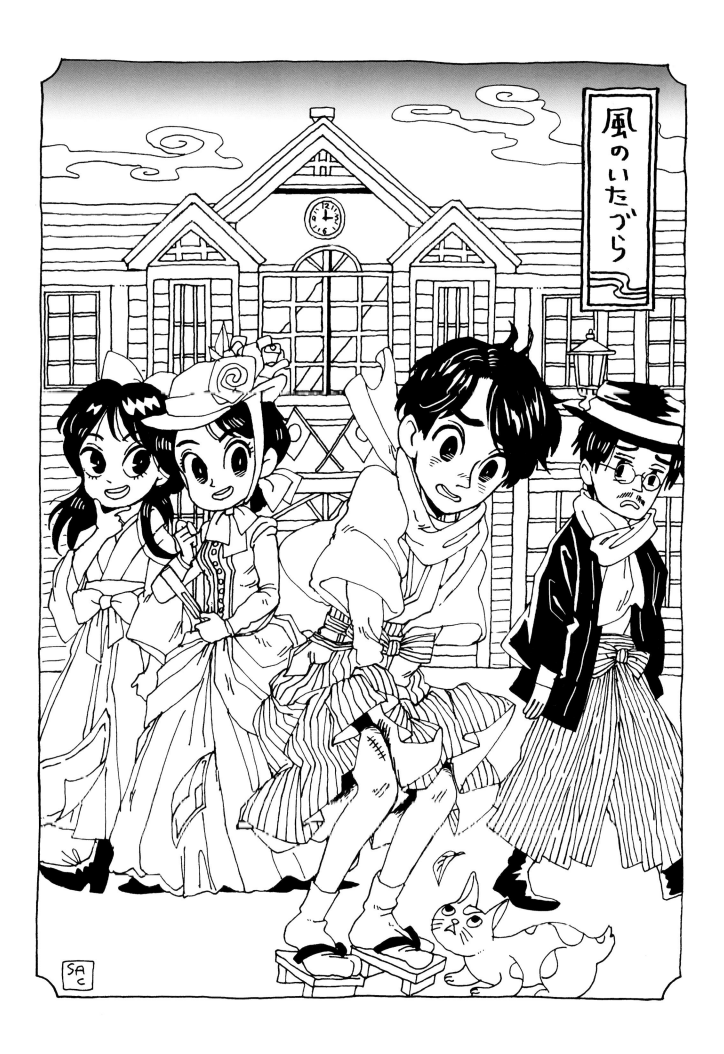

風のいたづら

155

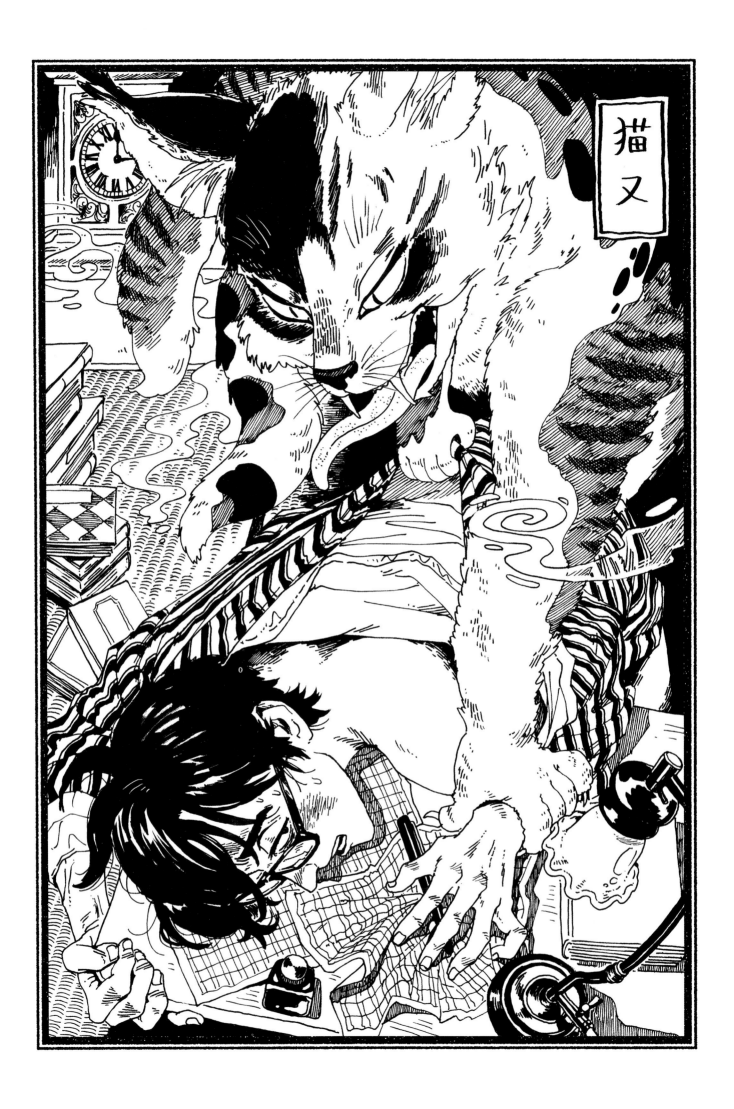

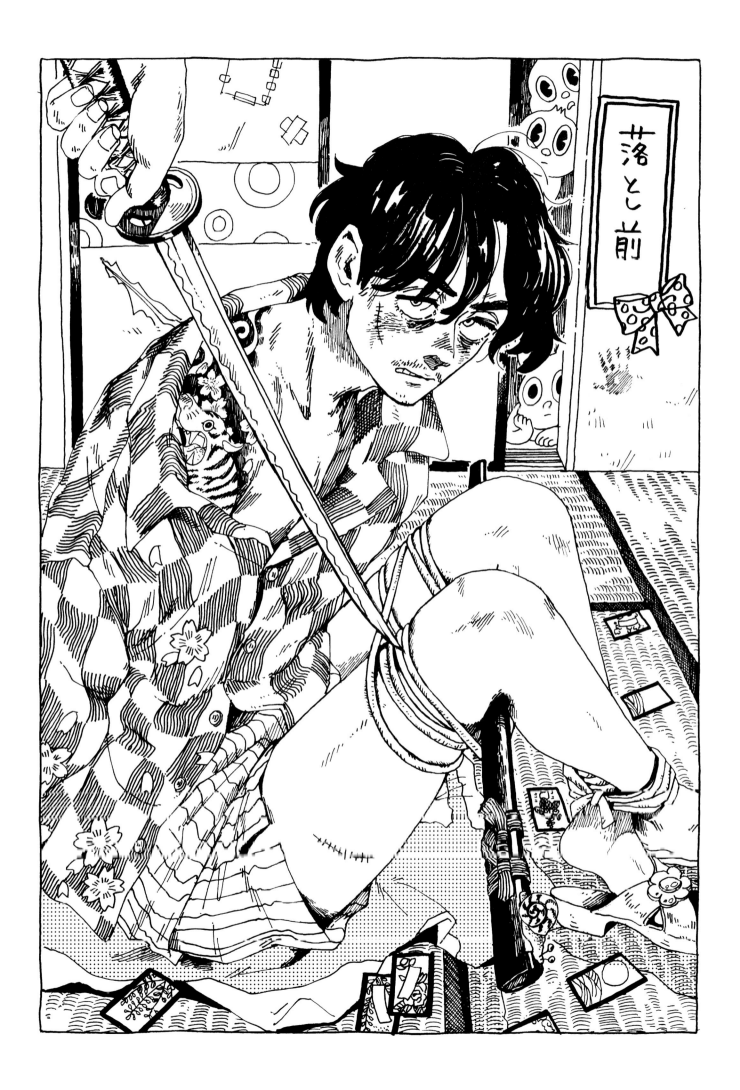

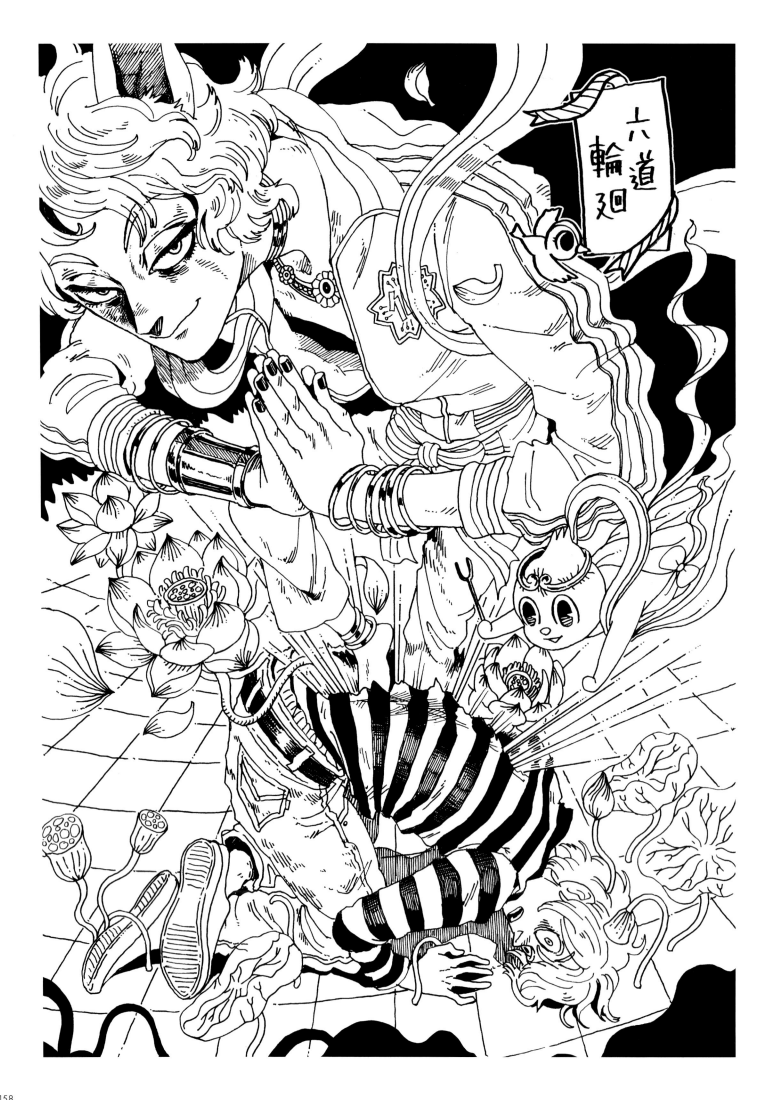

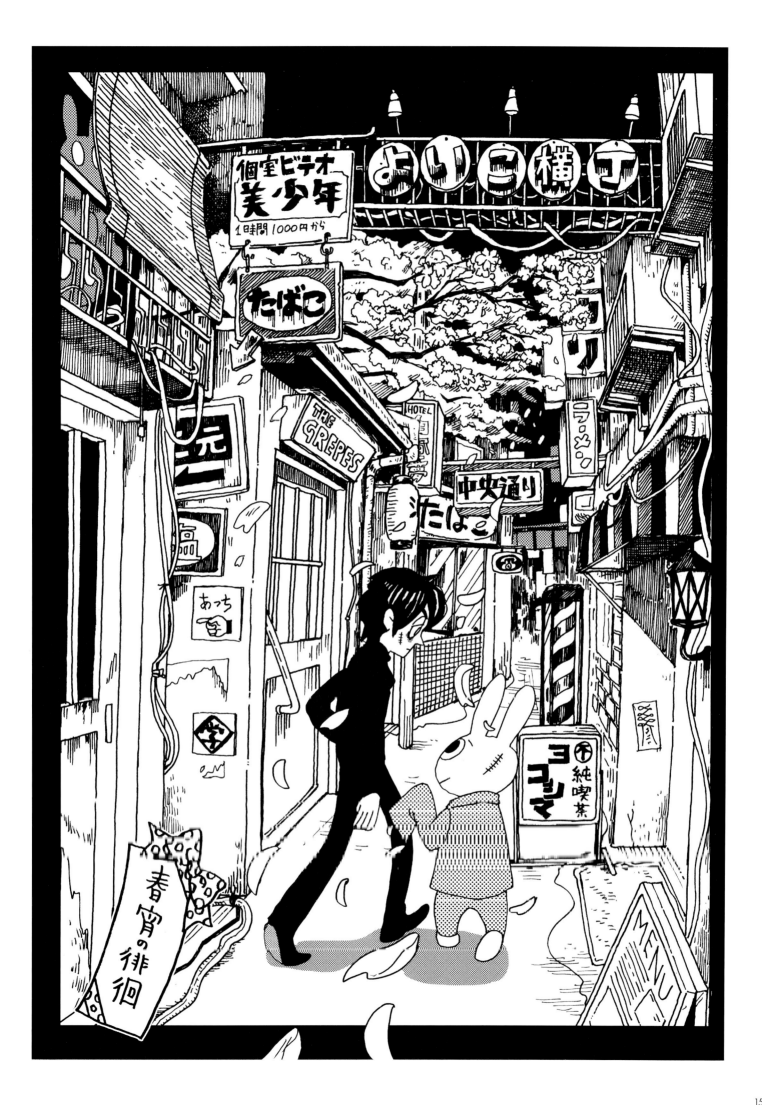

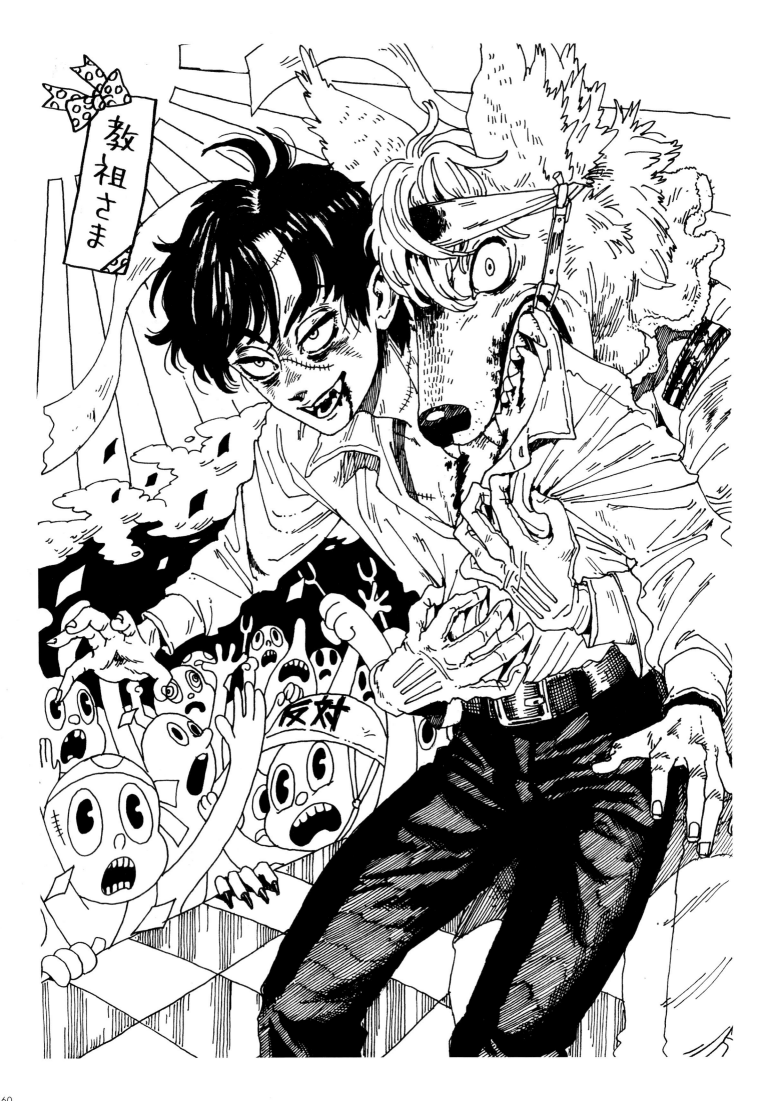

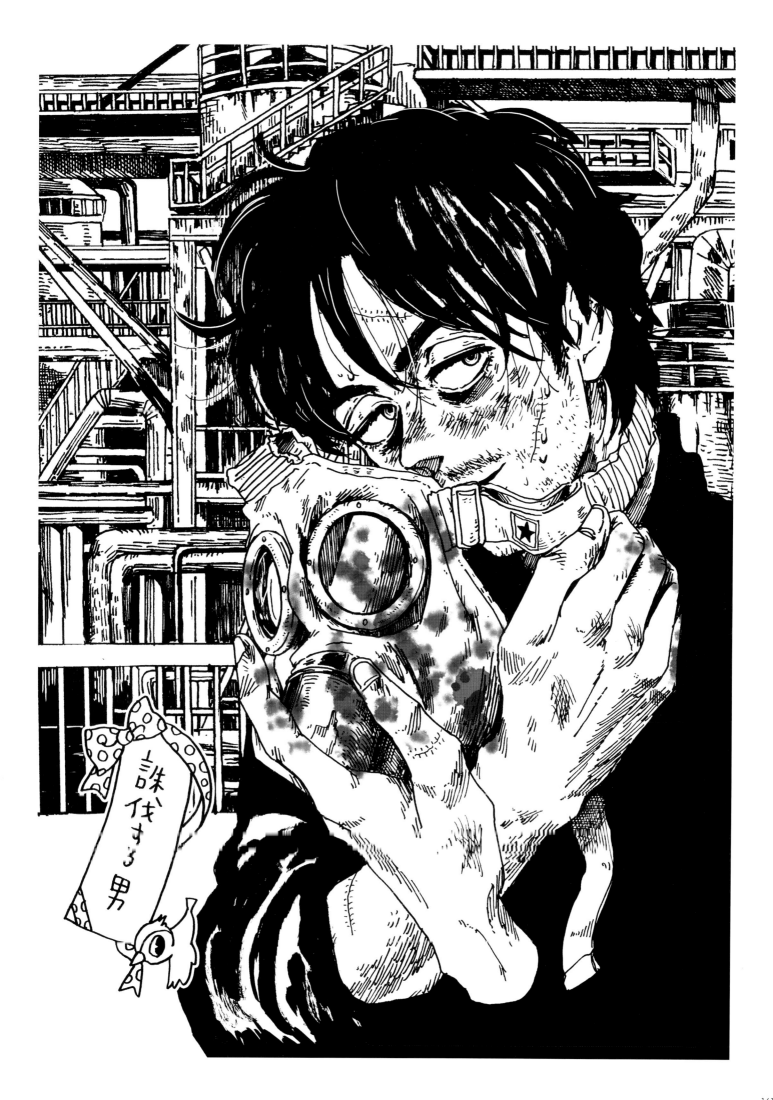

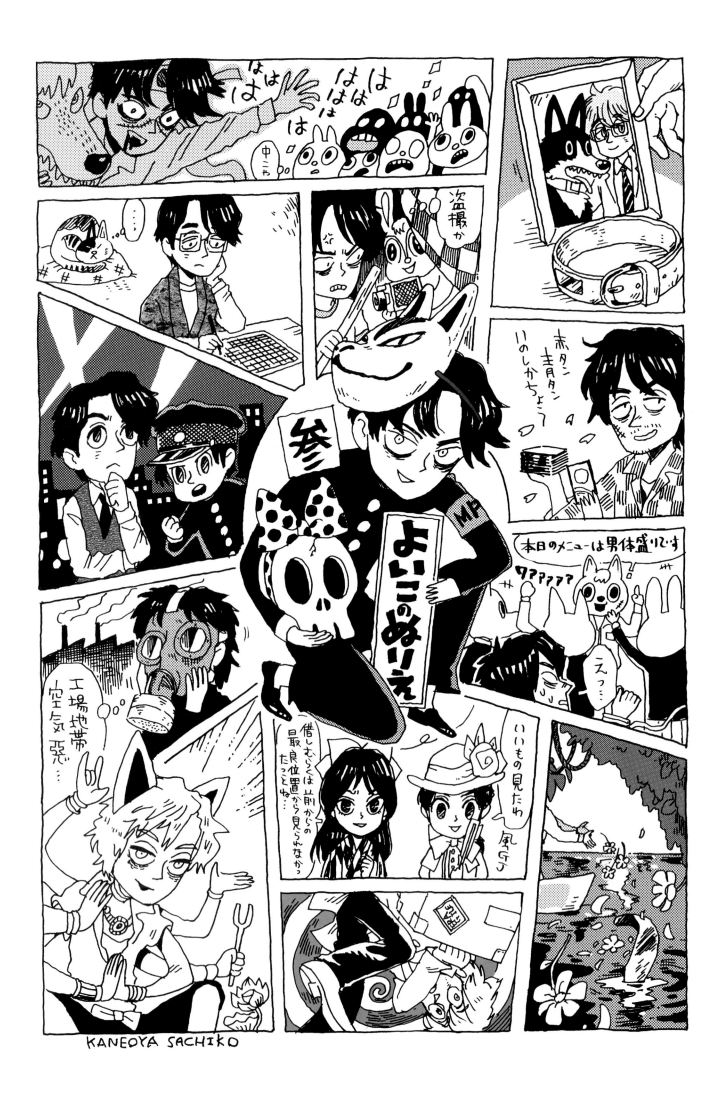

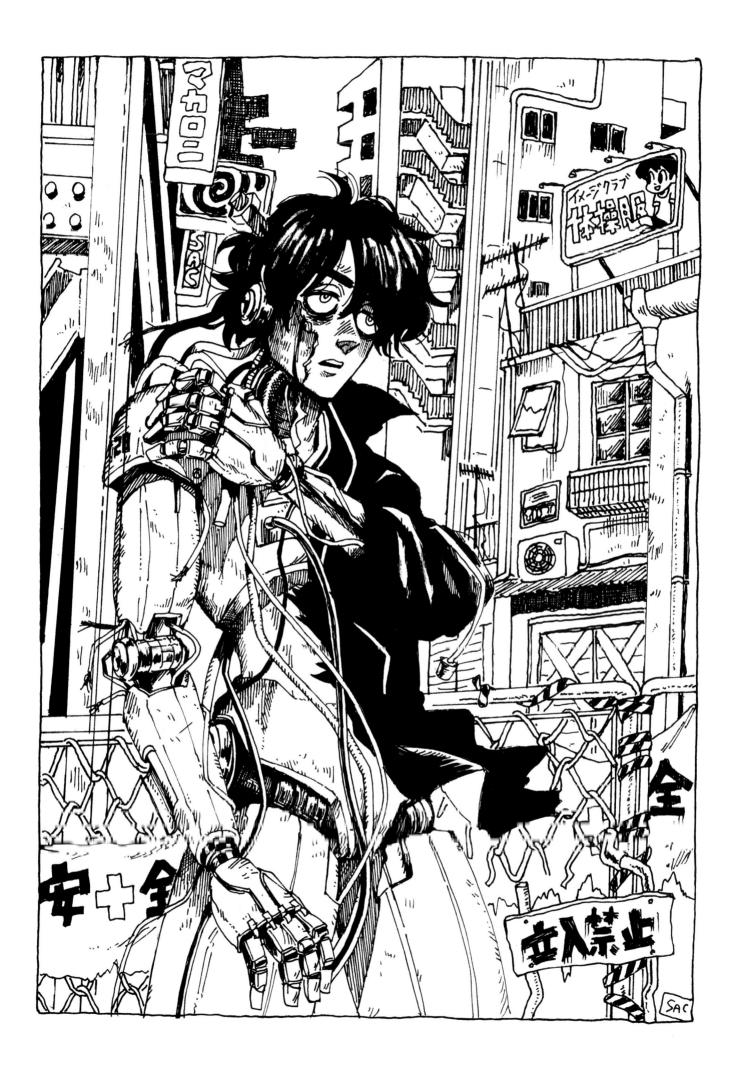

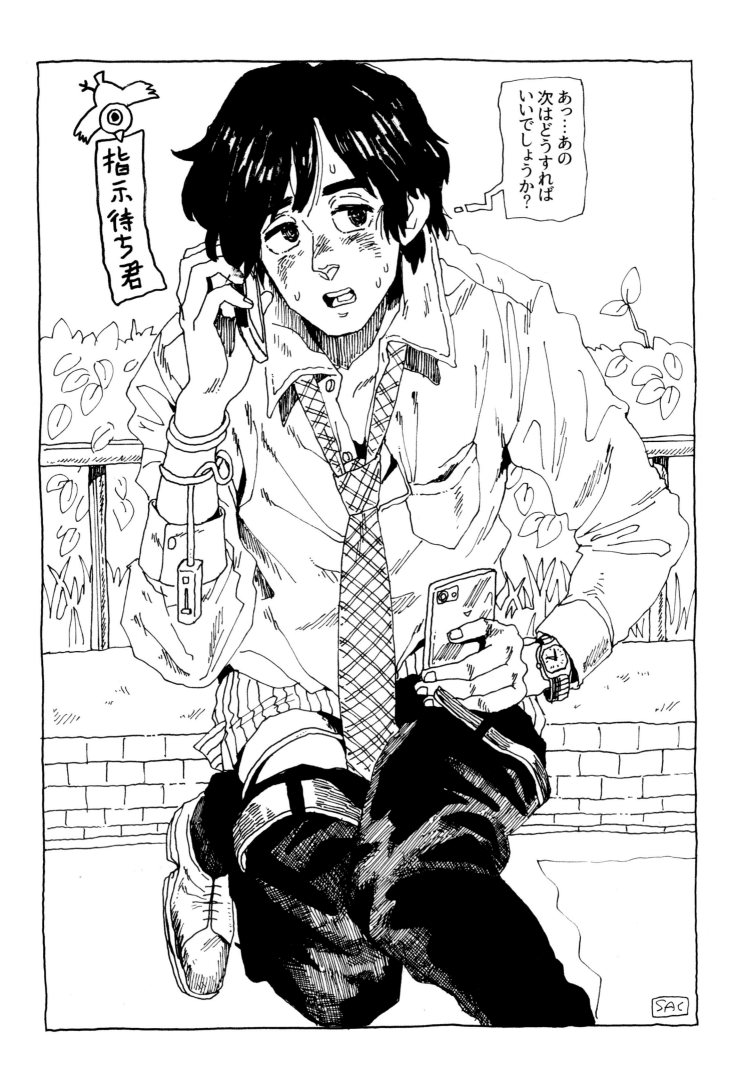

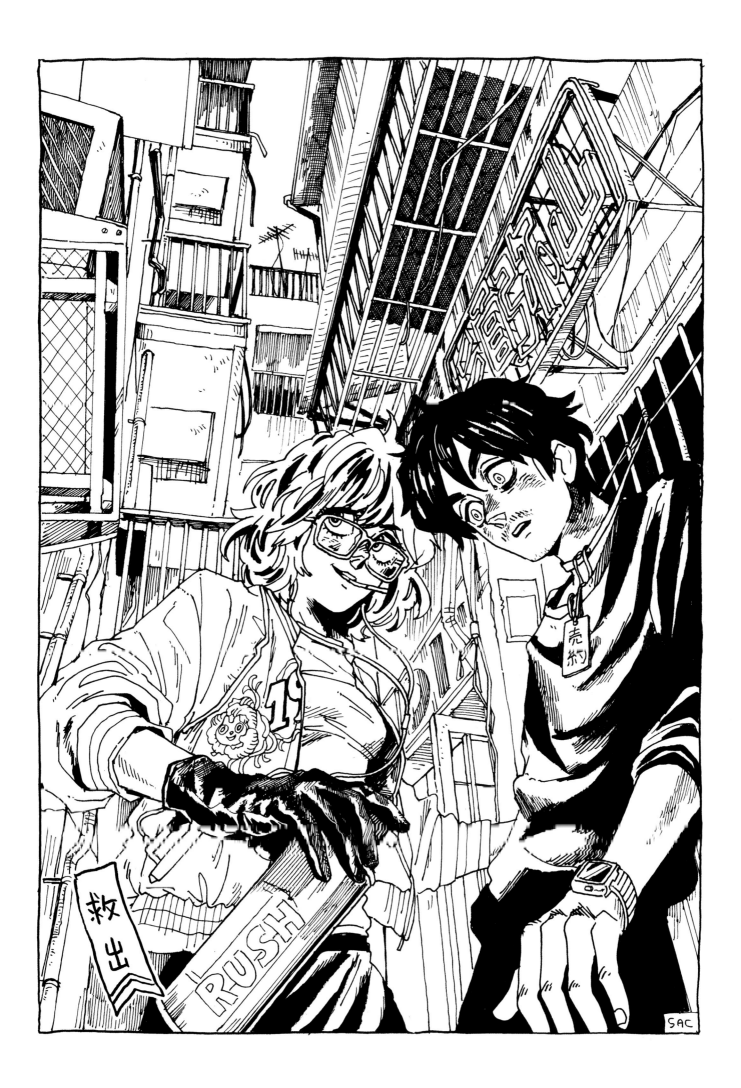

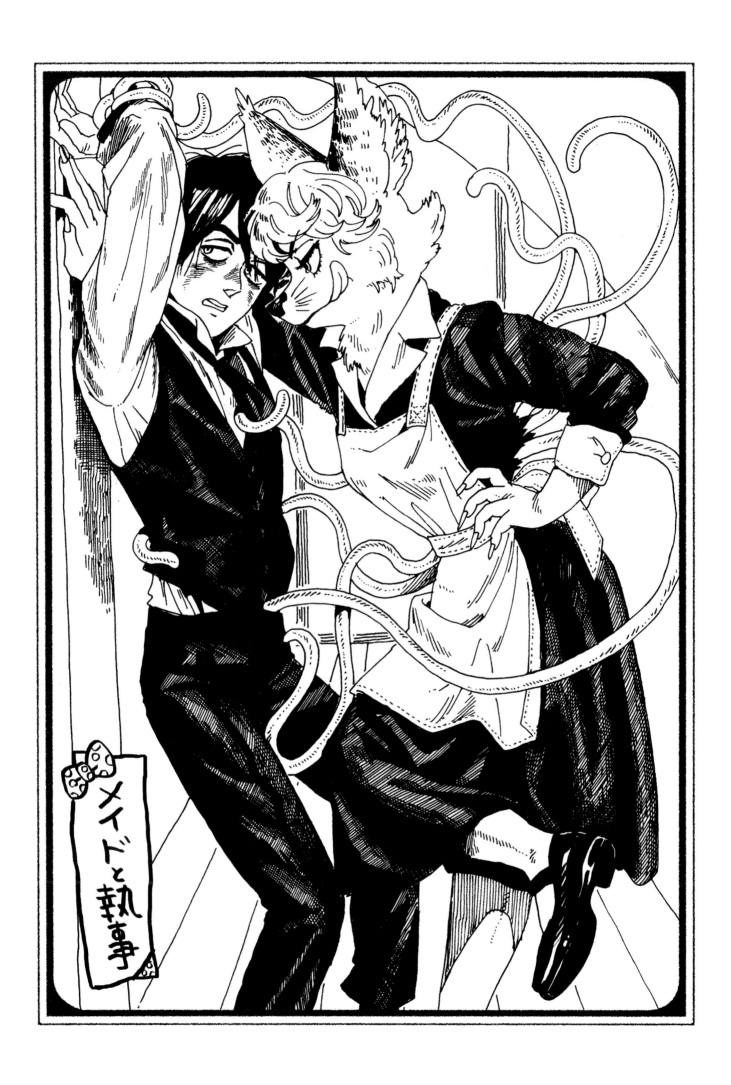

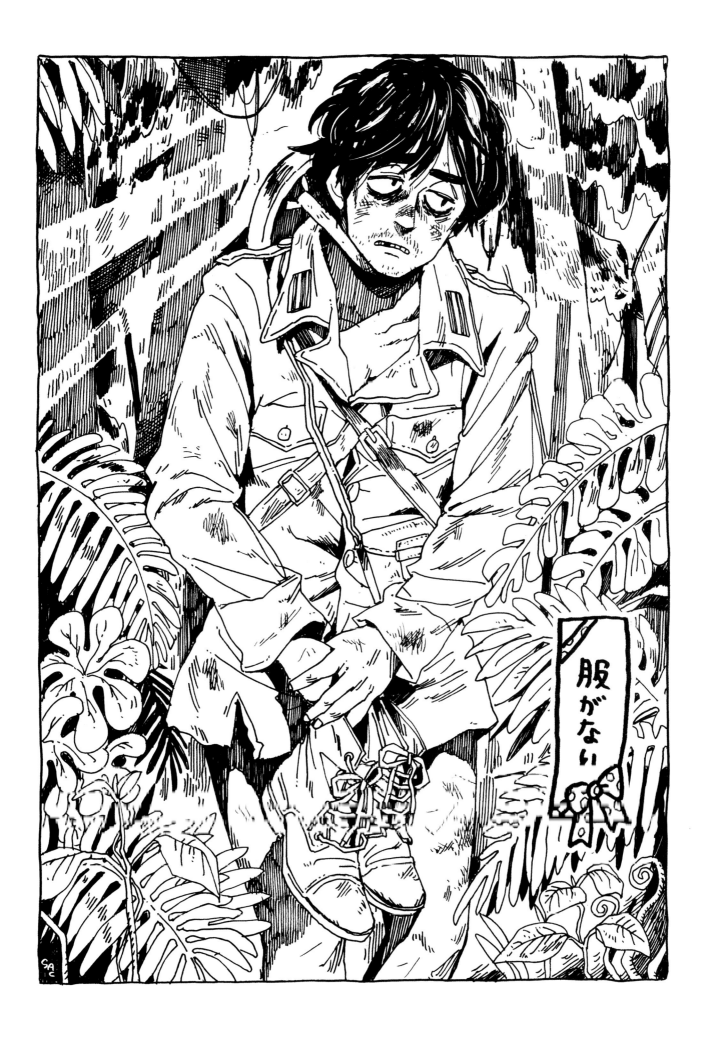

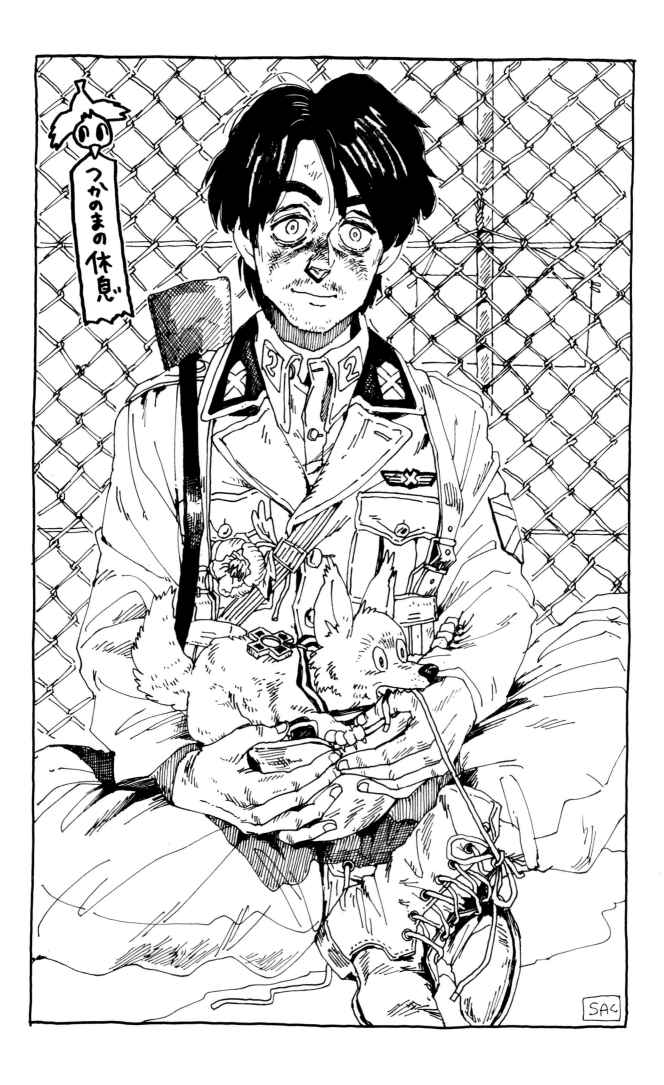

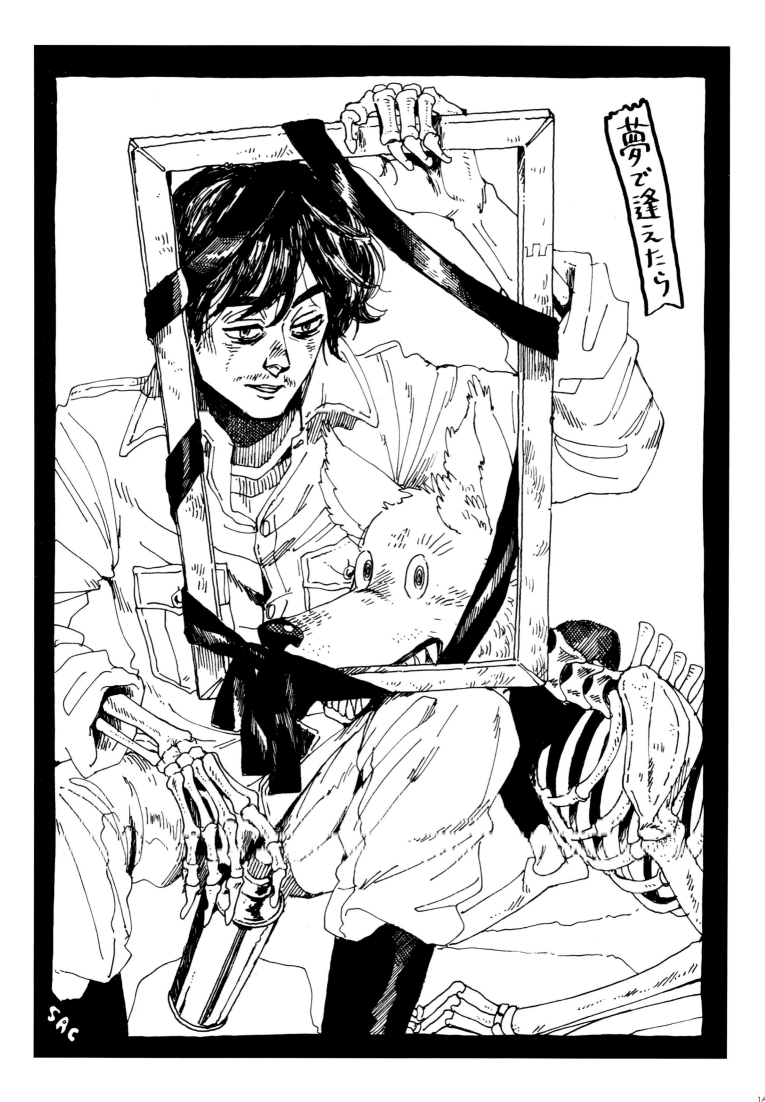

夢で逢えたら

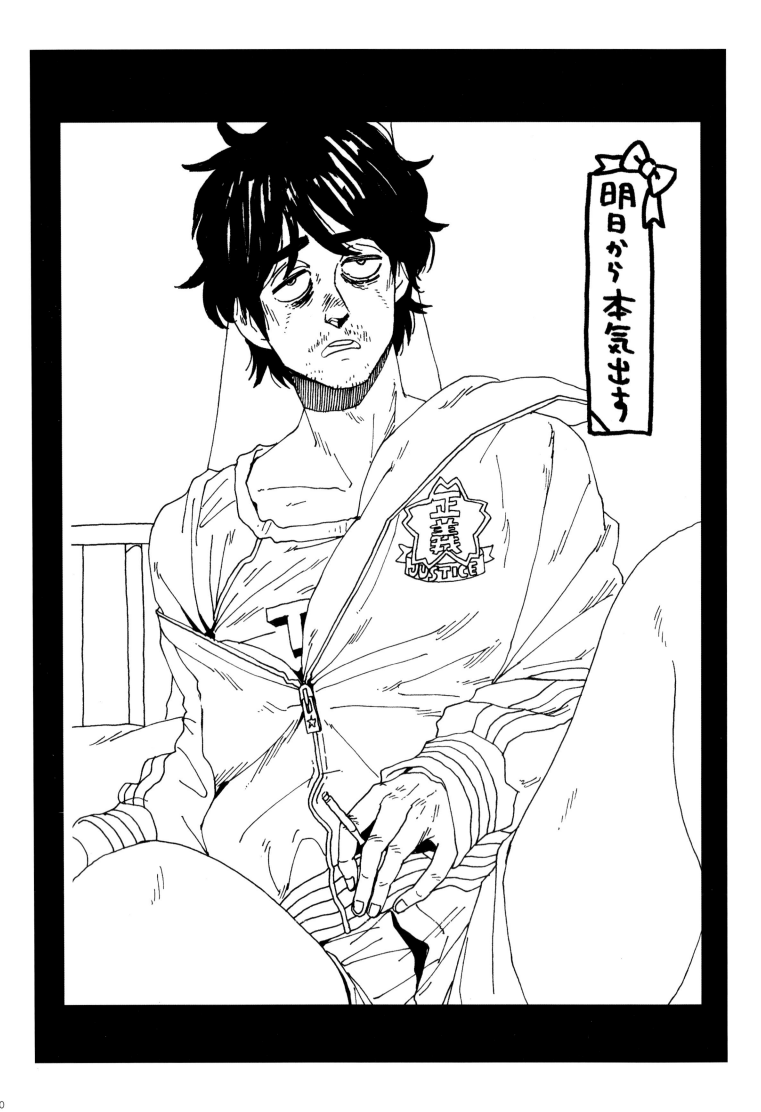

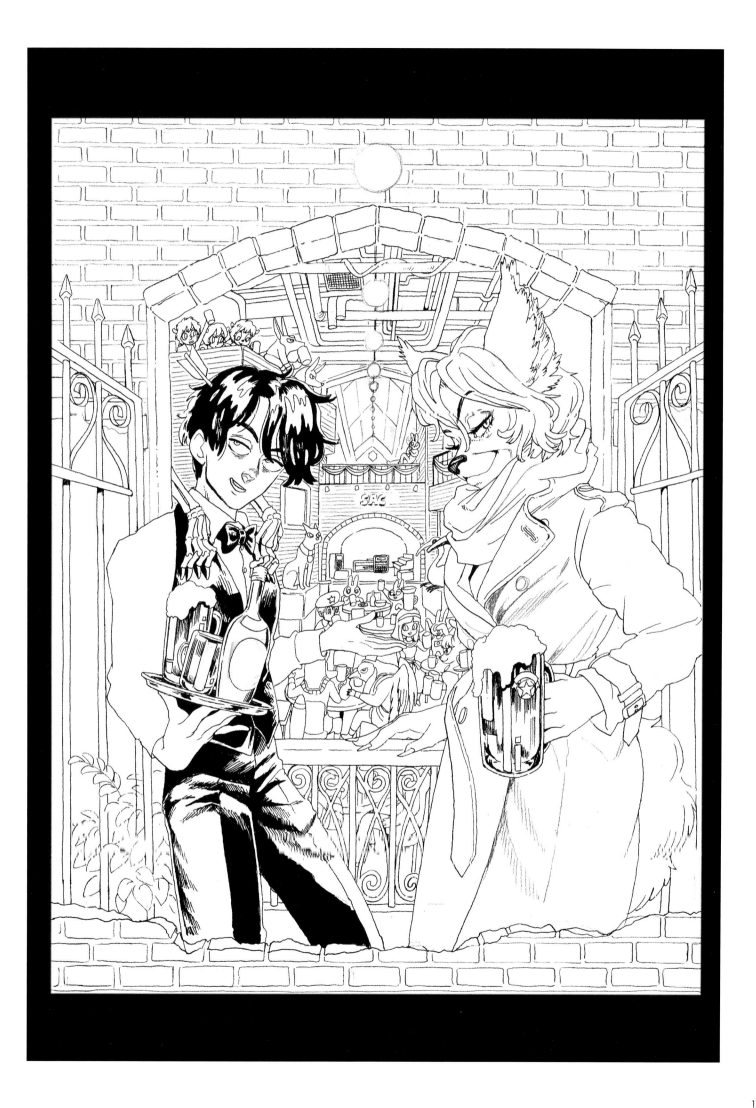

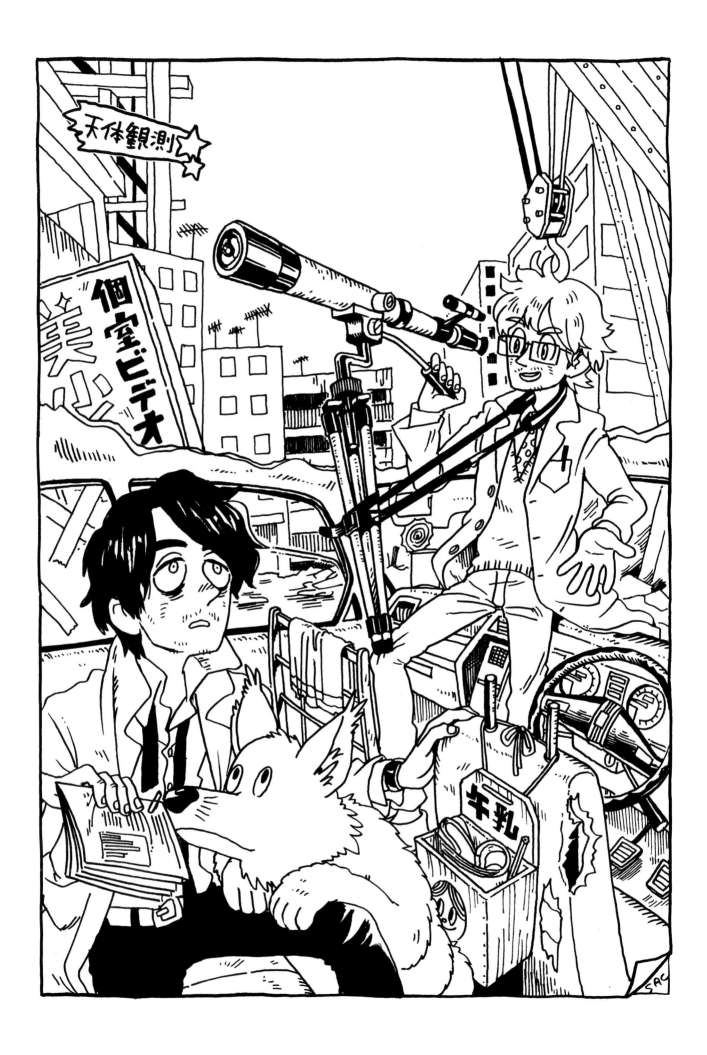

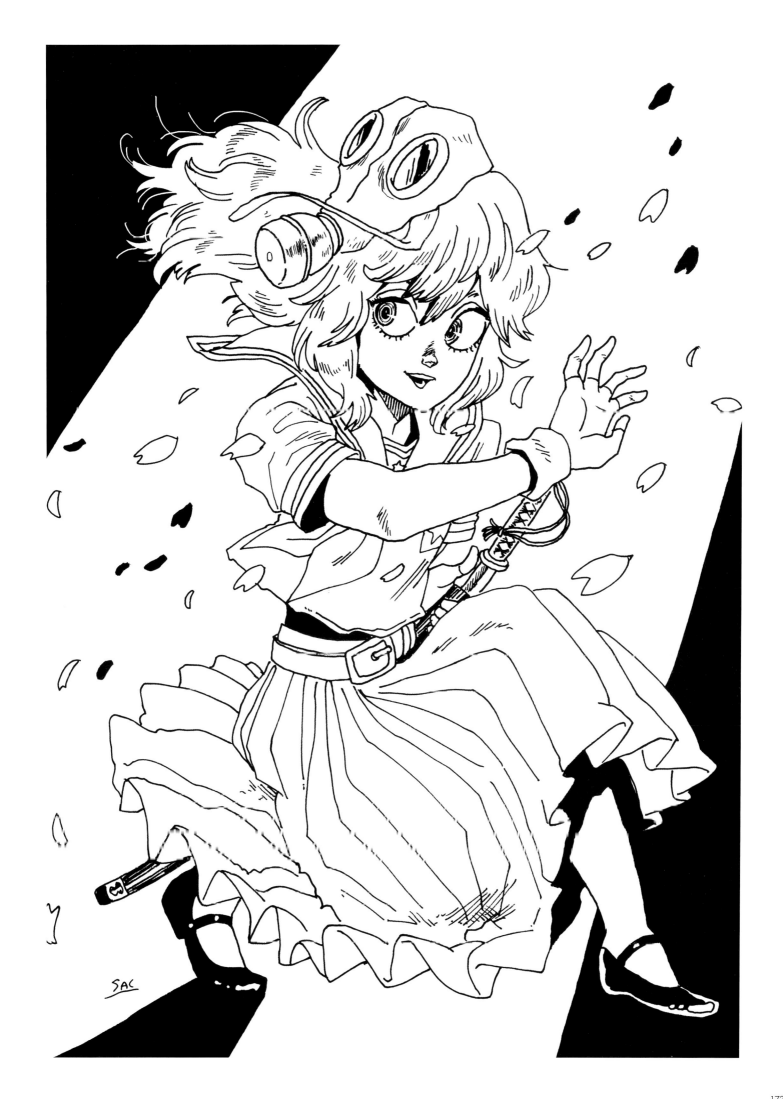

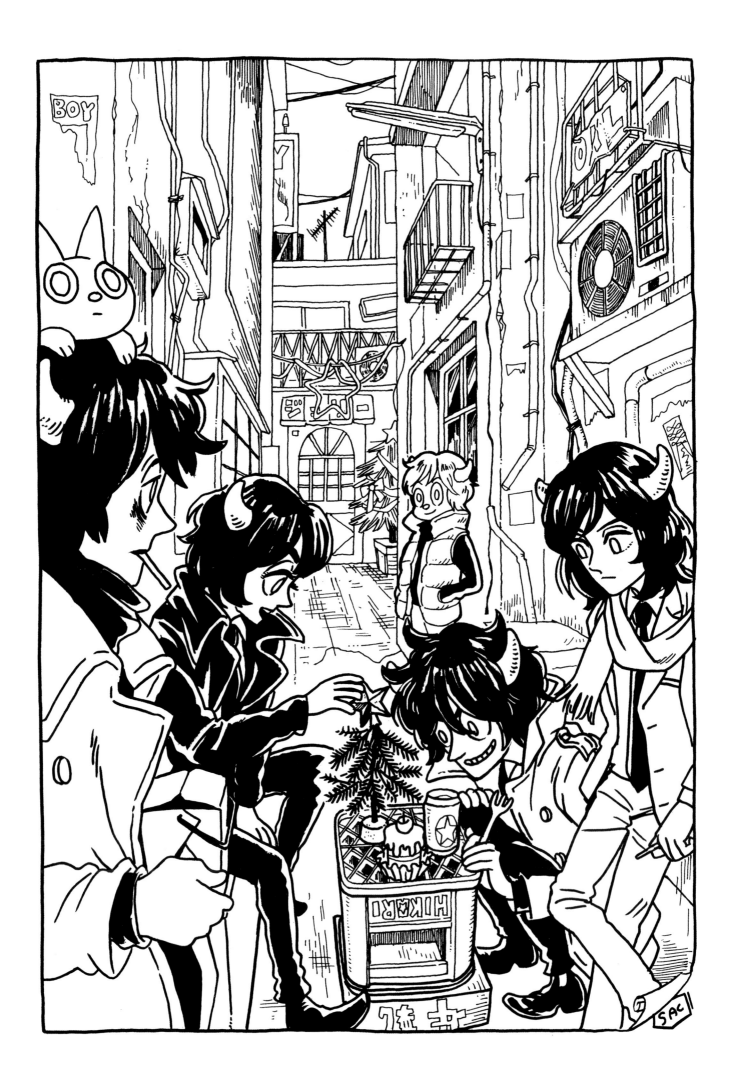

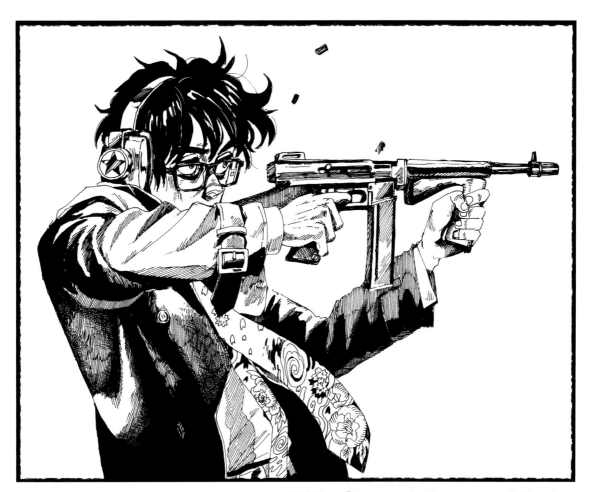

2011-2014に発行した「よいこのぬりえ」1〜3の再録です。

よいこのぬりえ 総集編

発行日　2017/8/3
発行者　カネオヤサチコ/KaneoyaSachiko
Web　「よいこ横丁」yoiko-yokochou.com
Mail　sacmacaroni009@gmail.com
印刷　金沢印刷

CHAPTER 9
SKETCH

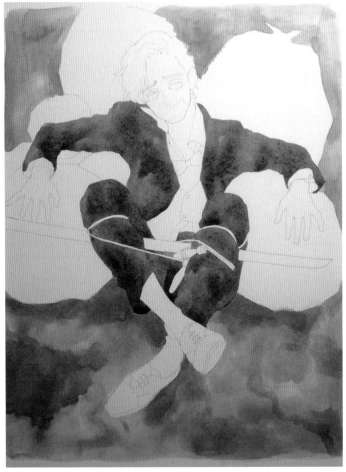
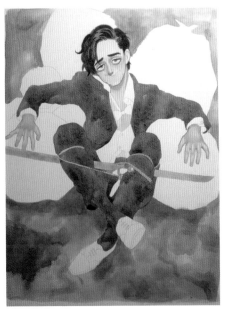
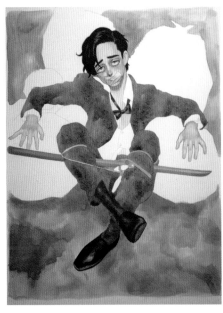
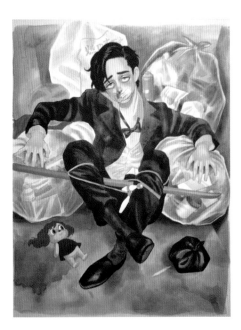

不都合な男 *Inconvenient Man*

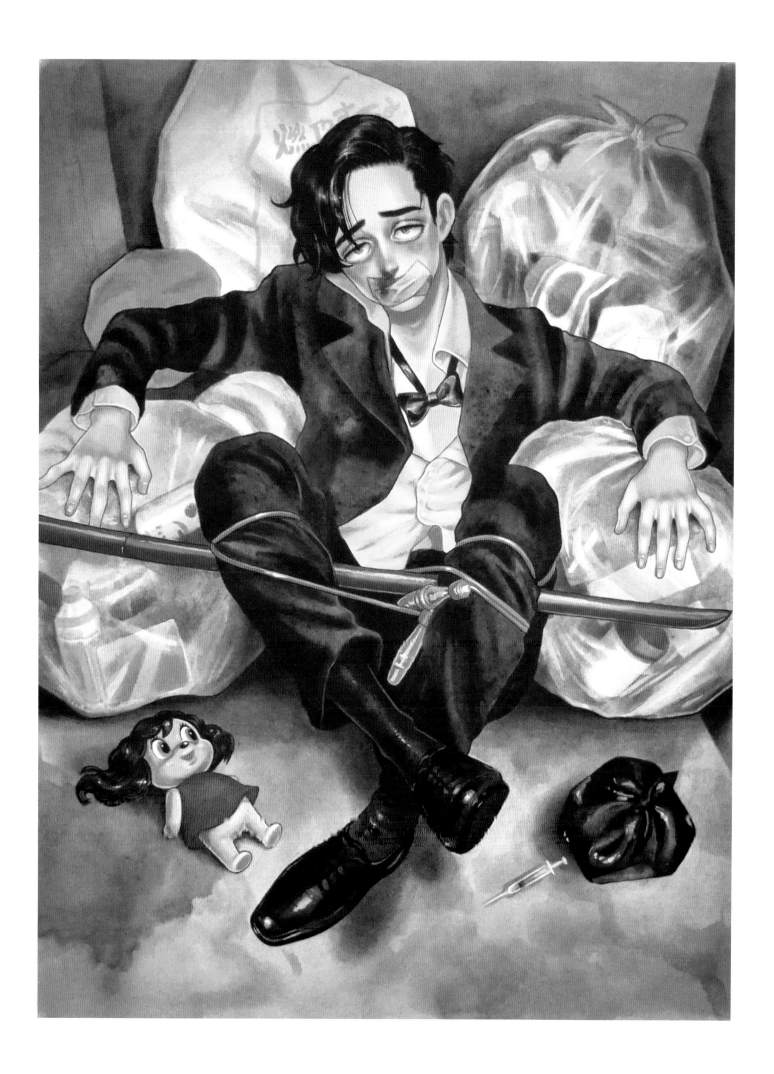

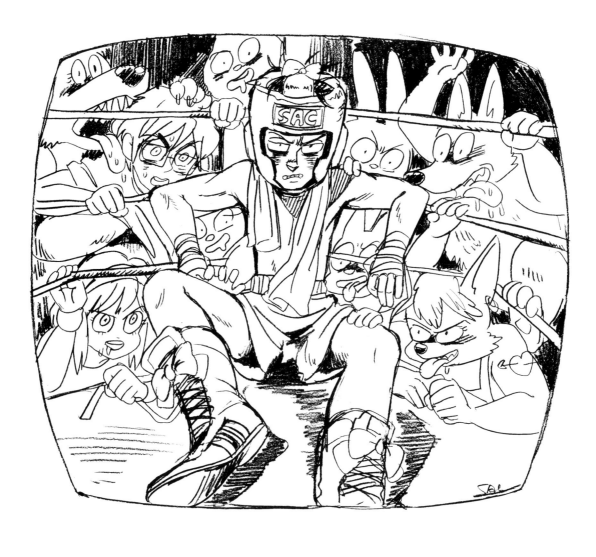

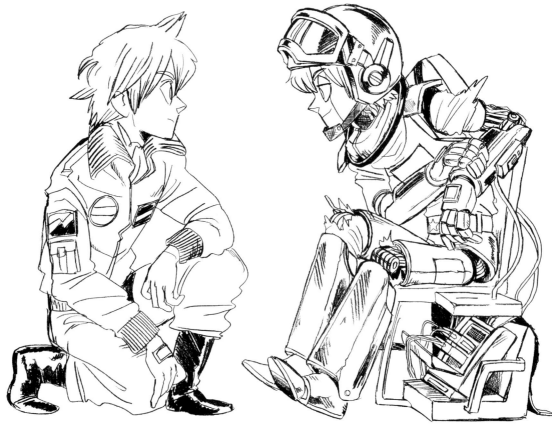

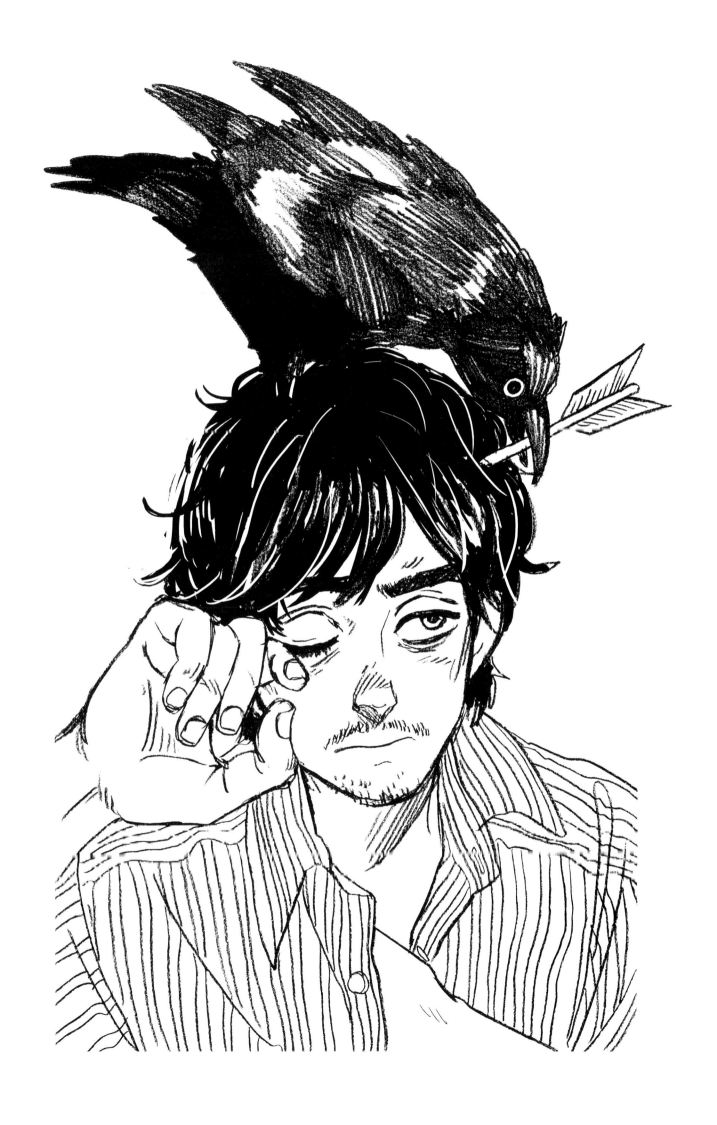

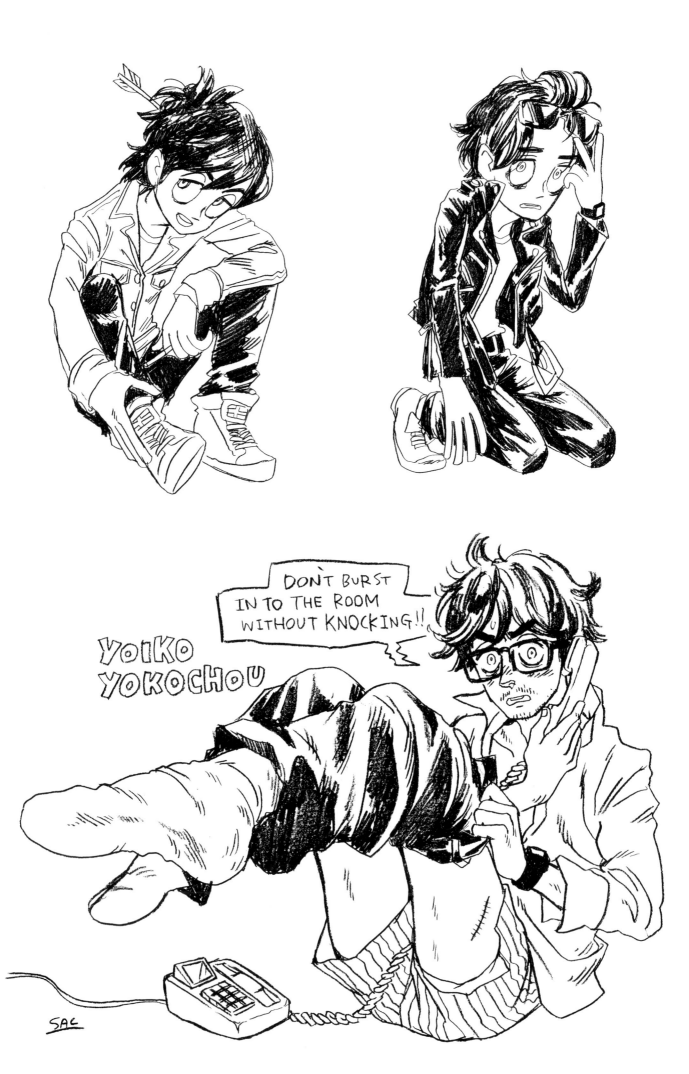

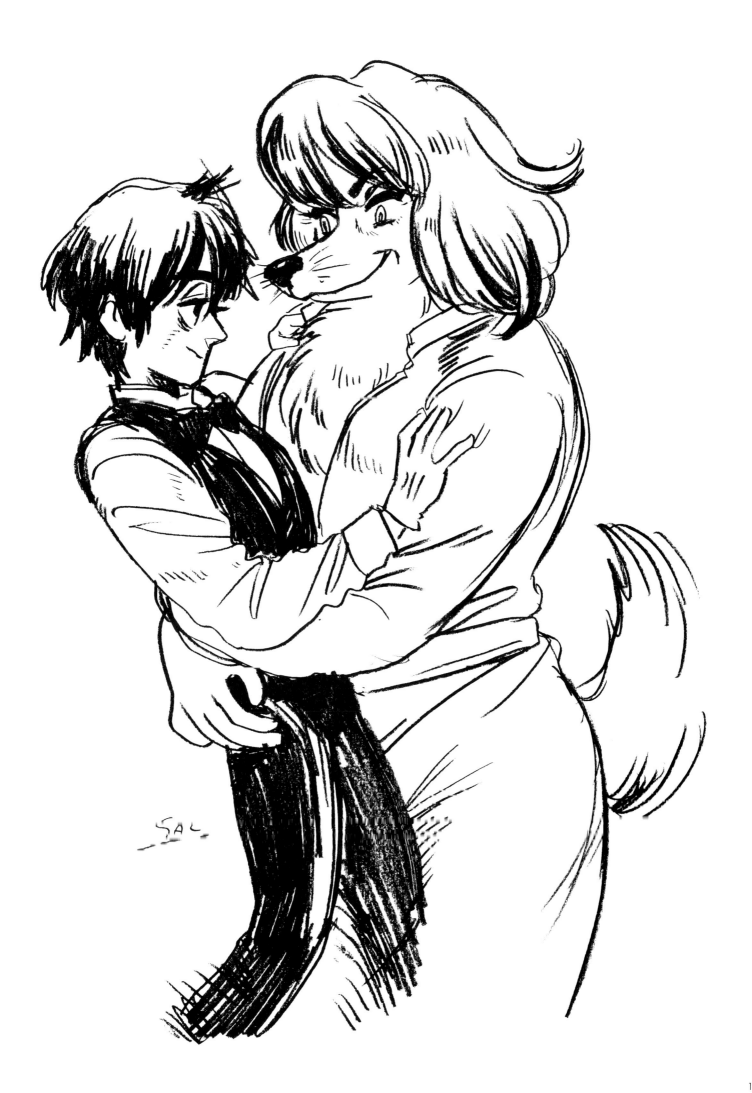

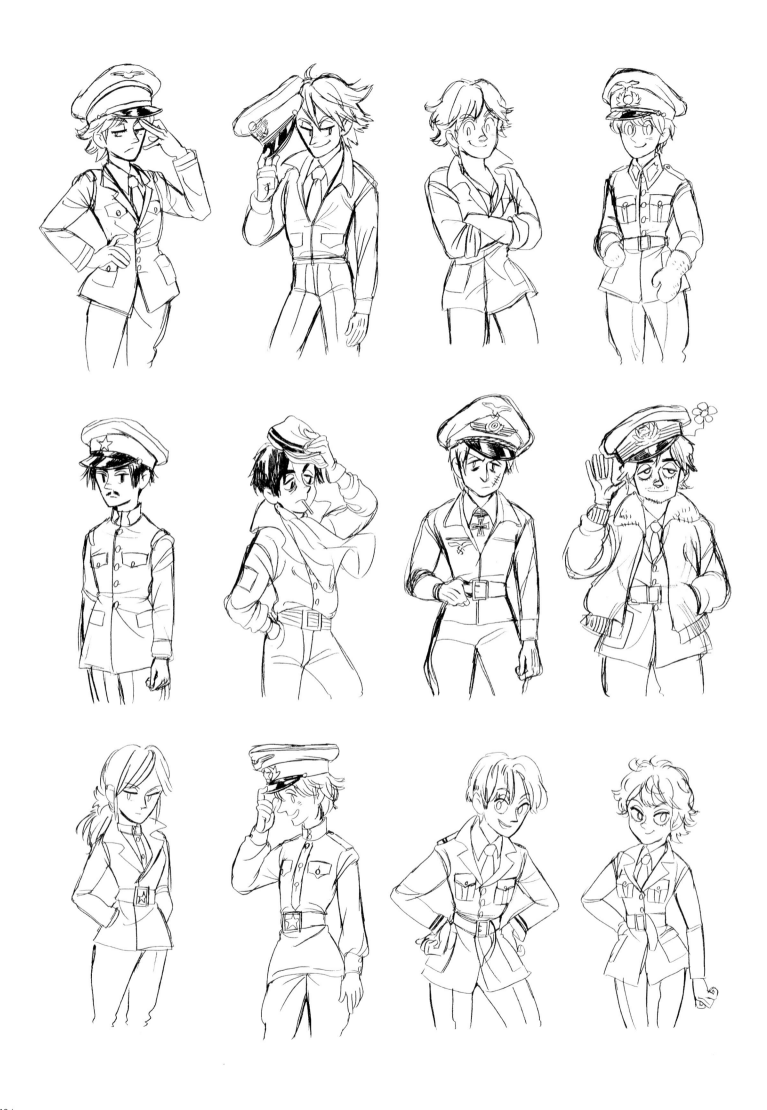

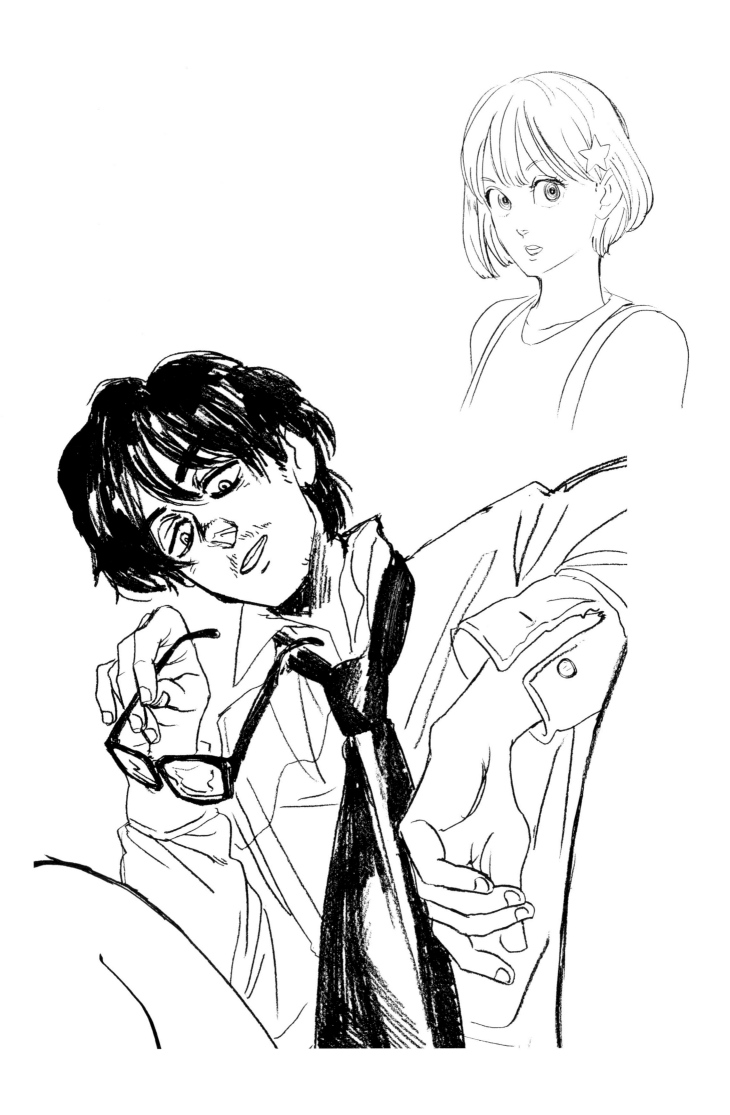

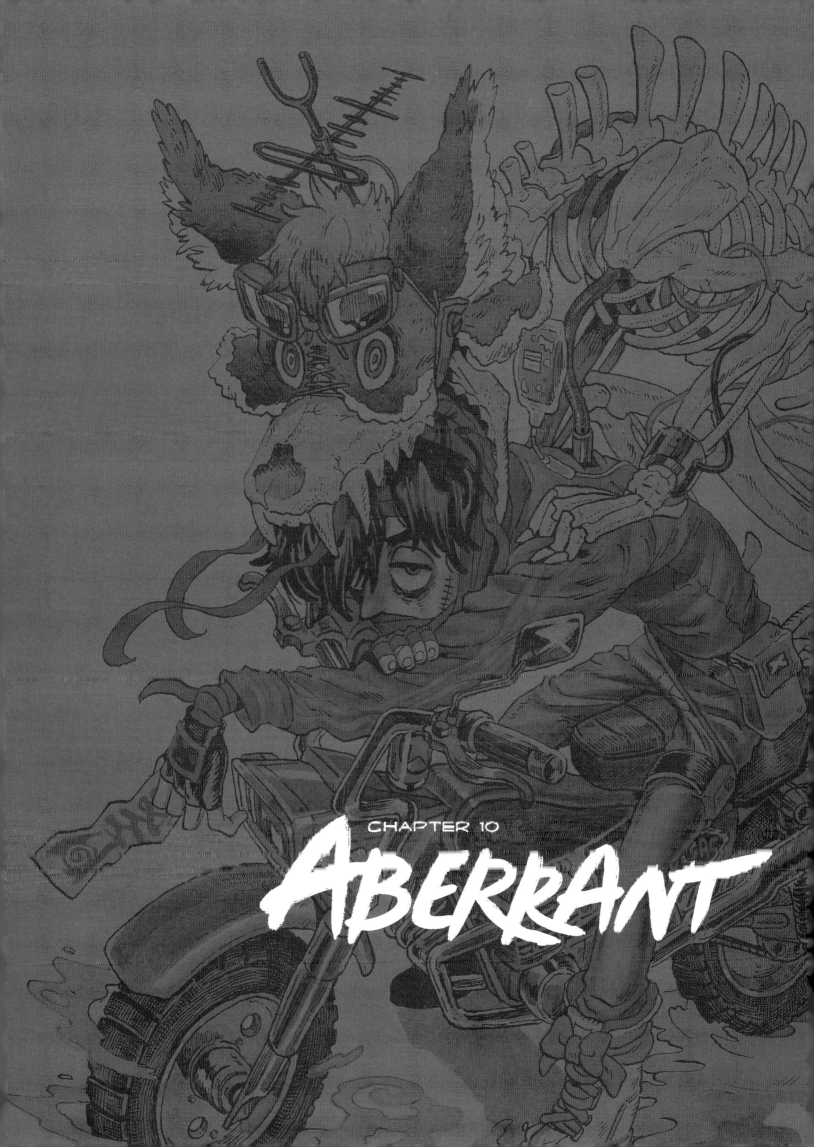

CHAPTER 10

ABERRANT

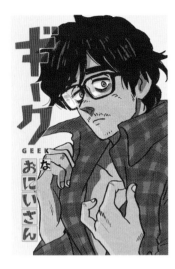

GEEKなおにいさん

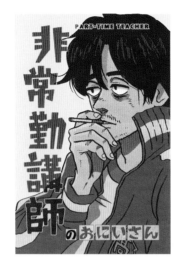

PART-TIME TEACHER
非常勤講師のおにいさん

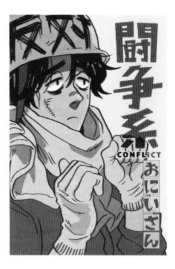

闘争系のおにいさん
CONFLICT

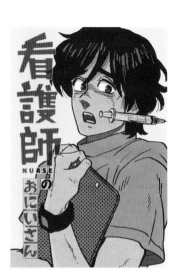

看護師のおにいさん
NURSE

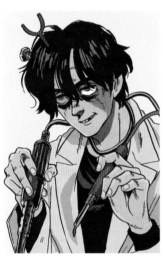

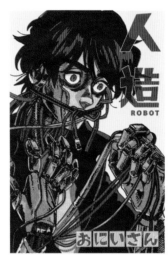

人造ROBOTおにいさん

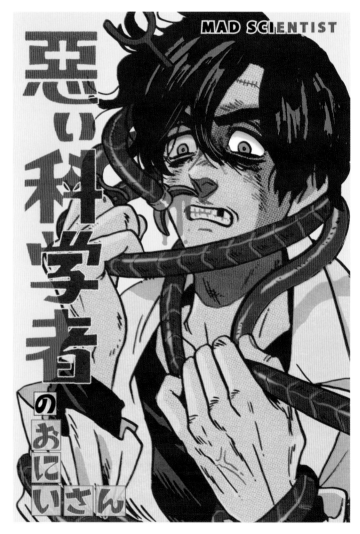

MAD SCIENTIST
惡い科学者のおにいさん

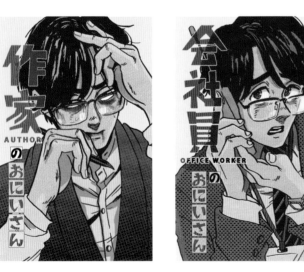

作家のおにいさん
AUTHOR

会社員のおにいさん
OFFICE WORKER

キーチェン用イラスト Illustration For Keychains

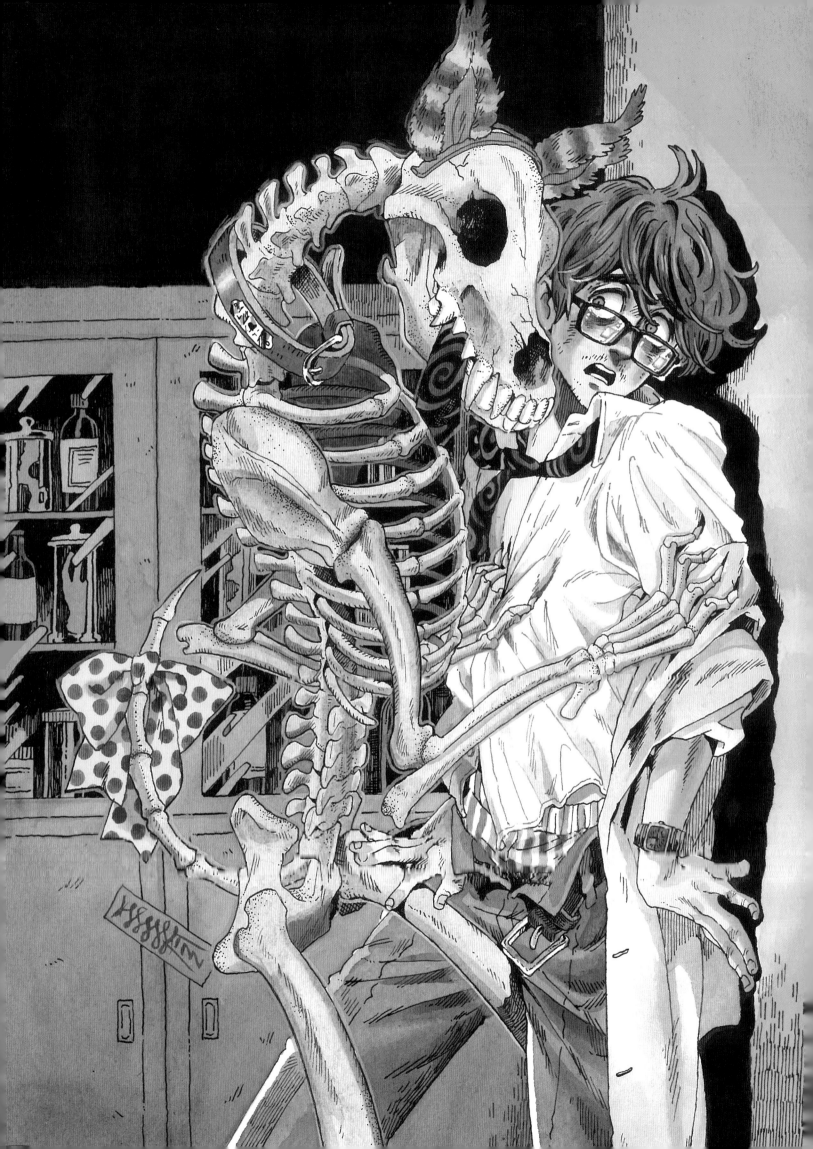

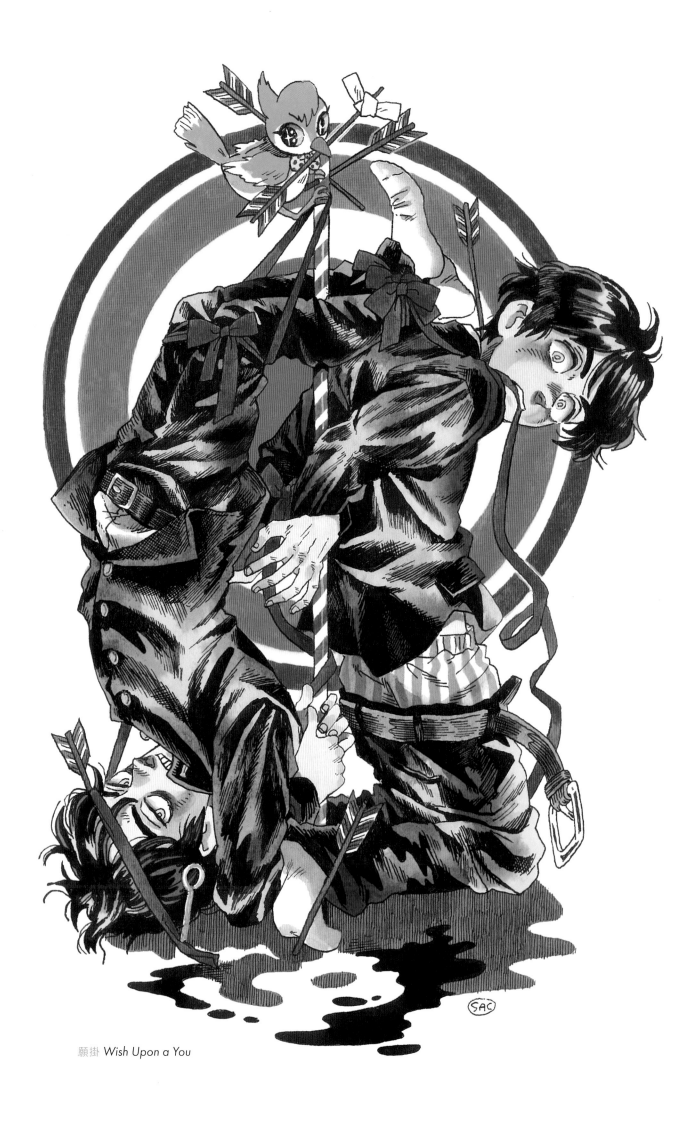

願掛 *Wish Upon a You*

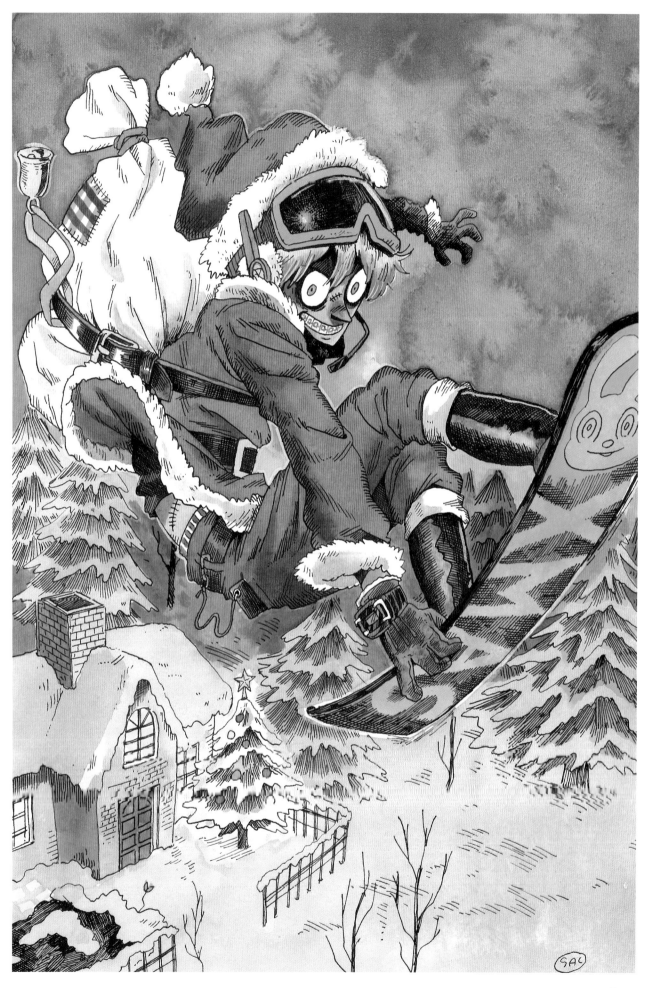

Xmas

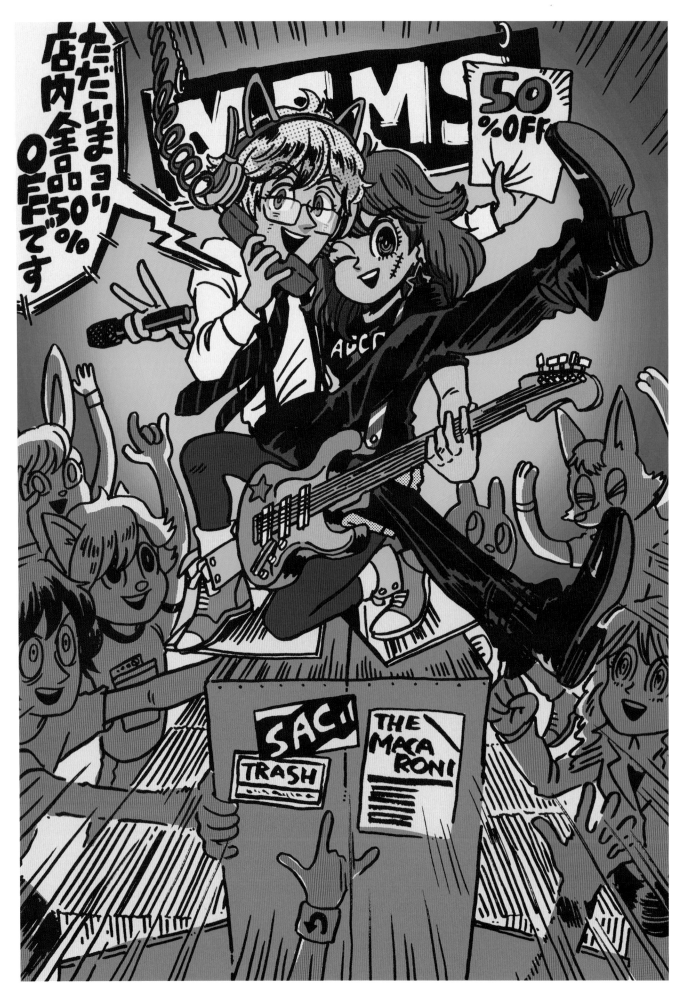

ックオブエイジズ Docks

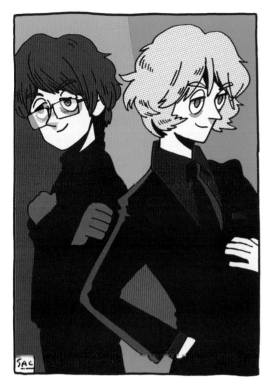

とあるふたり *A Certain Couple*

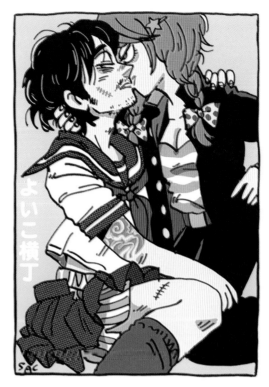

Transgender

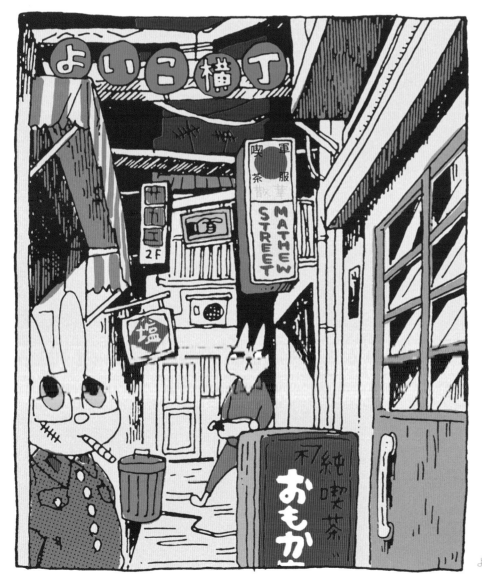

よいこ横丁 *Good Place Next Door*

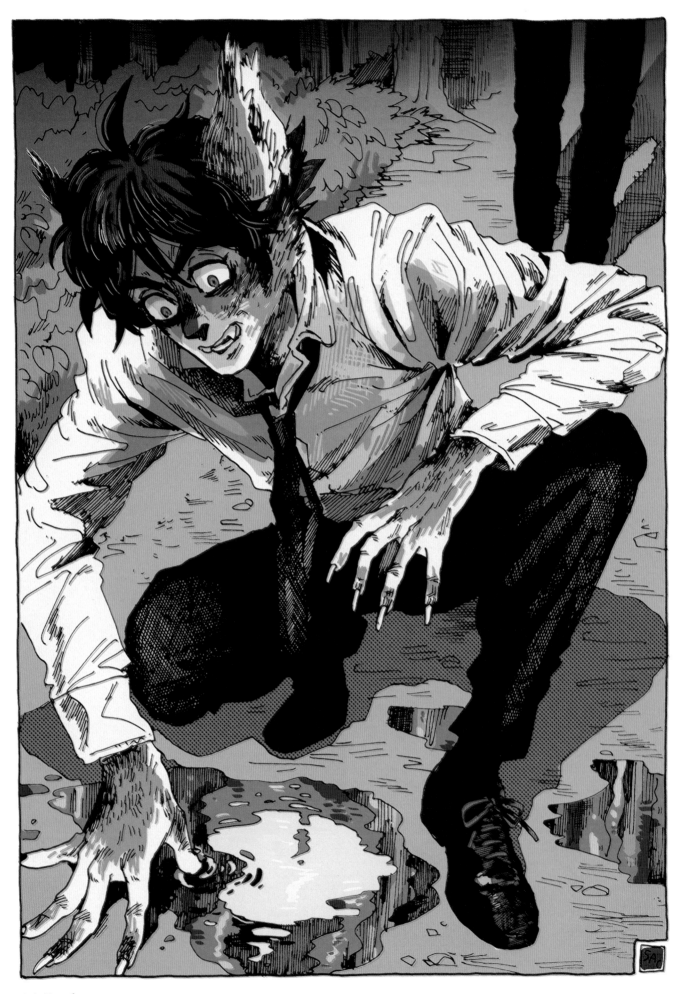

変身 Transform

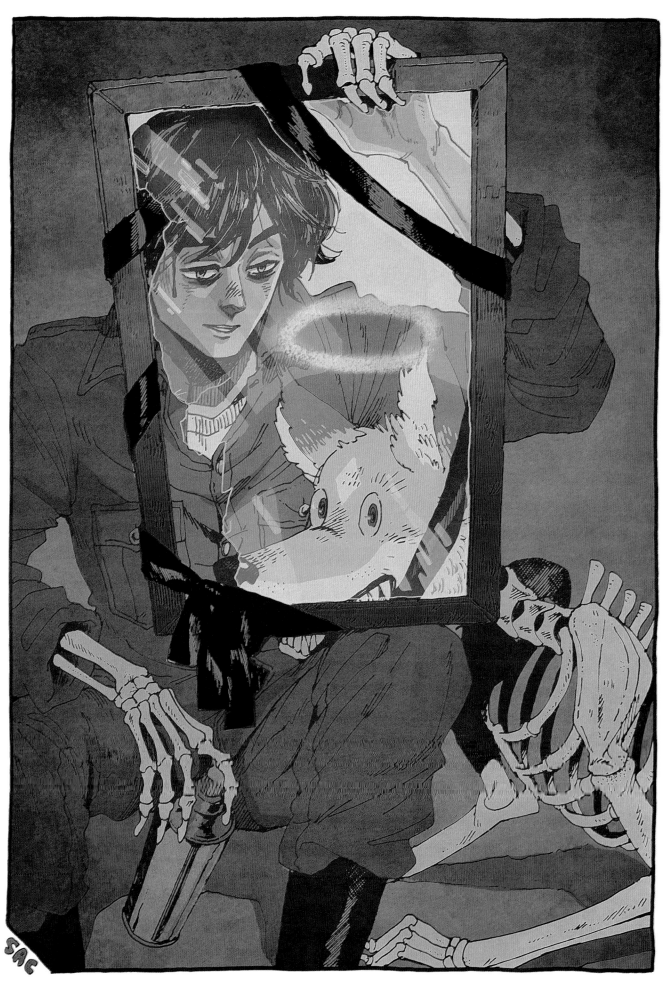

夢で逢えたら *Once in Our Dreams*

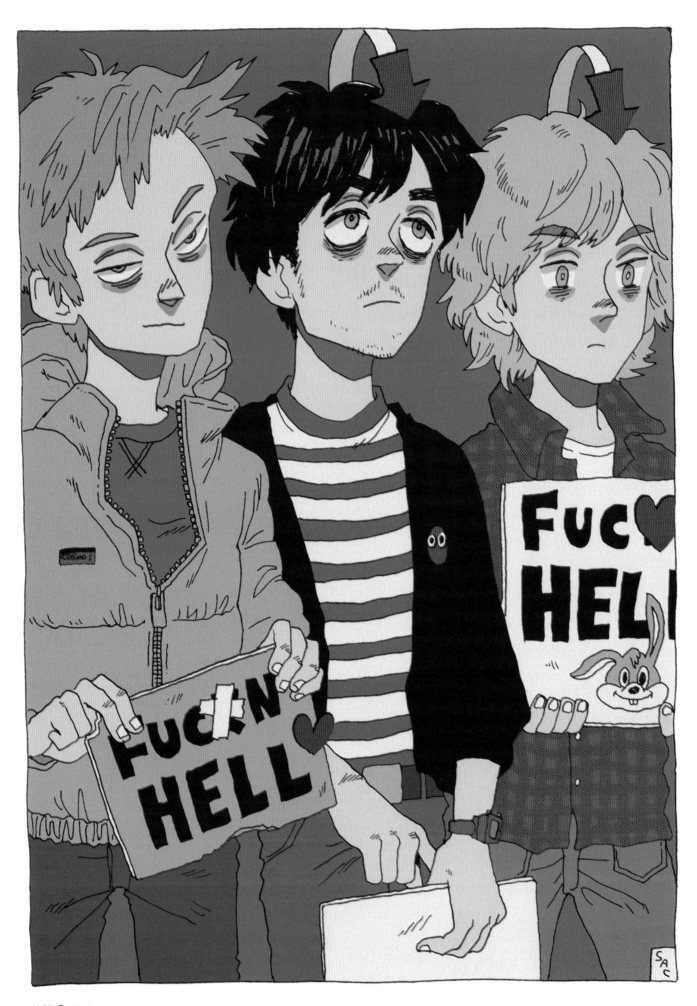

抗議 Protest

鉄のモンスターと摩天楼 Iron Monster and Skyscraper

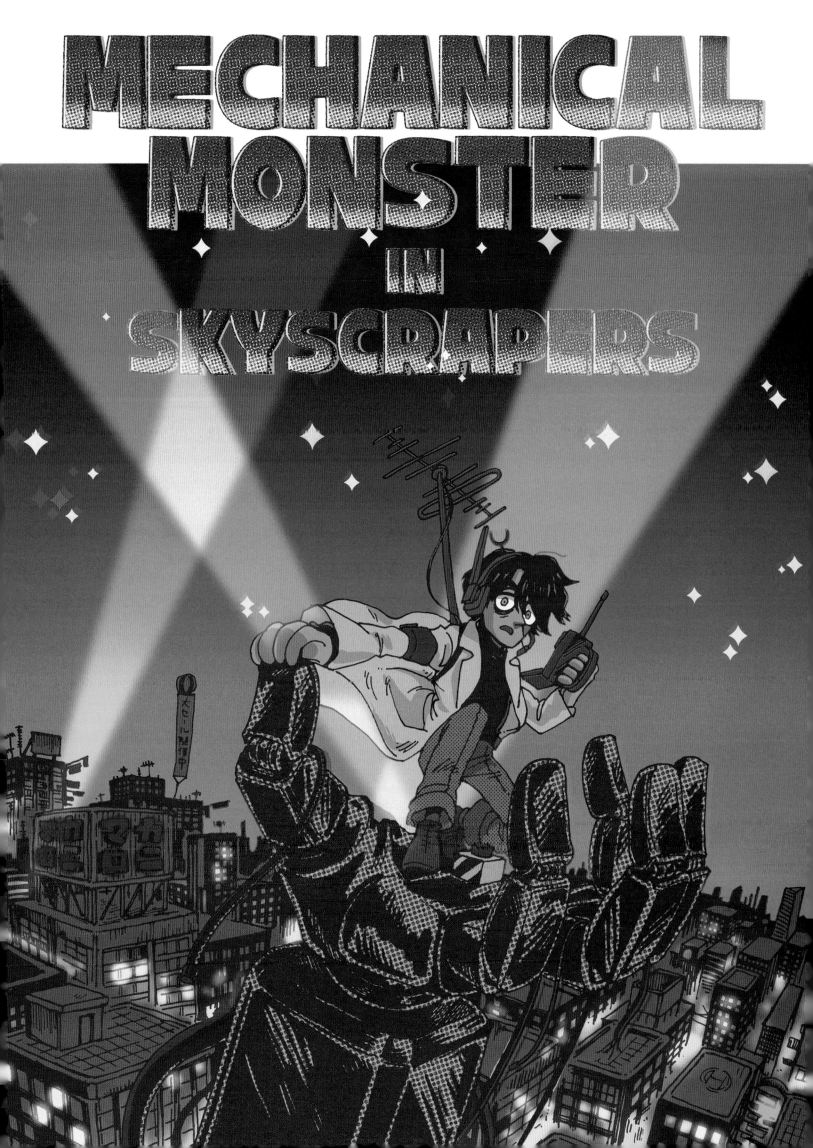

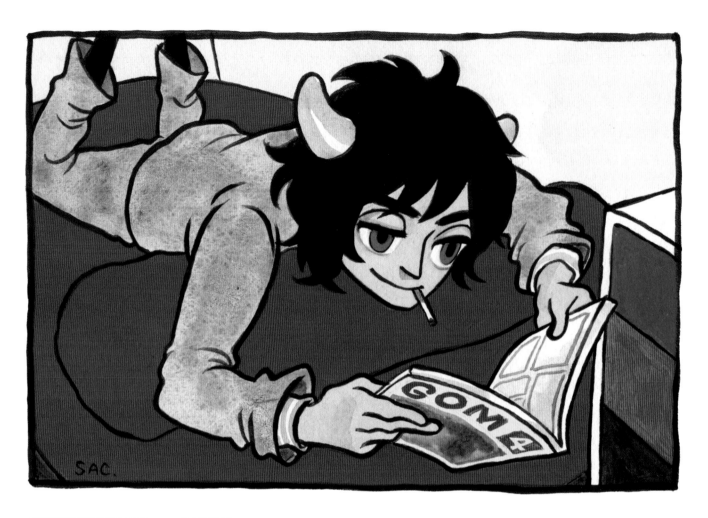

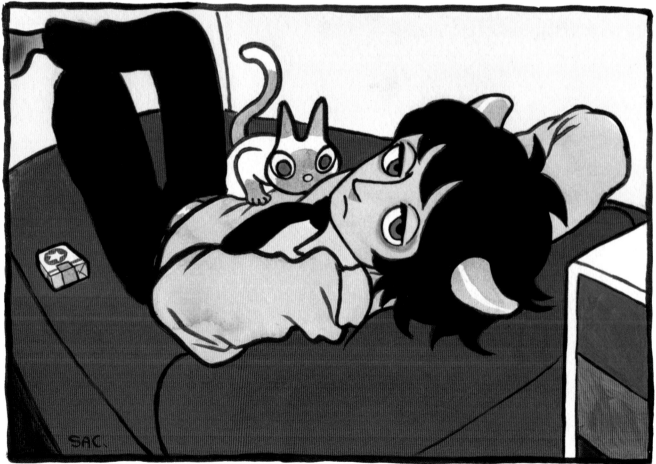

Top: /技法アクリル1 *Relaxin' 1* Bottom: /技法アクリル4 *Relaxin' 4*

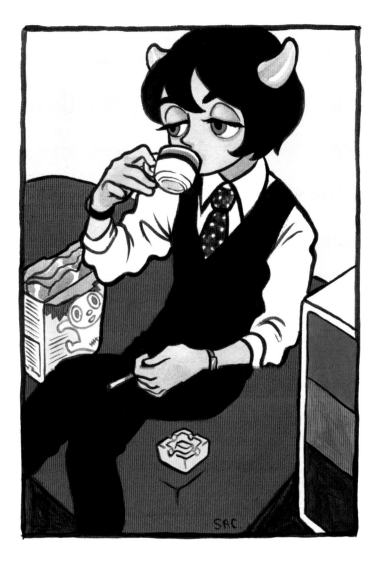
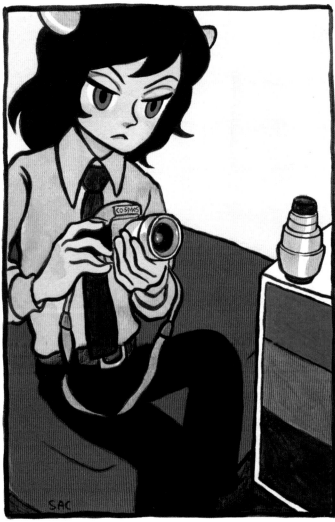
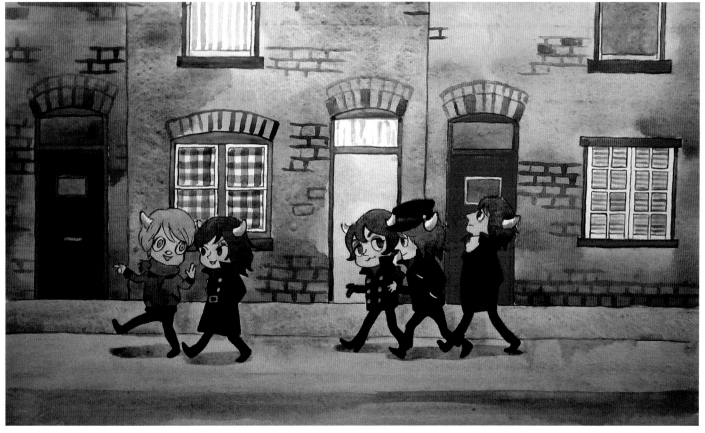

Clockwise from top: /技法アクリル2 *Relaxin' 2,* /技法アクリル3 *Relaxin' 3,* 曇天 *Cloudy Weather*

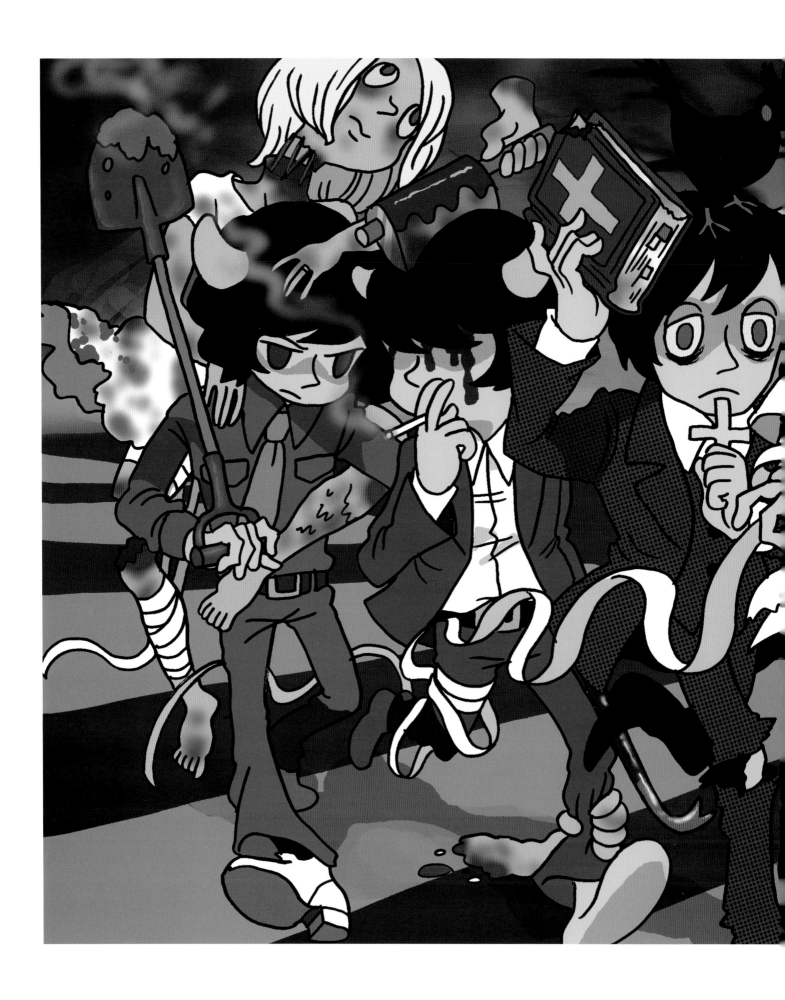

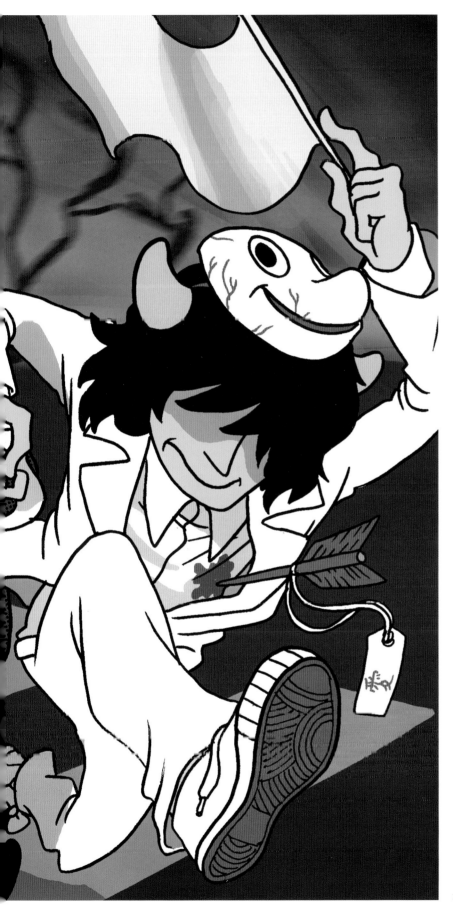

地獄へ行こう *Let's Go To Hell*

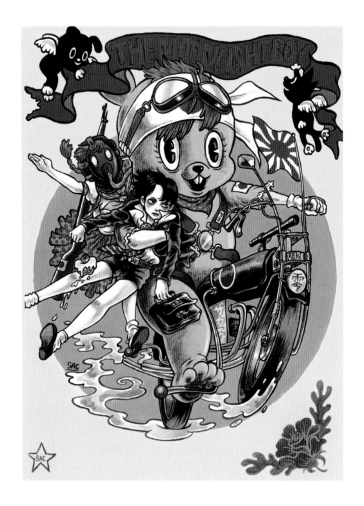

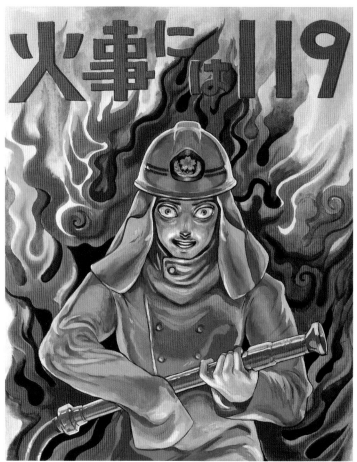

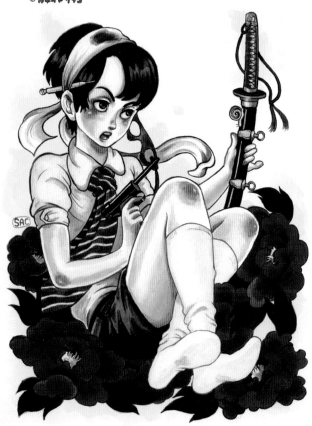

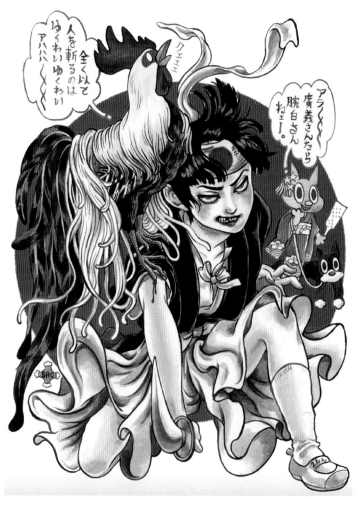

Clockwise from top: 拉致 *Abduction,* 火の用心 *Beware of Fire,* 酉年 *Rooster Year,* 牡丹 *Peony*

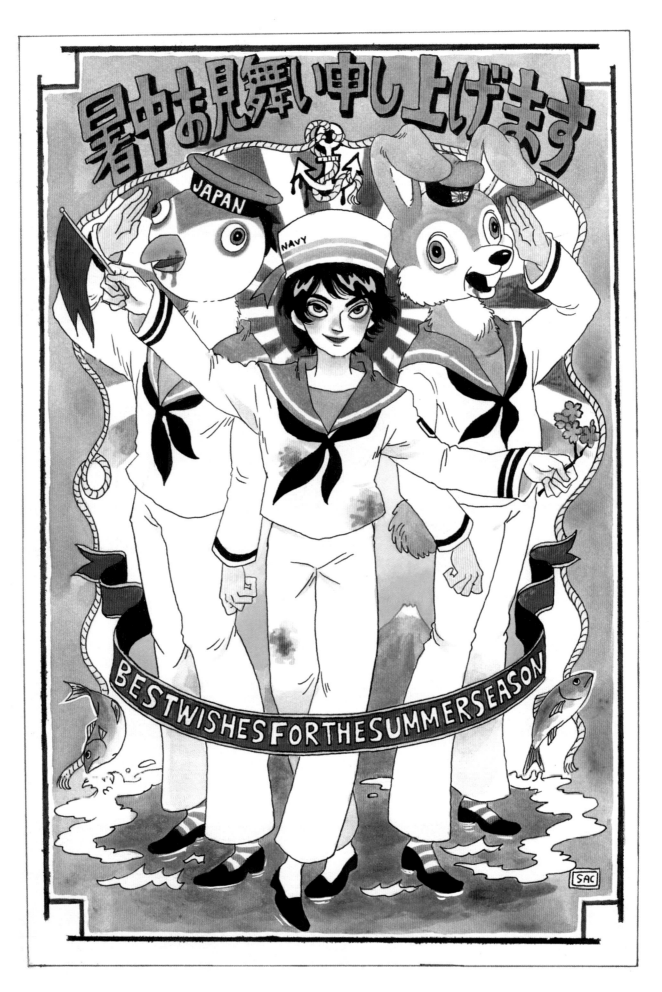

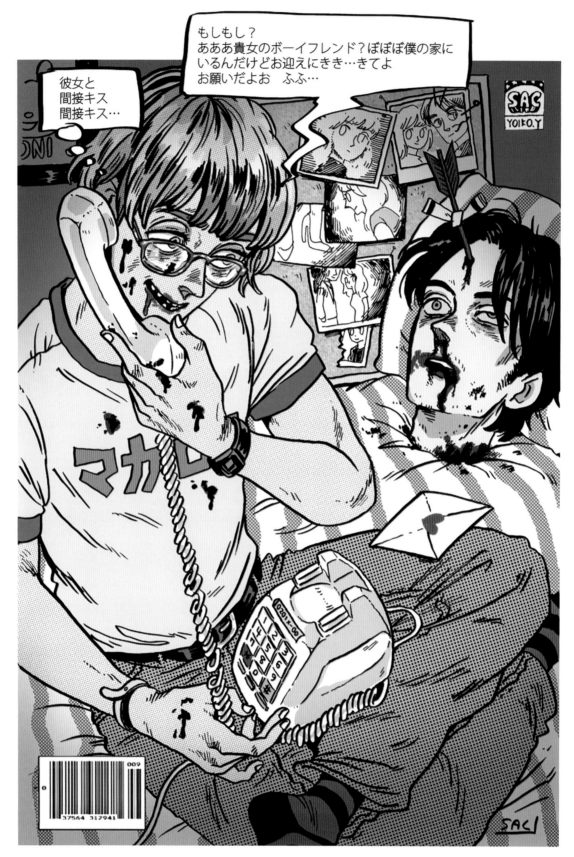

STK

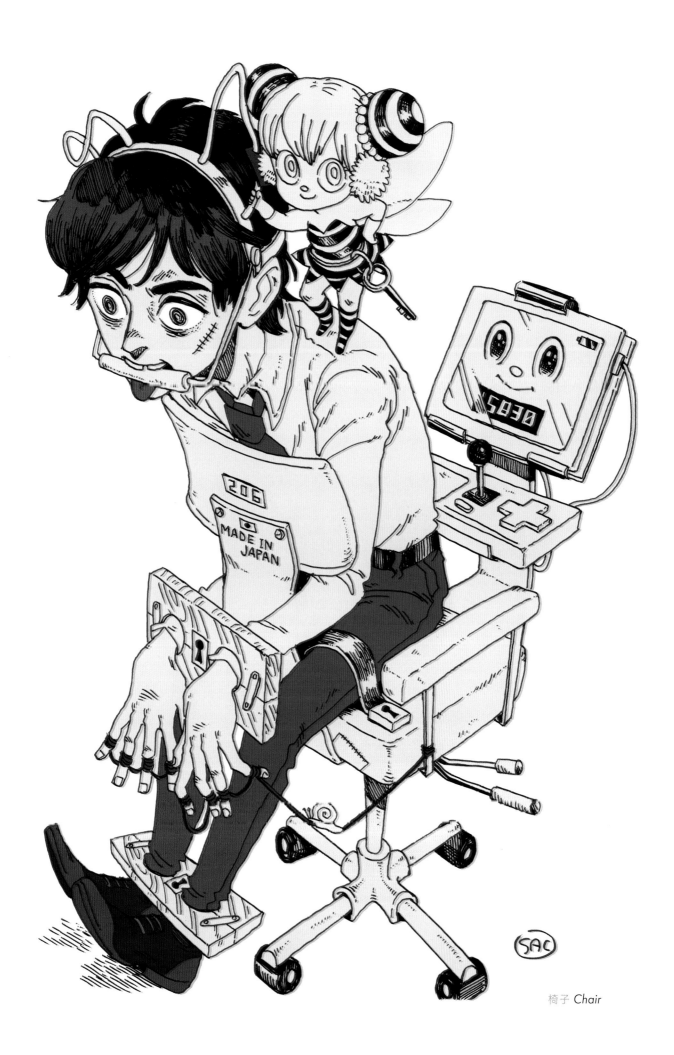

椅子 Chair

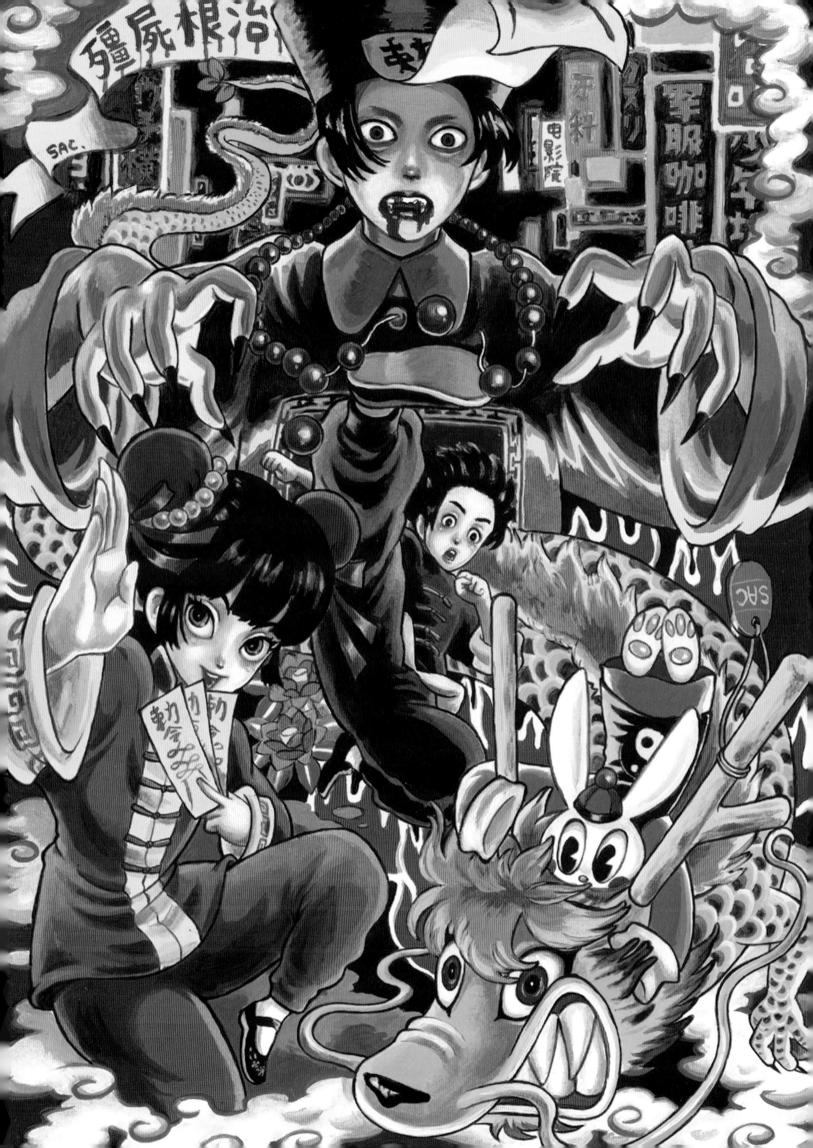

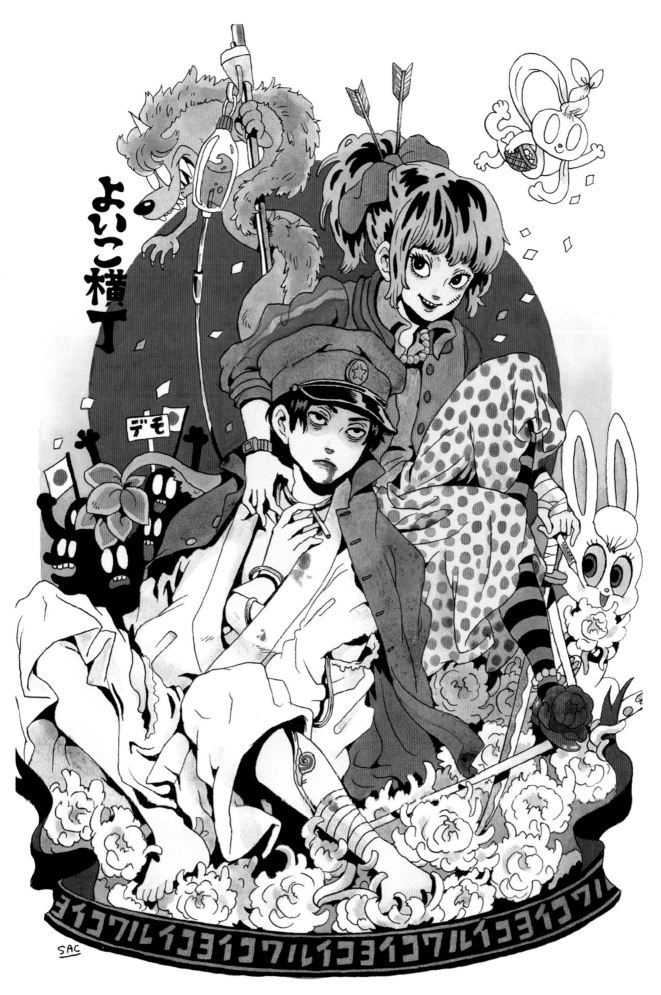

よいこ横丁

デモ

SAC

ヨイコワルイコヨイコワルイコヨイコワルイコヨイコワルイ

ヨイコワルイコ Yoyukowarikoly

ソファ *Sofa*

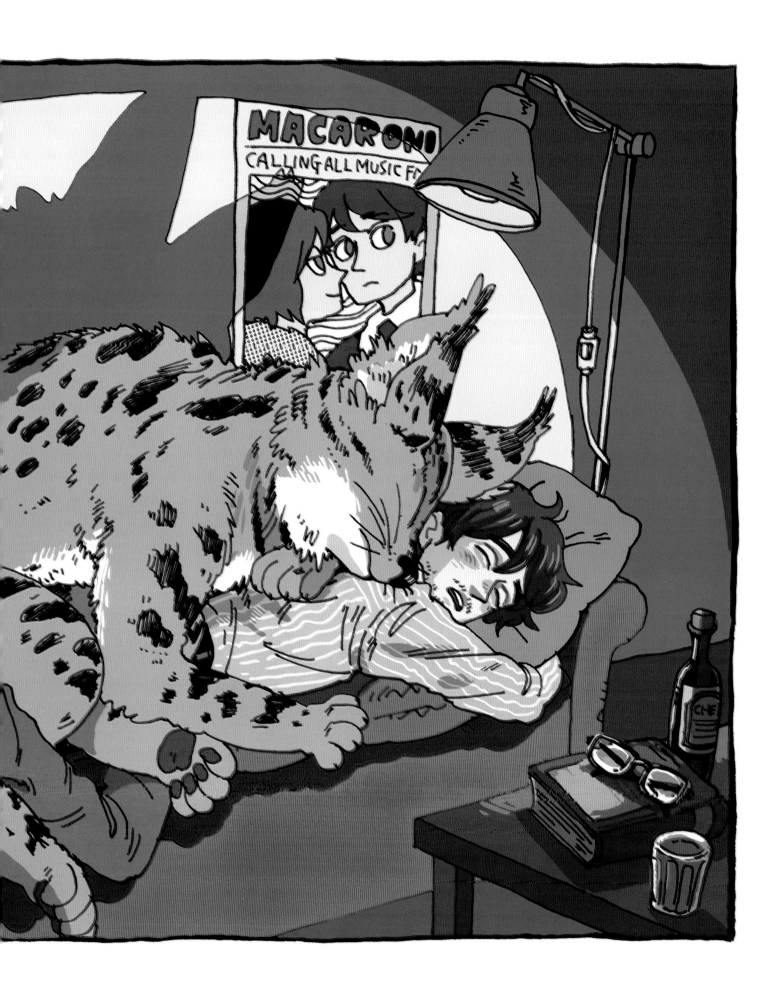

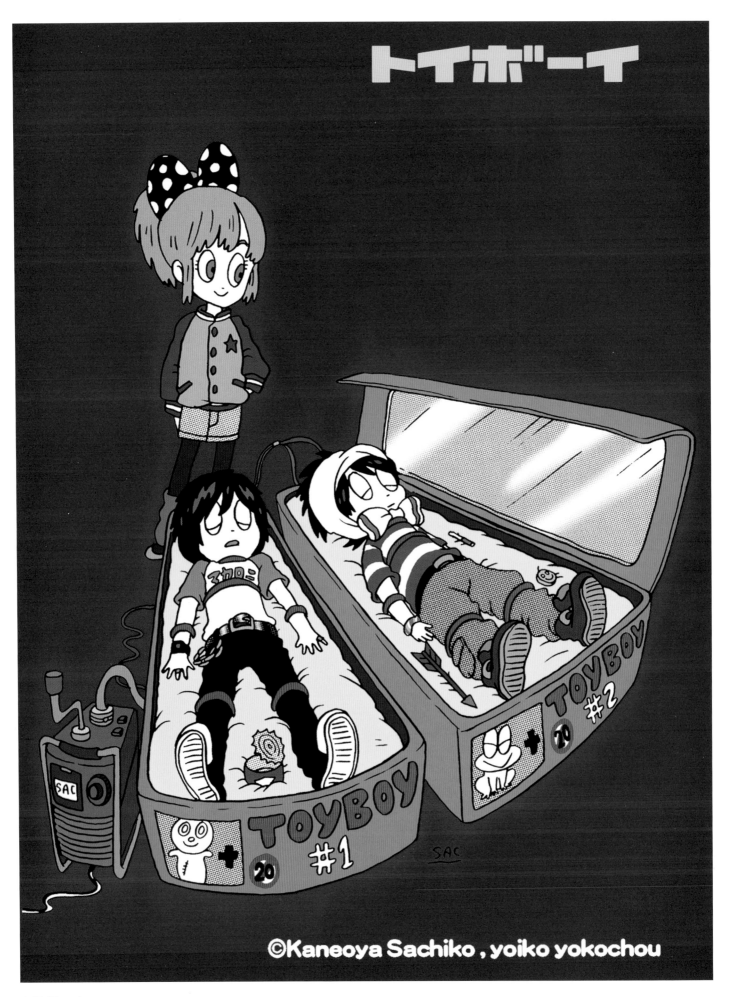

トイボーイ

©Kaneoya Sachiko , yoiko yokochou

充電 *Charging*

月光少年 *Moonlight Boy*

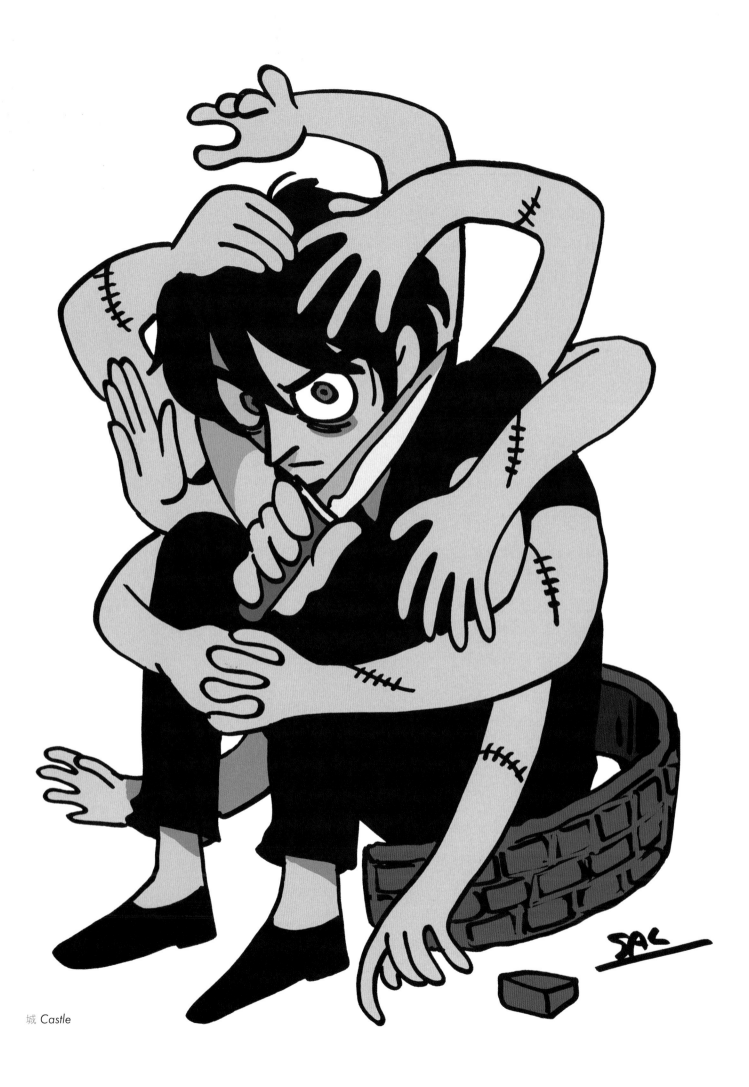

城 Castle

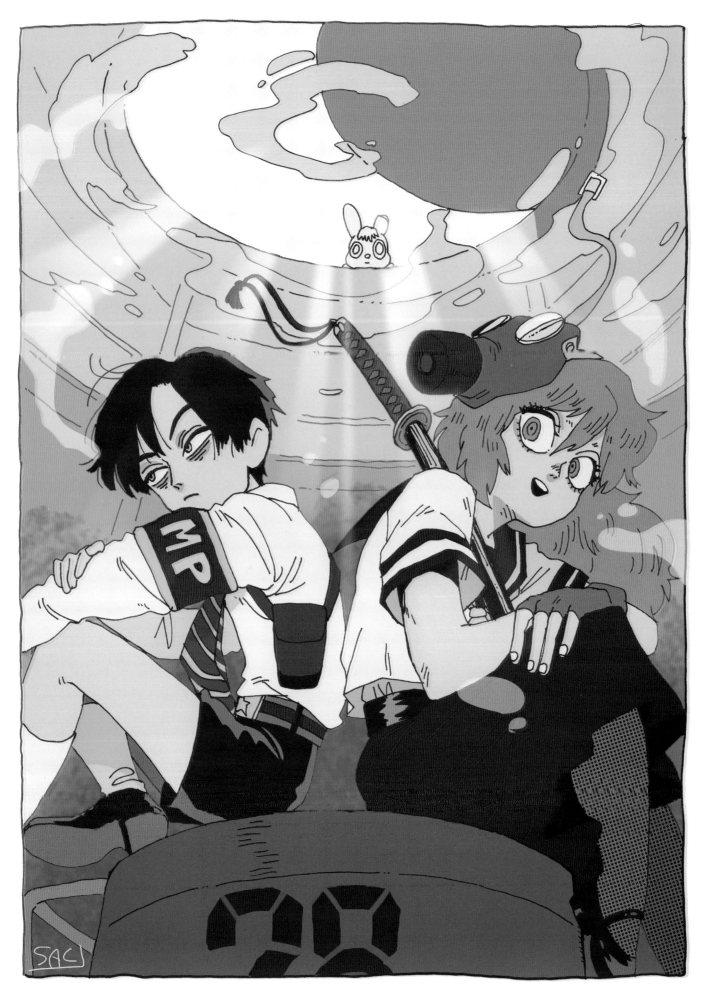

水槽 *Aquarium*

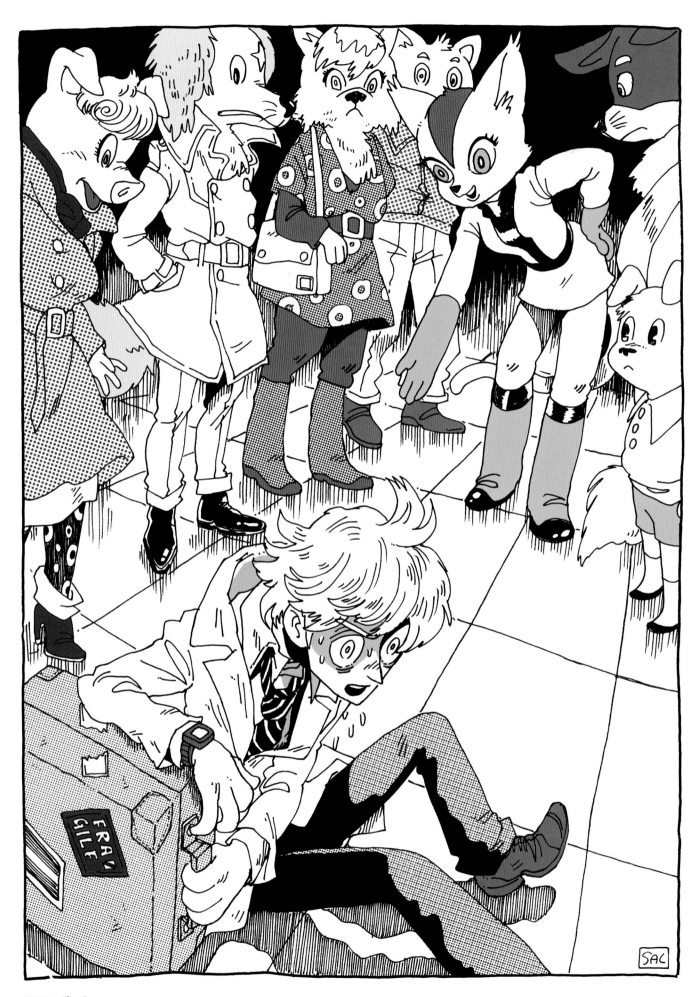

異邦人 *The Stranger*

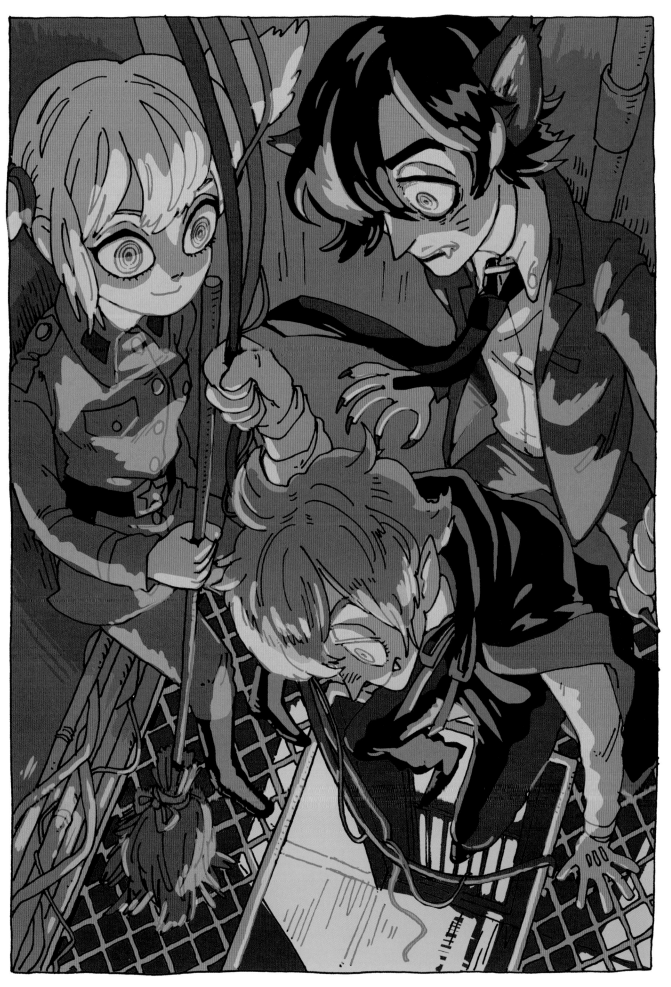

脱出大作戦 *Great Escape Strategy*

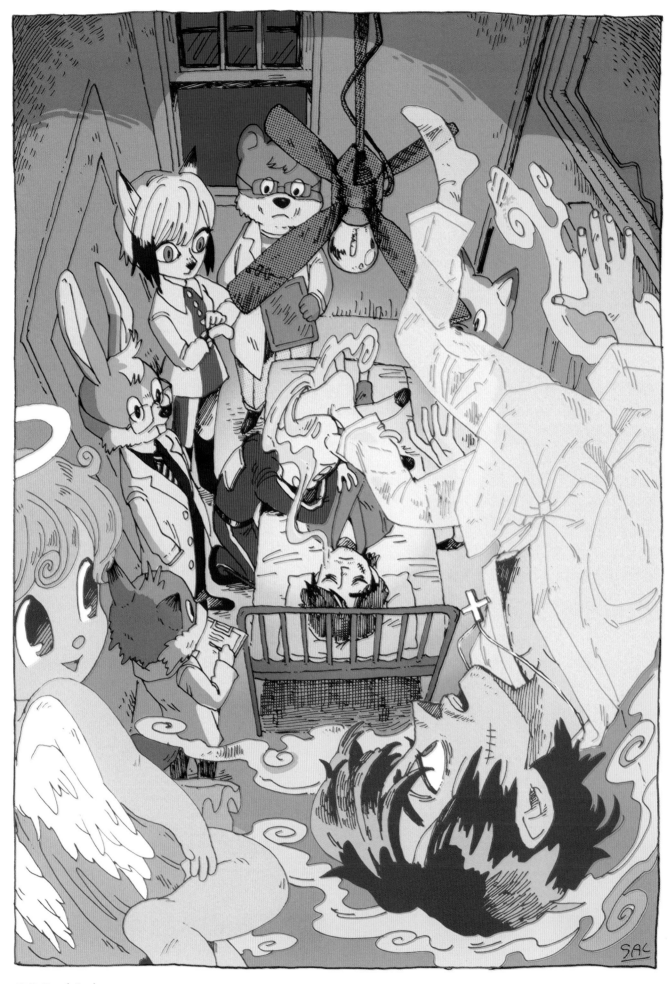

臨終 Death Bed

天体観測 Astronomical Observation

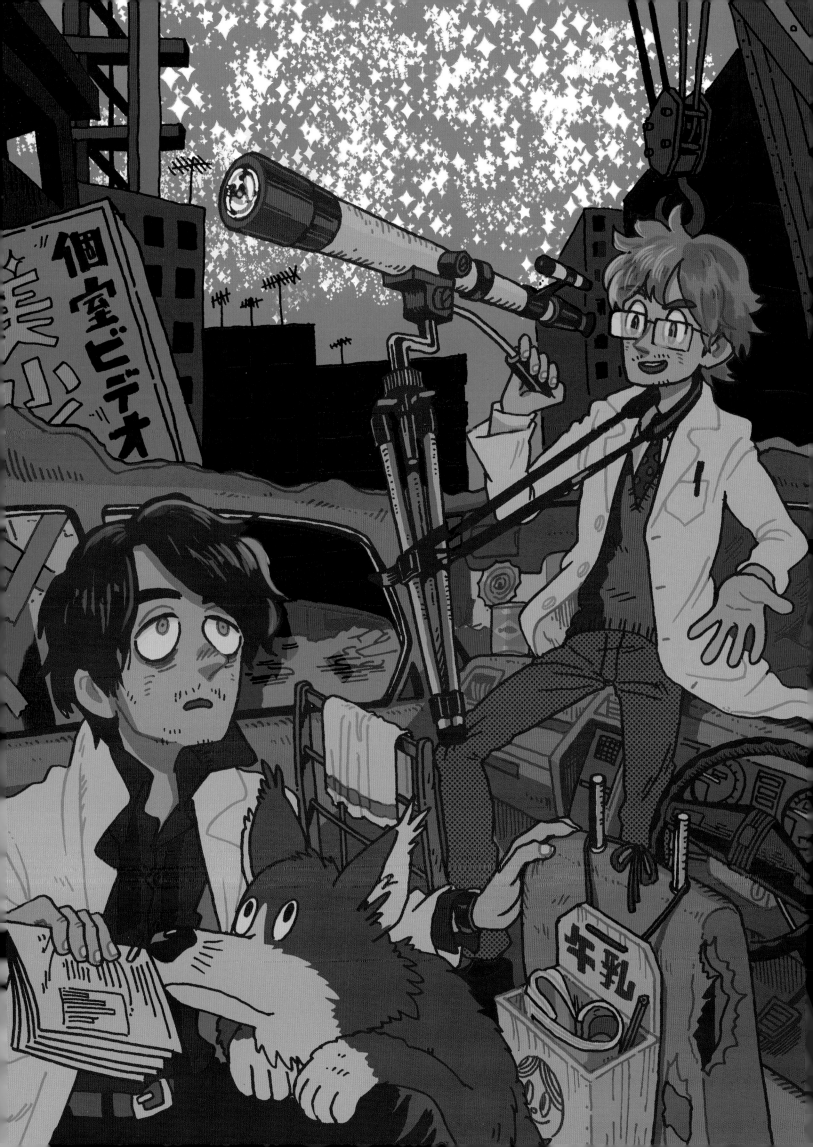

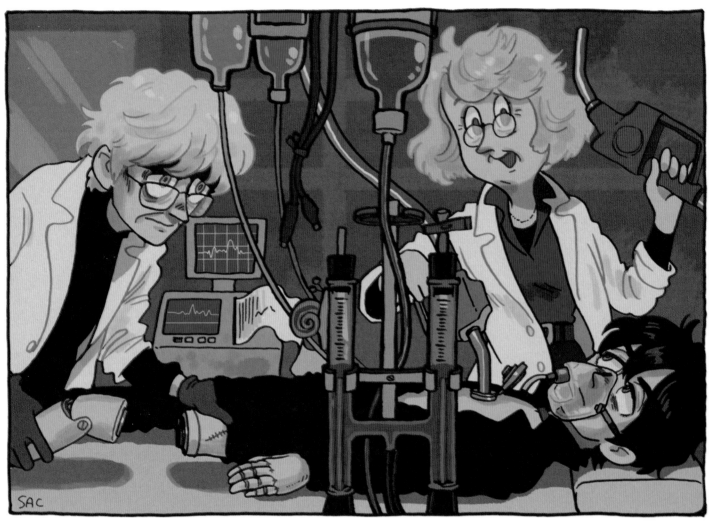

蘇生 *Resuscitation*

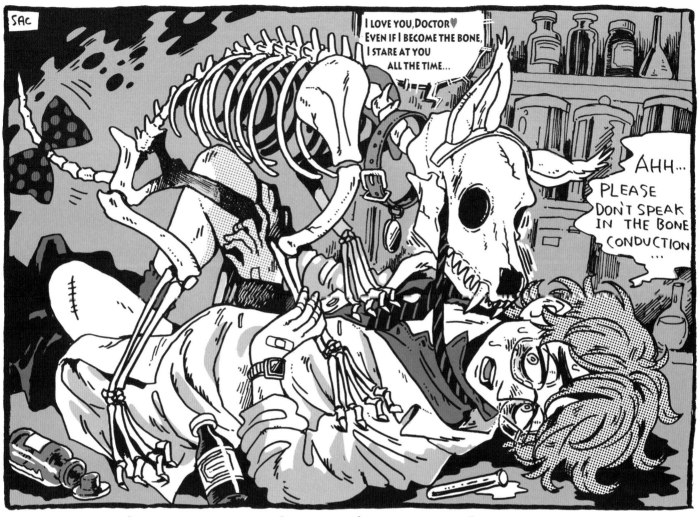

IF THERE IS LOVE, IT DOESN'T MATTER IF I AM A BONE.

 # MY PAST DAYS 在りし日の私

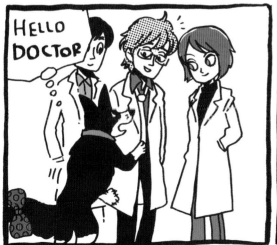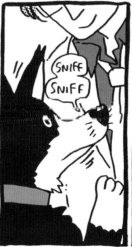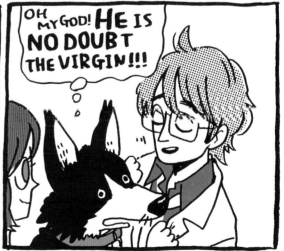

骨になっても *Even if it Becomes a Bone*

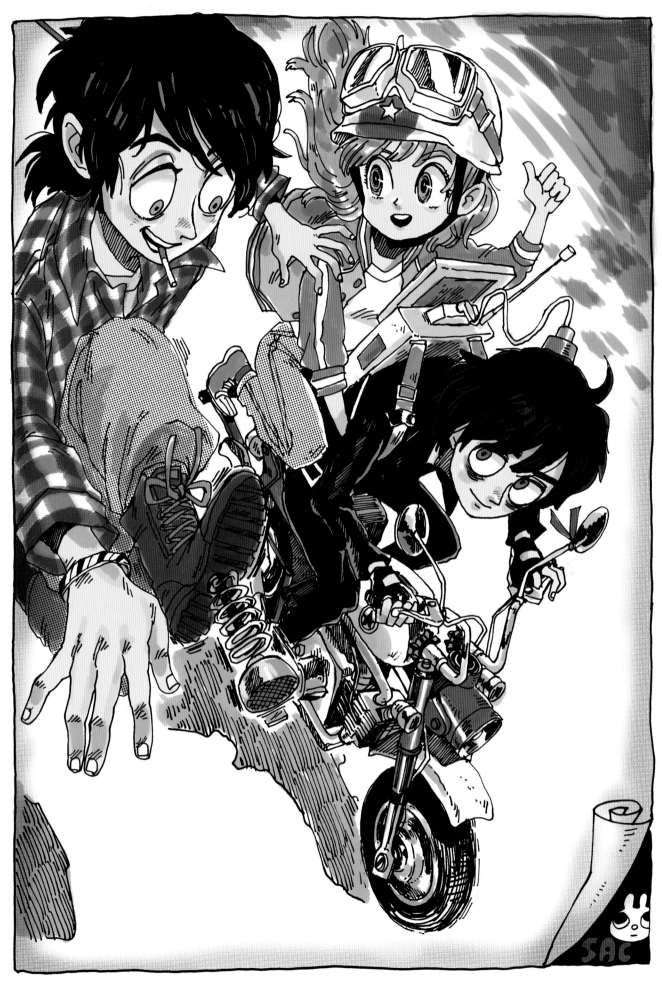

モンキー

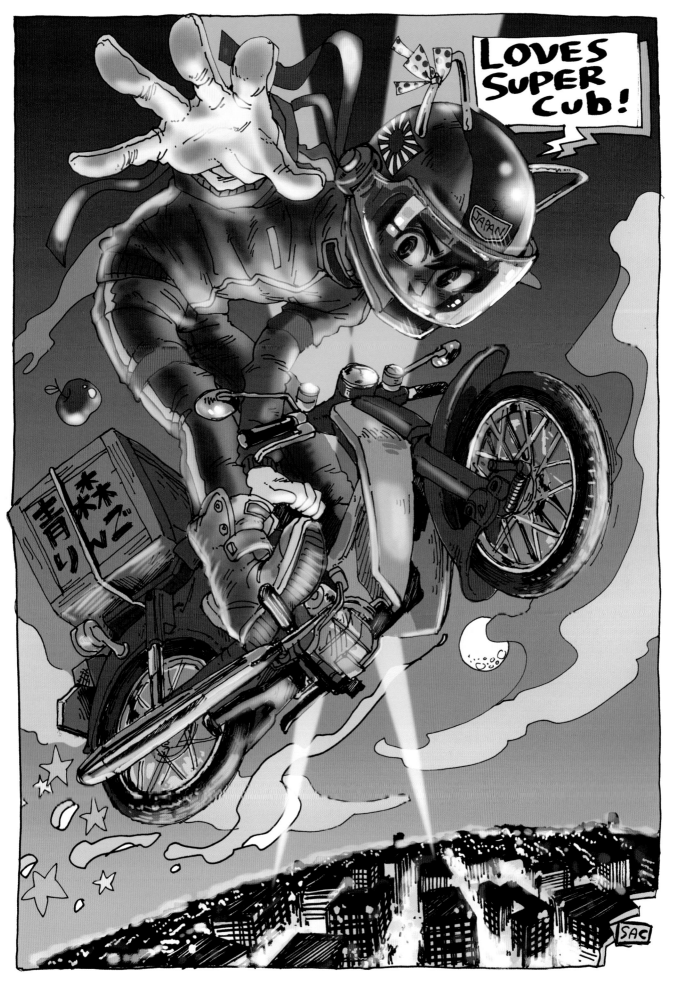

スーパーカブ *SuperCub*

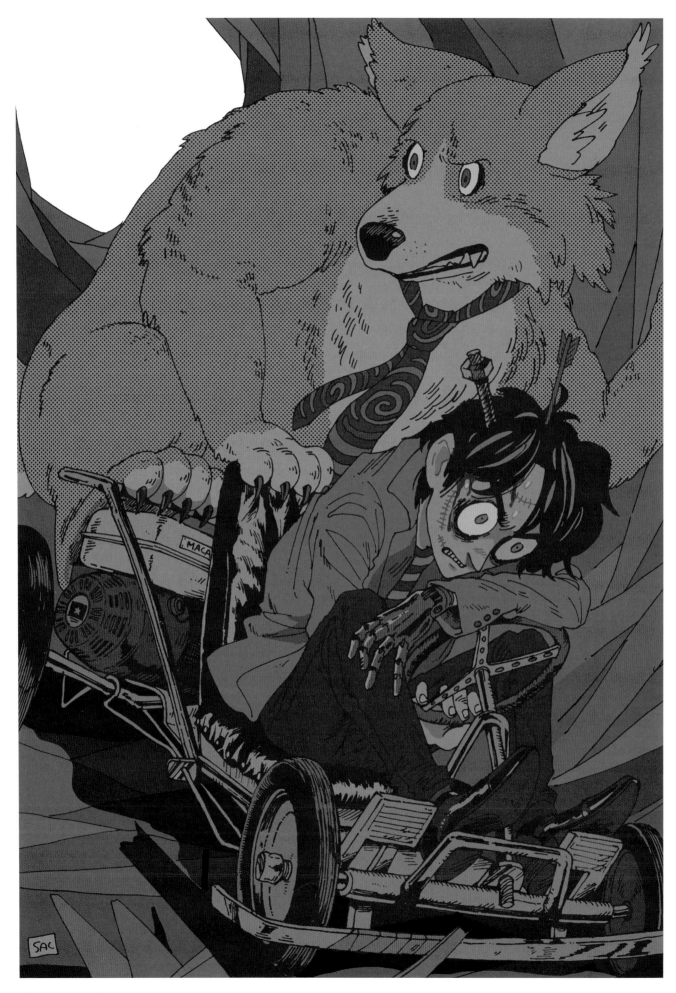

ゴーカート Go-Kart

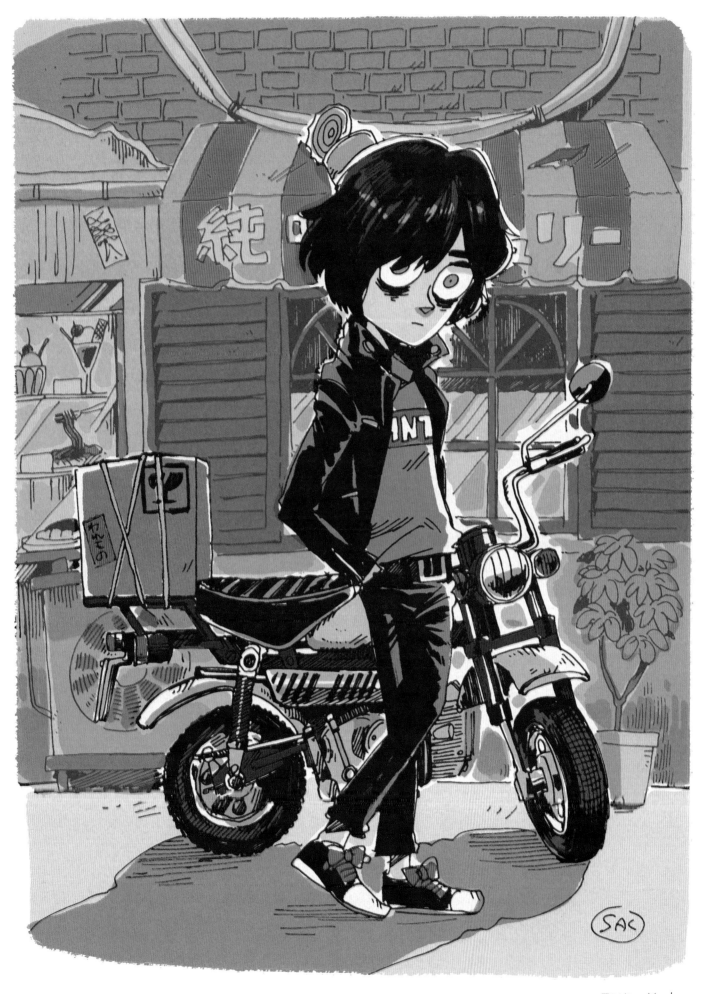

モンキー Monkey

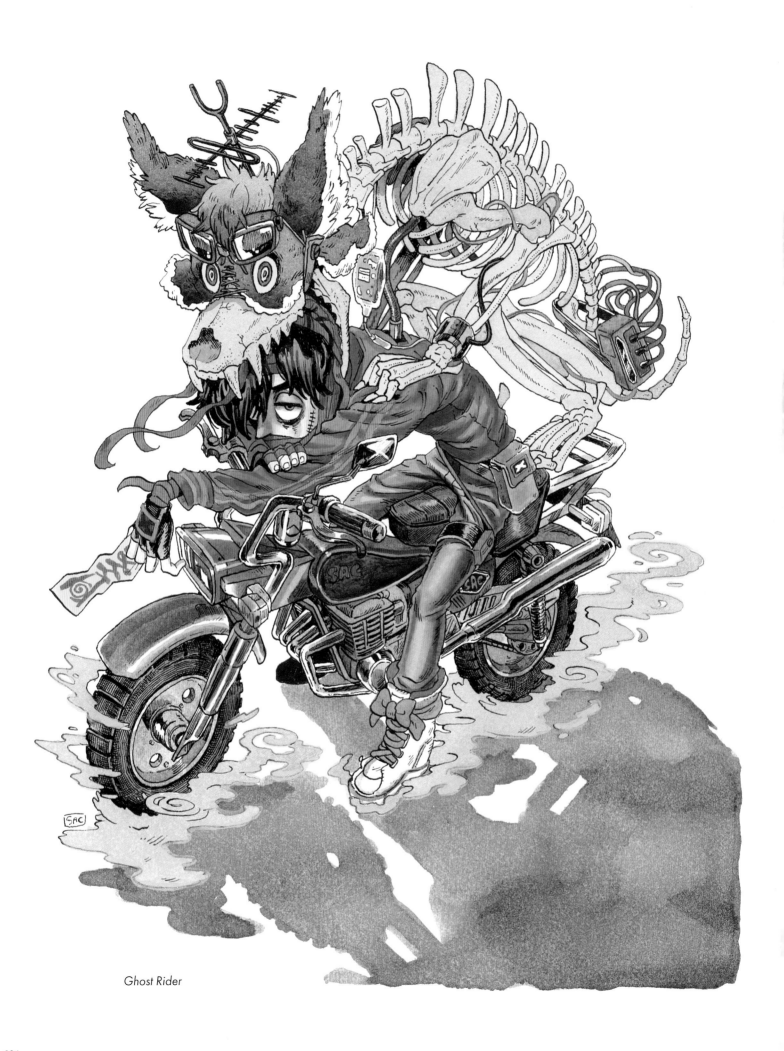

Ghost Rider